MAGAZINE DESIGN THAT WORKS

Secrets for Successful Magazine Design

GLOUCESTER MASSACHUSETTS

ROCKPORT PUBLISHERS

Stacey King

First published in the United States of America by
Rockport Publishers, Inc.
33 Commercial Street
Gloucester, Massachusetts 01930-5089

Telephone: (978) 282-9590
Facsimile: (978) 283-2742
www.rockpub.com

ISBN 1-56496-758-1

10 9 8 7 6 5 4 3

Design: MATTER/Cathy Kelley Design
Production: *tabula rasa*
Cover Image Photography: Bobbie Bush
Cover Image: Courtesy of *I.D.* magazine.

Printed in China.

MAGA ... VORKS

ROCKPORT

Stacey King is a writer and editor in the San Francisco Bay Area. She has worked in magazines and on the Web and is a frequent contributor to *HOW* and *I.D.* magazines. She holds a B.S.J. in Magazine Journalism from Ohio University's E.W. Scripps School of Journalism.

CONTENTS

About the Grid 30

Creative Process 46

Designing for Success: Q & A with Samir Husni 70

Evolution of a Magazine 90

Advertising Age 108

11 Steps to a Successful Redesign 132

8 Introduction
12 GQ
18 Details
24 Entertainment Weekly

>

34 Code
40 A

>

52 Real Simple
58 Dwell
64 *Surface

>

72 TransWorld Surf
78 Yoga Journal
84 Walking

>

96 Travel & Leisure
102 Blue

>

114 HOW
120 I.D.
126 Sony Style

>

134 Fast Company
140 Context
146 Business 2.0
152 Conclusion
156 Glossary
158 Directory
160 Index

INTRODUCTION

The world of magazines is an absorbing one. Even if you're not a self-proclaimed magazine junkie—coveting your 20 subscriptions, guiltily hiding *Glamour* and *People* before guests arrive—you can get a small taste of the rush by visiting your local bookstore. Skim the newsstand; take in the brilliant colors, the gripping cover lines, the clever or intriguing or outlandish photographs. Before long, you'll be fumbling at titles you've never seen before, comparing competitors, glancing knowingly at the masthead to see if you recognize the publishing company. And judging—always judging.

Magazines are among the most scrutinized of media. That's because the public likes to watch a good, bloody fight, and magazine publishing, for all its magic and allure, is a desperately cutthroat industry. According to "Mr. Magazine," Dr. Samir Husni, whose annual *Samir Husni's Guide to New Consumer Magazines* tracks the rise and fall of startup titles, 864 magazines started up in 1999, and nearly 50 percent of those failed by the end of that year. The ones who make it have a hard row to hoe—they face an uphill battle with advertisers, constant demand for image alterations to meet a still-undefined audience, and muttered criticism from the trade and mainstream press.

The old-timers, meanwhile, overhaul their images every few years to keep up, under the watchful eye of industry pundits and readers who holler every time a magazine changes its logo. Add audiences increasingly fascinated with electronic media's third dimension and critics who predict the demise of the printed word. That's not to mention the challenge magazines face during economic downturn, when competition for ad sales grows fiercer and established titles suffer layoffs and buyouts alongside their advertisers.

Put all these factors together, and you get an industry in which every decision is influenced by competition. Whether a magazine is a nationally distributed newsstand publication for consumers or a specialized title with qualified circulation, chances are that it has at least one or two direct and a dozen indirect competitors.

As with any product for sale in a crowded market, branding means everything to magazines, and that's achieved largely through packaging. Dr. Husni notes (p. 70) that a magazine has 2.5 seconds to grab a reader's attention on the newsstand. But the challenge goes further—not only must its cover succinctly sum up the personality, scope, and tone of a magazine but the inside must stay coherent enough from back to front (the way many readers flip) to pull people in, then continue to satisfy, surprise, and speak to them in every subsequent issue. And the magazine must consistently do all this with more depth, better character, and a more intoxicating voice than its competitors.

Role of the Designer

The magazine designer must step up to this monumental challenge. While editorial content and voice ultimately establish a magazine's brand, design is the elaborate stage from which that voice is projected.

Magazine design has undergone an interesting evolution during the past few decades. Traditionally, magazines were arenas for longer-form articles, competing— or perhaps supplementing—the daily dose of newspapers. With a few exceptions, magazines adopted the same cut-and-dried approach to layout as their newsprint cousins.

But a visual society erupted with the onset of television, and, as new generations of readers came to expect the same three-dimensional eye candy fed to them by the new medium, magazines responded in kind. Over time, design for magazines moved from utilitarian consideration to true art form.

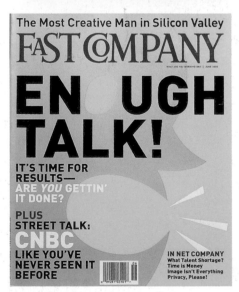

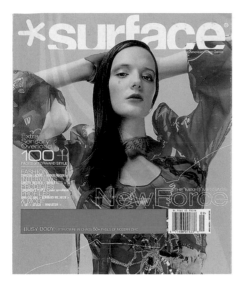

As with most art forms, the artists circled in their own universe. Universities introduced visual communication programs and added design classes to their journalism curricula. Trained graphic designers began chatting casually about "the grid" and "process." Magazine design consultants found a niche for helping publications establish and reestablish themselves in the increasingly competitive magazine market.

The 1990s were to magazine design what the 1960s were to rock music—a period of experimentation and resounding lack of clarity, but, ultimately, a time that determined the new direction for the genre. New titles on the market took design to new heights. In some cases, design was the format; it was to be pored over and marveled at rather than to support or surround the articles.

The world was changing drastically. The Berlin Wall had fallen, PCs were becoming ubiquitous, and the Internet was breaking out of its shell. Magazines such as *Wired* challenged readers to see, understand, and interact with the world in new ways. Layouts required readers to turn the magazine sideways and upside down to read text, to peer closely at colored text on backgrounds of the same color, or to squint to read tiny words. Magazine design came to look and function like Web design, which, with its short blurbs, boxes, and clickable information, was becoming a familiar platform for readers.

The techniques sparked both controversy and excitement. Design contest awards were doled out, art schools glorified the style, and experimental magazines such as *Raygun* and *Emigre* raised eyebrows throughout the industry. Meanwhile, magazine editors and old-school designers scoffed.

Regardless, the new approach was a breakthrough in the way magazine designers approached their subject. "So many barriers don't exist any more," says Lisa Sergi, art director for *Walking* magazine. "Things got so avant-garde a few years ago, and it really opened some doors. I think every designer has stolen from [experimental designers] in some way. We pay more attention to the way things feel together now, the way type works with photos."

The Four Fs

A major problem with such experimentation is that it sometimes ignored the predominant reason for magazines' existence: to be read. Illegible layouts alienated many readers. Eventually, many magazine designers realized they needed to harness the winds of change and bring them down to a more practical level. Mainstream audiences, no matter how smart or open-minded, still expected and appreciated underlying order to their chaos. They desired magazines that spoke to them, not above them.

Ultimately, successful designers turned back to an easy set of guidelines that have long been a loose standard for magazine publishing, a mantra preached to students in journalism graphics programs. They are the four Fs of magazine design:

1. Format: Design choices that span every issue and define a magazine's overall look and feel determine the format. These include the logo, cover lines, size of the magazine, department headers, and folios.

2. Formula: The formula sums the magazine's approach to editorial content. Feature type and length, departments in the front and back of the book, photographic style, and illustrations all contribute to the formula.

3. Frame: The frame is the standard for outer page margins and gutters. Some magazines use the same margin width through the magazine; others vary the width, using tall top margins for features to set apart the well, for instance. The rule for using margins establishes consistency from issue to issue.

4. Function: The function is, quite simply, what a magazine is trying to achieve and the message it's trying to send. A magazine like *Real Simple,* an elegant primer on how to live life elegantly, has a completely different function than *Entertainment Weekly,* which jolts readers with its head-spinning, ever-changing news about the entertainment industry.

The four Fs establish an overall look and feel—a brand, really—for the magazine. But here's where the magazine designer—the brave soul who stepped up to the challenge of arming a publication for the cruel, competitive battle—faces the true test. Every story in every issue must live up to the brand. Design's role is equal to that of editorial content in communicating the voice, mood, and concept of each article. At the same time, it must reinforce the identity of the magazine as a whole.

Know Thyself

The only way designers can balance these overwhelming tasks successfully is by understanding the magazine's purpose for being. Function, inarguably, is the most important of the four Fs, the factor that drives the rest of the F decisions. It is the creed to which designers must refer every day for decisions as small as font choice and as large as cover or department design.

Paying close attention to function helps designers steer their creative impulses away from *ars gratis artis* toward a calculated, purposeful technique that communicates a given message to receptive audiences. The designers interviewed for this book are all intimately in touch with their magazine's function. They powwow with editors regularly, read articles word for word before beginning layouts, can recite audience demographics and circulation numbers off the top of their heads. They know their reader and their subject matter and, when challenged, they can always explain their method.

One thing that sets magazines apart from other types of publications—and from other graphic design genres, for that matter—is their dependence on niche audiences. This poses both a benefit and a problem for designers, who must delve into the mindsets of

readers who may be unlike themselves. But the variety of design on the newsstand—and represented in this book—reflects the reality that every reader doesn't think or react in the same way. The haunting, esoteric images of **Surface* or the scattered, busy text of *Blue* may turn some people off. But readers of those magazines, for whom the design is customized, may bristle at the clean, refined layout of *Travel & Leisure* or the whimsical graphics of *Fast Company.* Designers know this. They plan their layouts, and set their limits, accordingly.

In *Magazine Design that Works,* designers and editors from nineteen magazines offer a behind-the-scenes look at how their design supports the editorial mission and the design choices they made in accordance with function. Some have formalized processes, others go by feeling, but they all know why and how they design. Some reasons might surprise you. Why, for instance, do *Entertainment Weekly* designers, on a strict weekly deadline, take the time to create painstaking illustrations for headlines? Or how did the creative director's personal need to simplify his life inspire *Fast Company's* now branded use of white space? Good designers are always reevaluating their decisions, looking for the reasons behind them, and verifying that they contribute to the common good of the magazine.

The magazines chosen for this book include many of the heavy hitters, magazines universally recognized for their design excellence. But a few quieter titles are in the mix—small magazines such as *A* and *Yoga Journal,* which may not win international design awards each year but whose smart, streamlined designs emerge like oases from the chaotic newsstands.

The lesson is that good design—no matter how small the design staff or limited the budget—is attainable when designers understand their audience and recognize their own reasons for existing. In the world of magazines, every product must fill a niche or risk being ignored by readers who are on information overload. Magazines whose purpose and goals glow in their essence will never fail to stand out from the crowd.

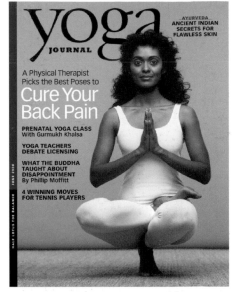

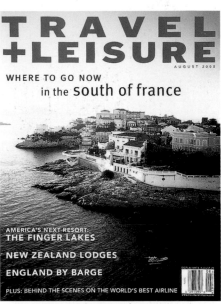

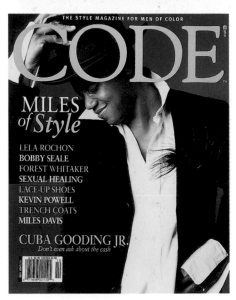

Fashion for the New Affluent Man

Magazines that survive the ages become staples of our culture: *Life, Harper's,* and *Time* among them. These titles are as familiar to us as great film classics and works of literature because they shaped how entire generations have seen the world.

GQ can easily be esteemed as one of the great magazines to weather the turbulent decades. After more than 70 years in circulation, the magazine's title has become synonymous with fashionable, as in, "You look so *GQ.*"

The magazine's design has progressed over the decades to mirror the changing image of the stylish, affluent man. In the era of 20-something millionaires and 30-something retirees, design expresses quality and confidence with a cool, yet reserved, edge.

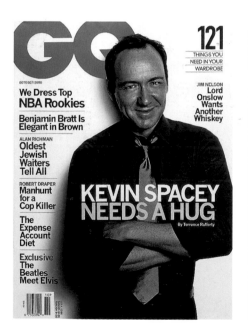

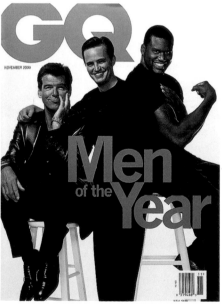

far left Strong, bold cover lines outline a straight-on portrait of Kevin Spacey on the front of the October 2000 issue—an example of the magazine's assertive,confident covers.

left A stunning lineup of stars grace the cover of *GQ*'s coveted "Men of the Year" issue.

WHY IT WORKS:

With few frills, *GQ* is straightforward in its attempt to be a timeless publication, giving a nod to its history while firmly maintaining its stylish reputation. Richly colored photographs and striking type treatment boldly accentuate clean, classic page layout—offering variety but staying grounded with a proud sense of the magazine's identity.

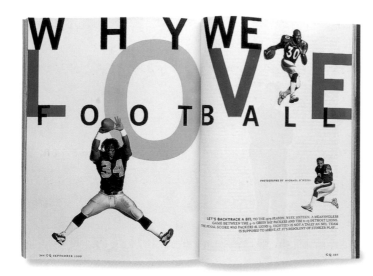

left *GQ* excels in covering a wide variety of subjects, reflecting the tone and message of each article through its design, while maintaining consistency. This playful series of layouts for the September 1999 football issue uses the subdued palette and plenty of white space, but inserts fun images and type to play off the energy and excitement of the featured game.

The New Gentleman

Still, *GQ* hasn't avoided becoming "a lot hipper" over the last several years, mainly to appeal to younger audiences who have grown up rather quickly, says design director Arem Duplessis.

"With the economy as good as it's been, we have a more sophisticated audience who's increasingly concerned with overall style," he says. "He dresses for the job he wants, not the job he has."

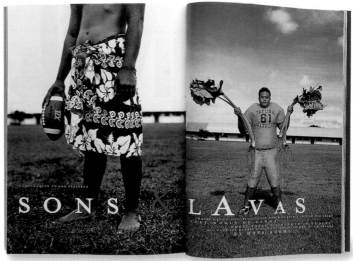

Average readers range from recent college grads to around 40 years old, generally hold advanced degrees, and make between $35,000 and $100,000 a year. Such an age gap may be difficult for other magazines to straddle, but Duplessis says the *GQ* reader responds less to generational messages and more to a prevailing attitude.

"Our readers already know who they are," he says. "We avoid anything over the top and stick to a classic aesthetic, one that has no time period."

above A variation on the football theme for the same September issue is a spread of loud colors and patterns, introducing the sport in Samoa.

left Tightly cropped photos act as a colorful banner across this silver-coated page introducing *GQ*'s coveted "Men of the Year" awards—an example of how accented color touches up ordinarily subdued pages.

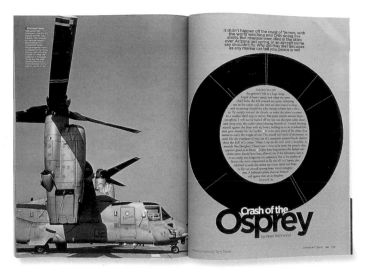

left While trying not to stray far from its consistent use of typography, the magazine often adopts themes for feature articles and plays them out in type. Here, a giant "O" encircles the opening text, a severe introduction to an article about an ill-fated aircraft named the Osprey.

Staying Consistent for Readers' Sake

Much like other publications launched earlier in the century, *GQ* is known for its literary legacy, and editors pride themselves on commissioning talented, recognized writers. But articles also must reflect current issues and appeal to a diverse readership, so the magazine covers broad topics—politics, sports, art, entertainment, as well as fashion.

"Our biggest challenge is staying consistent with all our concepts and reaching as broad of an audience as we have," says Duplessis. Design changes according to the mood of each story, but design elements must tie the book together from front to back.

A strict grid, generally three to four columns throughout the book, plays a role in maintaining coherence. Articles tend to be quite long, but rather than breaking them up with boxes and subheads, designers let them play out in two or three columns, usually with a pull quote or small photograph that acts as an anchor in the gray sea of type.

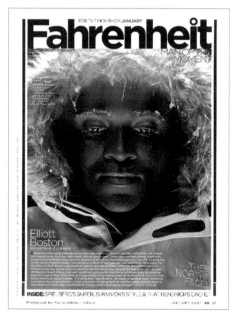

left A front-of-the-book roundup of news and trends, "Fahrenheit," offers short articles, intense photos, and a visual playground of layout techniques to represent changing pop culture. Here, an eerie, icy image of mountain climber Elliott Boston opens a winter edition of the department.

below In another example of text as illustration, the red deck of this story symbolizes the shape of the body's esophagus in the facing illustration, pouring between the first and second words of the headline.

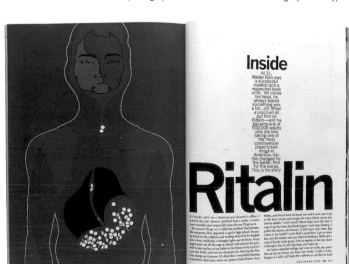

The one place the book strays from this format is in "Fahrenheit," the department in the front of the book that offers short reviews, product snapshots, profiles, and calendars. Colored boxes and heavy black rules break up articles so pages are attractive and delightfully easygoing. "It's a quick read for people who are skimming on the airplane or train," Duplessis says.

The color palette, though subdued, also unites the pages of *GQ*. Heavy blues, grays, and reds guest star in headlines and pull quotes, never taking over a layout but garnishing dense pages of text with just enough color to intrigue and entertain.

Retro Influence on Type

In the same fashion as color, display type gives pages power and pop without detracting from the article's message. Bold headlines contrast handsomely with white pages and tiny body copy, while bold or colored pull quotes, inside shapes or escorted by heavy black rules, break up second or third spreads in articles.

below A bold, all-caps headline, bleeding to the edges of the left page, and the facing photo are a dramatic debut for an article on actor Philip Seymour Hoffman. Yet the pallor of the article is relatively upbeat because of the sharp contrast and demanding type.

GQ's signature typeface, rolled out during a redesign in January 2001, contributes to the designers' goal of consistency as well as to the "modern yet classic" feel of the book. "We hired a typographer to draw a font for us," Duplessis says. "He studied old subway posters from the early 20th century and built a sans-serif font based on the type in those posters." The resulting typeface, with its rounded letters and flat-topped and flat-bottomed ascenders and descenders, graces everything from cover lines to sidebar copy with the geometric character of early Art Deco.

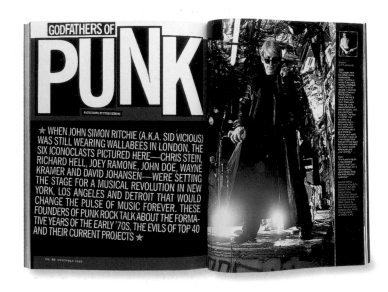

Occasionally, designers experiment with display type somewhat—enlarging it to make a big splash on opening spreads, illustrating it to match the concept of a story, or playing with leading for a "crowded" effect. But even these attempts are somewhat subdued, never venturing out of the realm of expectations or veering too far from the magazine's standard look. Type also rarely strays from the limited palette of colors, taking on some red or blue here or there but more often emphasizing its point with bold, black characters.

The reason *GQ* doesn't get carried away with type treatment? "We don't want display copy to take away from the impact of the photography," Duplessis says.

above In a show of how display type can exploit opening spreads to set a mood, patched together letters and a skewed opening paragraph reflect the iconoclastic mood of the founders of the punk movement.

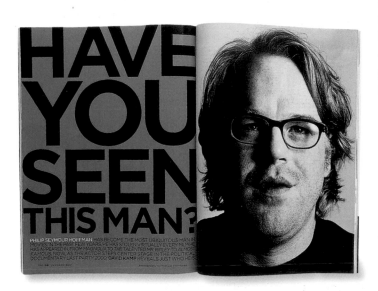

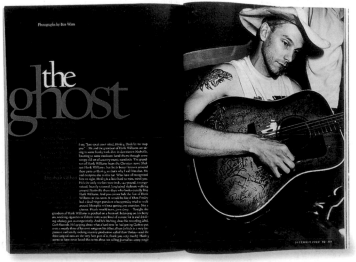

right By contrast, a more shadowy, somber photo of Hank Williams III is surrounded by dark, soft colors, setting a very different mood.

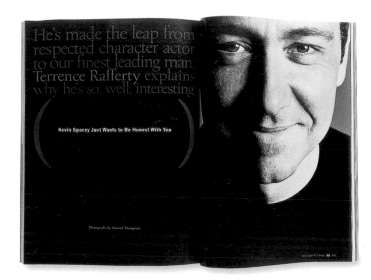

Signature Photography and Illustrations

Photography is a cornerstone of *GQ's* design. Though they change to reflect the tone of the story, images are sophisticated, beautiful, and often lighthearted. Like the pages themselves, colors in photographs often steer toward neutrals—grays, beiges, and blues, with subdued lighting—with occasional explosions of bright colors as accents.

GQ's director of photography, Jennifer Crandall, recently started taking some chances with photographic choices, says Duplessis. "In the past we've always been known for using big-name photographers," he says. "Now we're still using big names, but we're also finding innovators, mixing it up, and doing a lot of experimenting."

The same goes for illustrations, which are another major part of the magazine's brand. Fun illustrations generally accompany fictional pieces or essays that may not lend themselves to photography. Lately,

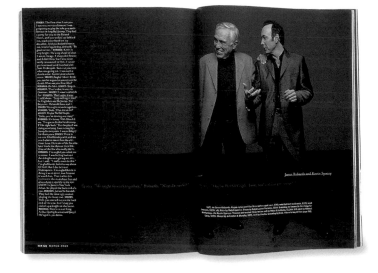

Duplessis says, the magazine has been looking at European magazines to find new illustrators and showcase emerging talent. Illustrators must be familiar with *GQ's* look and feel and work within a loose framework—using colors that complement the palette, for instance.

The result of *GQ's* commitment to sophisticated consistency is a refined-looking magazine that feels mature and self-assured—much like the readers who subscribe to it.

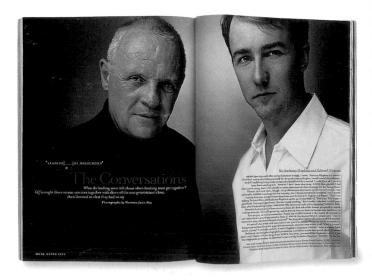

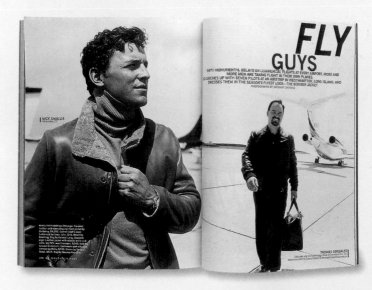

left Combining black-and-white and neutrally colored photos offers a realistic yet rugged feel to this fashion layout involving professional pilots.

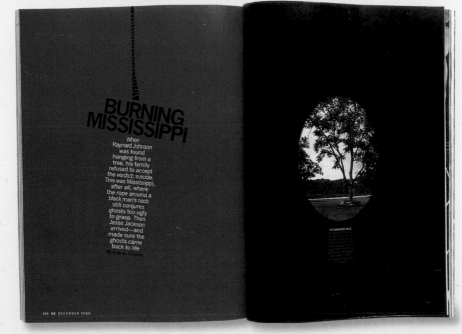

right Reds and blacks are among the boldest shades in *GQ*'s color palette and are often used as accents. Here, however, they've been pulled out to suggest the rage and intensity surrounding an event. A clever use of type and graphics—including a "window" to the scene of the depicted crime—builds the reader's curiosity about a sensitive subject that's difficult to portray visually.

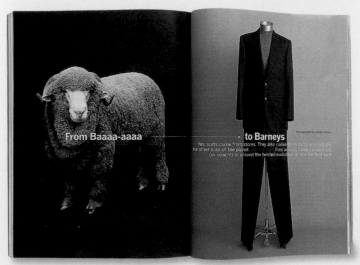

left One of *GQ*'s greatest successes is that no matter how much of a cornerstone of men's fashion it becomes, the magazine never takes itself too seriously. Here, while sticking to its sophisticated neutral palette, facing pages comically link a straight-faced sheep to a highbrow department store suit.

Urban Male Style and Culture

One of the great launches of the 1980s, the wayward *Details,* is finally home again.

The 18-year journey of this popular men's magazine reflects how difficult it is to pin down the 20- and 30-something male demographic in magazine publishing. Publishers struggle to find the balance between fussy fashion magazine and babes-and-beer smut, in much the same way that their readers contend with society's own expectations of what is acceptable "male" behavior.

Details ran the gamut, changing personalities several times during its history. But after a relaunch in late 2000, it returned to its roots as a smart, thoughtful magazine about celebrity, fashion, and art. It expresses its revived personality through brilliant photography and design that ranges from urban style to gritty realism.

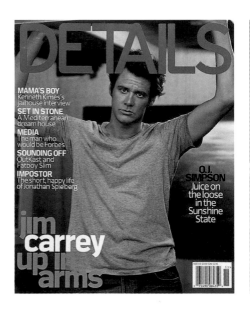 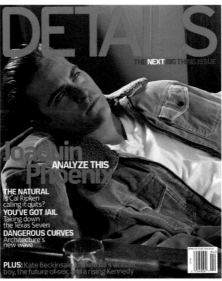

far left Covers introduce different sides of celebrities than those the public usually sees. On the November 2000 cover, comedian Jim Carrey offers a deep, somber gaze—intriguing to anyone familiar with his usual public face.

left A cover shot of Joaquin Phoenix explores the actor's subdued, James Dean-like qualities, accentuating his moodiness with soft lighting and a daydream pose.

WHY IT WORKS:

Atmospheric photography sets the tone for articles, from exposés to celebrity profiles, telling the stories as provocatively as the words. Color, type, and graphics reflect the mood and music of readers' generation, a combo of retro appreciation and fast-moving digital influence.

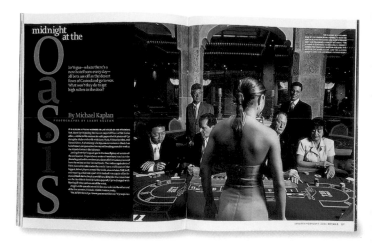

left Colors from the magazine's palette are a muted but colorful introduction to a story on the bawdiest of destinations, the casinos of Las Vegas.

In early 2000, publisher Condé Nast closed the publication in order to reinvent it. After six months, *Details* rolled back out in all its glory: a larger format, new logo, redesigned pages, and a new commitment to style and smart, funny dialog. Condé Nast subsidiary Fairchild Publications, known for its lineup of fashion magazines and dailies, took on *Details* as a consumer cousin to the trade journal for the men's fashion industry, *DNR*.

A More Mature Audience

The story of *Details* is one of the strong surviving. The magazine began as an early 1980s glossy fashion magazine for men, a title that grew out of the club scene in New York City. It made such an impact that countless new magazines modeled themselves after its intelligent, ultrahip format. Media analysts note it was one of the first magazines to explore a broad scope of masculinity—the idea that men could break out of traditional stereotypes and enjoy a magazine that was fun, fashionable, and even, God forbid, sensitive.

Over the next several years, under various editors, *Details* began to lose its focus. The magazine shifted to an emphasis on music, then became yet another cleavage-happy men's title on the newsstand. Audiences took note of the change; newsstand sales dropped almost 15 percent in 1999, while the number of ad pages was down 22 percent that year, according to *Folio:*, a trade publication for the magazine industry.

With a circulation of 400,000, the magazine targets affluent, educated men from 25 to 35 with a slate of articles about business, politics, and social issues. The main focus is still fashion, though, and *Details* primarily tells this story through profiles of celebrities.

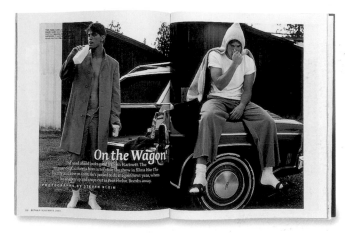

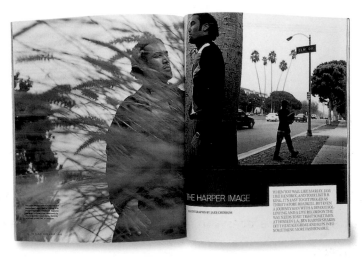

above A less-than-glamorous fashion shoot with emerging actor Josh Hartnett shows off the clothes without pretentiousness.

left A fashion shoot with pop musician Ben Harper shows the celebrity's off-stage side through quiet, private photographs: the singer walking away from the camera or brooding behind weeds and glass doors.

Control freak

BY ANDREW ESSEX

PHOTOGRAPHS BY STEVEN KLEIN

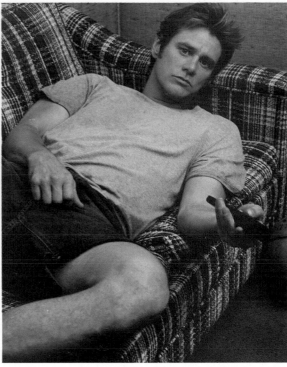

After two box-office disappointments and a high-profile breakup, Jim Carrey has another movie-star girlfriend, the same breathtaking paychecks, and a brand-new megabudget movie. So how come he's still not (completely) happy?

82 DETAILS NOVEMBER 2000

left Another after-hours look at perennially silly Jim Carrey, this spread features colors and textures meant to look as glum as the actor does in the photograph.

Soulful Portraits

Photography, combined skillfully with other design elements, makes the magazine. "The relationship between photography and layout is the principal element to a successful magazine design," says art director Rockwell Harwood. "It's not always about a picture that tells a story but rather a visual communication as a whole. Combining image, space, and typography in a clever method creates the right message. My intention is to balance these factors interchangeably, taking into mind to resist the idea of too much symmetry."

The images themselves aren't your father's photographs, and they certainly aren't the elaborately staged and playful images presented by most celebrity mags. A celebrity feature usually includes several portraits, each as soulful, frank, and curious as the last. At the end of an article, it's easy to feel as if you've spent as much time with the person as the writer and photographer actually did, and that you've learned something about the celebrity you didn't know before.

Featured photography tends to be relatively serious—a sort of silent plea of "It's time to take me seriously" from actors, writers, and musicians who have been paraded through the shame of the spotlight. Hunter S. Thompson shields part of his face in the shadows of a barn at his Colorado ranch, even perpetual goofball Jim Carrey pouts on a cover. The photos are intense, a mix of black-and-white and color portraits with dramatic lighting, candid poses, and endlessly fascinating subjects.

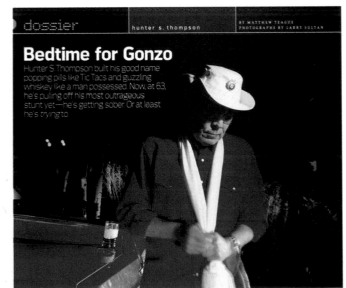

dossier · hunter s. thompson · BY MATTHEW TEAGUE · PHOTOGRAPHS BY LARRY SULTAN

Bedtime for Gonzo

Hunter S Thompson built his good name popping pills like Tic Tacs and guzzling whiskey like a man possessed. Now, at 63, he's pulling off his most outrageous stunt yet—he's getting sober. Or at least he's trying to

H UNTER THOMPSON HAS A TOOTHACHE. HE NEEDS SOME MEDICATION. "AGK," HE SAYS, pressing a surprisingly dainty finger against the tooth. "Faak! Mawh faaka Faak!" He reaches, not for cocaine or multicolored uppers, downers, screamers or laughers, but for aspirin. Deborah, his longtime personal assistant, rubs his back, cooing in his ear, while Anita, his twentysomething girlfriend, peers into his mouth and confirms that a crown has separated from its tooth.

He did not crack the crown while chewing on one of his famous cigarette holders, or biting off the top of a Wild Turkey bottle, or smashing his jaw against the steering wheel of a wrecked car, but instead injured himself while working over a mouthful of pasta with white clam sauce.

I sit at the end of the kitchen counter and watch as the scene unfolds with all the excitement and derring-do of an octogenarian's bowel movement. Is this the great Dr. Hunter S. Thompson? Champion of freewheeling fun and danger? Could this be the man who supposedly refined the angst of the late Sixties into powder form, then snorted it up with such force and appetite that his blood turned to venom? Is this the man who sent nearly everyone who crossed his path—from hotel bellboys to American presidents—fleeing from his shadow, lest they be felled by a fleck of spittle cast from his snapping teeth?

"I just got back from the dentist," he cries, rocking in his chair.

THOMPSON HAUNTS THE GROUNDS OF HIS ROCKY MOUNTAIN RANCH AFTER THE SUN SETS, BUT THAT GLASS OF JACK DANIELS IS A MORE INFREQUENT COMPANION THESE DAYS.

I look away. It isn't the toothache that shames him—even lions chip their teeth—but it's all the events that have led up to the moment. I had come to Thompson's Colorado farm seeking an answer to the question that has always divided his fans from his enemies—Is he a prophet, or a flake?—and the apparent answer is too much to bear.

HUNTER THOMPSON STARTED TO GET ON MY NERVES at exactly 4:55 a.m. one morning in late July, when my phone rang. Thompson is known for his vampire hours, so I shook myself awake and fumbled around

90 DETAILS OCTOBER 2000

above A mysterious portrait of Hunter S. Thompson peering from the shadows opens an interview with the iconoclastic writer.

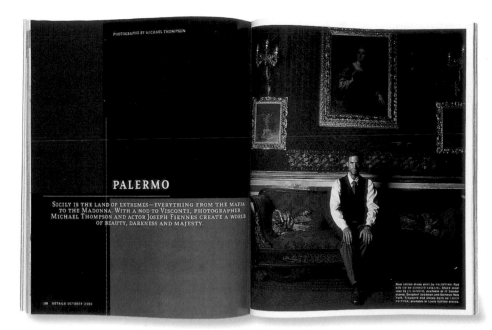

PALERMO

SICILY IS THE LAND OF EXTREMES—EVERYTHING FROM THE MAFIA
TO THE MADONNA. WITH A NOD TO VISCONTI, PHOTOGRAPHER
MICHAEL THOMPSON AND ACTOR JOSEPH FIENNES CREATE A WORLD
OF BEAUTY, DARKNESS AND MAJESTY.

left and below The
musty and exquisite sur-
roundings of traditional
Sicily—complete with old
photographs of families
and photos of majestic in-
teriors—envelop dark,
lush portraits of brooding
actor Joseph Fiennes.

The photographic mood also continues into non-
celebrity features, exposé-style articles, and profiles
of less-known personalities. The gaudiness of 1950s
Hollywood-style glamour is played out in a scathing
look at Venezuelan beauty pageants. A row of side-by-
side snapshots portrays the endless unassuming ex-
pressions of a 25-year-old convicted killer. Even
fashion shoots never fail to surprise, ranging from
snapshot-worthy pictures of kids jumping into a pool
to plain, honest portraits of models making eye con-
tact with the camera.

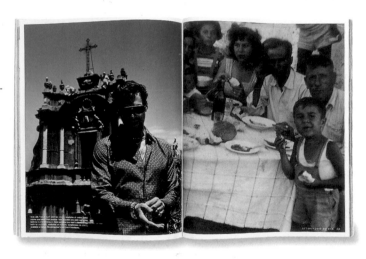

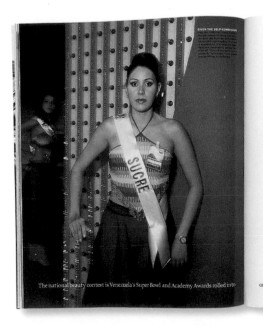

The national beauty contest is Venezuela's Super Bowl and Academy Awards rolled into

one. Thousands of women dream of winning it. One man gets to decide who will.

By Lance Gould
PHOTOGRAPHS BY JEFF JACOBSON

left The tension of the
opening photograph
works with the severity
of pointed letters in the
headline to mimic the
nerve-wracking, cut-
throat environment of a
South American beauty
pageant in this exposé.

left As neatly compart-mentalized as a Web page, this new product review in the middle of the book fits pieces into every square—even if it means placing images on their side.

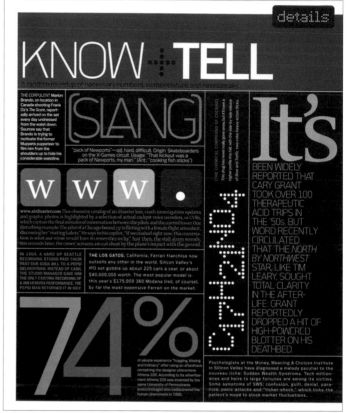

Futuristic and Classic Converge

Details assigns great importance to images by letting them serve as the primary focus of feature layouts. Though features are usually long, the magazine never-theless dedicates at least two or three full pages to pic-tures and, aside from creative use of type, rarely adds other graphic elements to compete with these visuals.

Bookending the well, however, are departments that make bold allusions to popular culture in their design. They are techno and house, but with an undercurrent of classic jazz—an energetic, trendy, forward-thinking look that's at the same time smooth and reserved.

The first department, "Know + Tell," reveals this in the most experimental ways. The section fits together the slices of bizarre news, statistics, definitions, and facts like a jigsaw puzzle. Touches of the colors in the maga-zine's palette make cameos in this section—deep red, rusty orange, soft blues, and muted gray, beige, and gold—fall and winter colors that set a mood of sophis-tication and quiet affluence.

"Consideration for the front of book design relied pri-marily on a way of creating design elements, each with its own use, to enable the reader to quickly iden-tify the main subject of the article along with the al-lowance toward enough space for the stories' concept," says Harwood.

While features are usually left open, with few rules or borders restricting the flow of copy on two-column pages, thick black headers top off departments. For in-stance, the section called "Dossier," a gathering of shorter news pieces and profiles, runs the name of the section reversed on the black bar with a red center containing a one- or two-word catchphrase describing the nature of the article. This technique, continued on the last page of the magazine and in fashion and new product roundups as well, maintains a consistency and distinctly separates departments from features.

Another trademark is introduced in departments: a name-in-lights font made entirely of dots. Used for the plus sign in the department's name, this dotted font also characterizes the name of the magazine, which appears in a red box at the edge of some departments and the heads of other front-of-the-book sections. The font occasionally makes an appearance as a headline or callout in feature articles as well.

above "Know + Tell," a front-of-the-book depart-ment, adopts Web-style cartography, then serves as an easel where *Details* artists can play with type, color, and graphics. The resulting section comprises an artistic and urban tapestry.

that rotate text and break up pages of text. Typefaces mix and mingle in department pages, though a consistency in their usage helps maintain a brand from front to back.

Type treatment, along with the other design choices, reflect the audience to whom *Details* reaches out. They're men who are stylish, curious, and in tune with the latest, hippest trends, but they take life seriously enough to appreciate an honest approach. Repositioning its brand and mission to serve these readers, *Details* has declared its unapologetic commitment to a new, mature personality. The artistic approach supports it, creating a fiercely intelligent and swank place to which former *Details* readers can finally return.

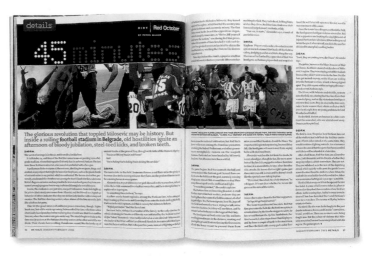

Traditional and Techy Type

The use of type, in fact, is another way *Details* builds character. Besides the dotted font, a techy sans-serif typeface, squared off with rounded edges, is reminiscent of the space-age look popular on the urban club scene. These two fonts are combined with more traditional serif and sans-serif faces that pay tribute to classic and futuristic styles alike.

Artists take chances with type. Enormous letters contrast dramatically with small body type in the opening spreads of features, while callouts turn into vertical rules

ISLE COLLEGE
RESOURCES CENTRE

Entertainment Weekly

Behind the Scenes of Movies, Music, and Media

It's long been said that while Great Britain has its royal family, the United States has Hollywood—the jet set that captures the country's fascination and imagination. Entertainment consumers follow the stars' lives with the same anticipation and thirst for detail as subjects who peer reverently into the personal business of their monarchs. They appreciate a movie or CD all the more when they know exactly what went into making it, leaving no stone unturned in the process.

Entertainment Weekly is the media junkie's dream, a weekly magazine packed from top to bottom with news, in intimate detail, of what's going on in the world of entertainment. The magazine serves up behind-the-scenes looks at movies, eagle-eye details of stars' lives and careers, interviews, quotes, and reviews, all in a package as spectacular, intricate, and action-packed as the industry it covers.

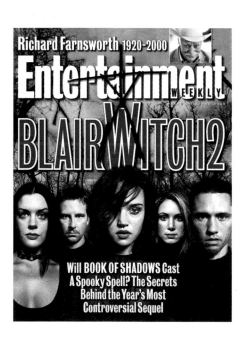

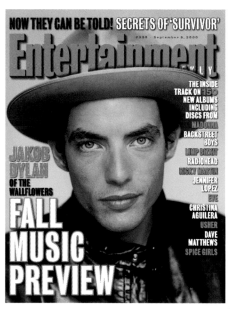

far left *Entertainment Weekly*'s covers, like movie posters, draw readers by promising the hottest stars and biggest buzz. Here, the cast of *Blair Witch Project 2* glowers against a gloomy background. The logo is often partially obscured.

left This traditional celebrity cover matches Jakob Dylan's eyes with the blue of the logo and cover lines. Cover photos are straightforward and engaging; they lure readers with the intensity of Hollywood stars and illuminating design touches.

WHY IT WORKS:

A magazine about the fast, ever-changing world of entertainment, *Entertainment Weekly* packs its pages from edge to edge with strategically organized information and intoxicating images. An exceptional use of type as illustration also amuses readers and captures their imagination. It's a format that readers can devour in one read, important for a weekly magazine based on not-so-serious subject matter.

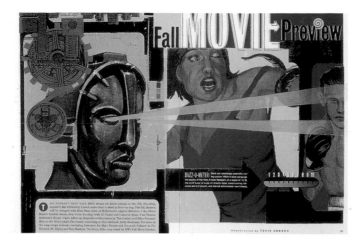

Making a Big, Expendable Splash

Having recently celebrated its ten-year anniversary, *Entertainment Weekly* hooks 1.5 million people a week with its clever, funny writing and minutely detailed coverage of the entertainment industry. It's intended to be read cover to cover, drawing readers in with regular and familiar departments, then capturing their attention with wildly designed features in the well.

Each week, the Time Inc. title gives its readers all it's got, with loud enthusiasm that encourages living for the moment. "It's meant to be disposable," says Geraldine Hessler, the magazine's creative director. One week's hot

topic is usually old news the next. With the exception of collectors' editions, these issues usually aren't stored and displayed on a bookshelf like *National Geographic* or *Vogue*. Therefore, designers can afford to be a little outrageous. "This is not a quiet or pensive magazine," says Hessler. "It's an entertainment magazine, so we want it to be fun, with big, splashy layouts."

Despite the tight timelines and throwaway nature of the product, however, each issue is stuffed with masterpiece layouts, each a customized party thrown in honor of the article it presents. The artistic layouts are part of *Entertainment Weekly's* signature look, and they draw people in for a fast, fun read.

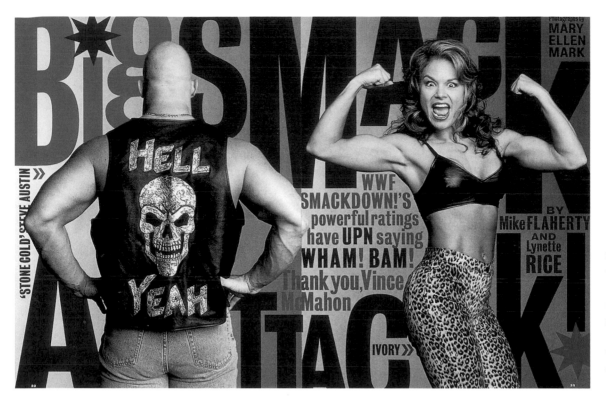

Illustrative Type That Shocks and Amazes

A primary way designers achieve this is through typography. Headlines morph into outrageous parodies of the article's topic. Letters are sliced off at the left as if they're peering out from behind a doorway in an article about stars who come out of the closet. In the introduction to the movie *Pay It Forward,* windlike lines slash letters to create the illusion of speed. Hollow letters shatter into pieces for a story about the film *Unbreakable.*

"We reflect what the story's about through typography," says Hessler. "Headlines usually conjure up images." Though the magazine also uses excellent photography and illustrations, the headlines help provide the kind of in-your-face mania that moviegoers are used to. They also set *Entertainment Weekly* apart from the other celeb mags.

Interestingly, artists don't scramble for the perfect typeface every time they set out to design a story; it's already right in front of them. "We basically use one font: Bureau Grotesque," Hessler says. "We manipulate that—push, pull, and redraw it—to make it interesting and distinctive." Staffers do all type illustration in house each week, adding value to the magazine's already rich inventory of artwork.

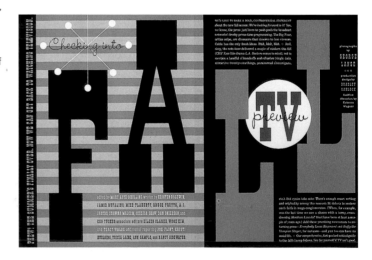

above The magazine presents splashy, amusing, or visually captivating text; layouts are created by morphing one font into several forms against intricate backgrounds. This opening graphic spread for the 1999 fall television preview was inspired by 1950s TV credits.

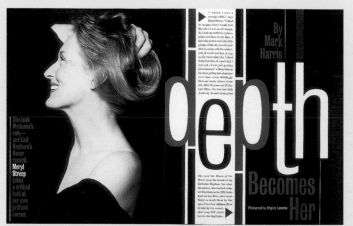

left This layout plays off the headline in several ways. White letters and a column of text contrast dramatically with the black background, as does the portrait popping from the shadows. Colored letters are filled with white to suggest multiple layers.

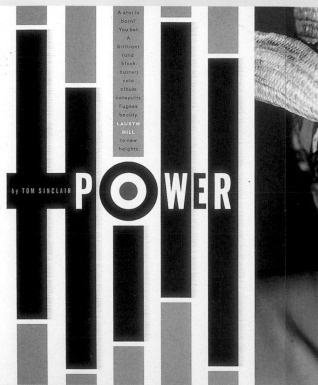

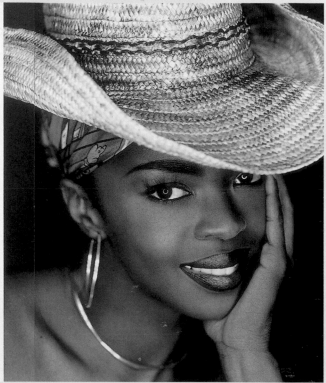

above A bull's-eye and bold stripes on the opening page make a strong statement for a story about singer Lauren Hill.

right In a play on Steely Dan's album title *Two Against Nature*, one layout mirrors the other in this spread, while a giant 2 straddles the fold.

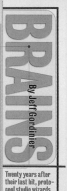

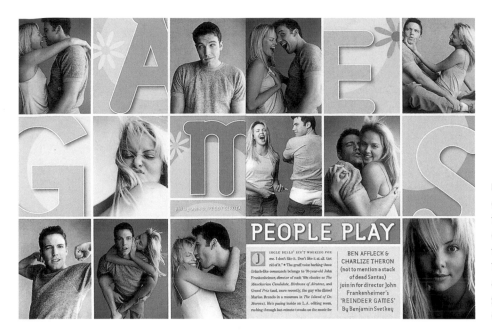

Fun, Flashy Celebrity Portraits

Entertainment Weekly's illustrations of stars are comical, strange, and usually dead on—from watercolor caricatures with deep shadows and lines to cubist-inspired patchworks of faces. Hessler says the magazine assigns "tons" of illustrations to freelancers, about 20 per week, and more for the magazine's special issues.

Illustrations work best when an article is covering celebrities who are already familiar to the media-savvy public—people such as Madonna or the Spice Girls—Hessler says. In those cases, photography is not only hard to set up, it grows repetitive. Illustrations are also helpful for reviews of music or books, which are difficult to characterize in photographs. They are especially useful, Hessler says, when reviews are negative.

Photographs, on the other hand, are better suited to new material or emerging artists, and they're always used on the covers. That prime real estate often is dedicated to flattering, straight-on portraits of stars, surrounded by a flag and cover lines usually etched in or filled with metallic silver and gold. Your face on the *Entertainment Weekly* cover, you might say, is the equivalent of having your name in lights, the presentation is so flashy.

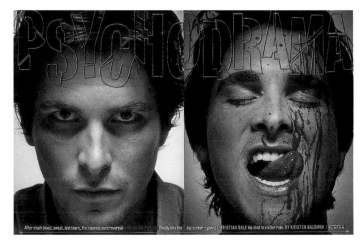

Inside, however, the magazine gives way to more experimental photography. Some shots are candid and spontaneous. Photographer Matthew Welch captured an intimate portrait of actress Hilary Swank in bed with her husband the day after winning an Oscar; Alastair Thain shot quick, painfully detailed closeups of Jack Nicholson on the same black-and-white film used for satellite pictures.

Other photographs are intricately staged. Robert Trachtenberg, in a dig at Jennifer Aniston's hairdo, asked the actress to pose with her head through a shelf alongside wig mannequins. Richard McLaren took two days to construct a set that left Conan O'Brien dangling from a clock face 10 feet in the air.

Photograph or illustration, these portraits never fail to make readers study them again and again.

left Capturing—and perhaps even parodying—the spirit of the violent drama *Fight Club*, an article opens with grim, battered mug shots of the stars.

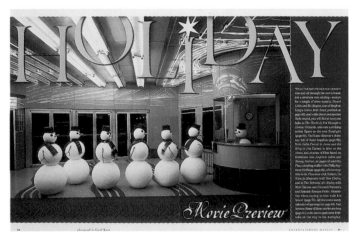

above Delicate pastel letters dance like sugar-plums across a whimsical illustration to create a magical holiday-themed opener.

Fast-Paced But Orderly

Entertainment Weekly is especially skillful at filling its pages with a variety of news, tidbits, charts, and reviews. "We really jam a lot of stuff onto every page," Hessler says. "It's like a big puzzle."

Though stories are typically short, there are many of them. Each issue includes about four features and ten departments, usually containing several stories apiece.

So pages are packed to the gills with text and pictures. Departments are usually divided into boxes, often shaded or separated by illustrations and photos to distinguish them. Sidebars with loosely related news or fun facts often accompany longer features. Designers use boldface when writing celebrities' names as anchors for readers to grasp as they skim the crowded departments.

Yet the magazine is clearly organized. Color-coded tabs at the edges of pages in the back of the book identify music, film, theater, and Internet reviews, while creative use of color and art in front-end departments prevents overstimulation. In fact, the design drives the magazine's energetic, snappy pace and delivers the feeling that reporters have scraped up every interesting morsel available in Hollywood this week.

About the Grid

Publication designers love to talk about the grid—why they do or don't choose to use one and, if they do, how much it contributes to their work process every time they sit down to design an issue.

Truth be told, most designers refer to some kind of grid, even if it's a set of simple guidelines rather than a defining framework. Here's a short primer to demonstrate how a grid is used, how designers talk about it, and how it can help create a structure for your magazine.

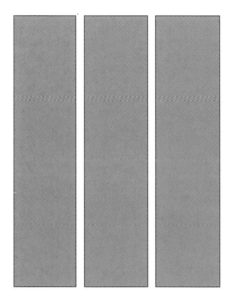

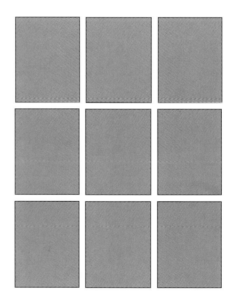

above This simple grid comprises three vertical units and one horizontal unit (a 3x1 grid). Each gray area is a grid unit. The white spaces between the units are alleys; the spaces surrounding the grid are the margins.

above This slightly more complex (3x3) grid has nine units. Elements should fit neatly within the boundaries of these units, even if they cross over the alleys.

Invisible Frame

As a magazine reader, you never see a grid. It's an invisible set of guides, usually printed on a paper template or set in a template file with a designer's layout software. Quite simply, its purpose is to guide designers in placing text and images.

The grid helps define the format of the magazine—its overall look and feel. It can be responsible for how sporadically or neatly elements are placed on a page, how clean or crowded a page looks, and whether a page is full of illustrations or text.

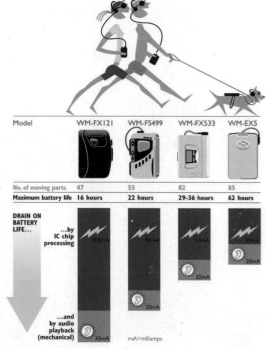

DESIGNDISCIPLINES

From Graphs to GUIs

by Megan Lane

In an age of media overload, information designers may be our only hope. Content rustlers of the new frontier, they'll tame the information stampede. Do you have what it takes to join their ranks?

The first thing you should understand about information design is that very few people actually call it that anymore. This design discipline that used to encompass charts and maps and diagrams has exploded mainly because of the Internet. So, for example, Aaron Marcus calls what he does "information visualization." And because Nigel Holmes concentrates on explaining things for print publication, he calls it "explanation graphics."

Consequently, it can be very tough to pin down a precise definition of what an information designer does. "You can tell you're an information designer if, when someone gives you a thing to design graphically, you wind up changing words and content structure because you've become interested in the content," says Marcus, principal of AM+A in Emeryville, CA.

DIGITAL DESIGN

Marcus opened his information-visualization studio in 1982 and immediately concentrated on digital design. "If you

Model	WM-FX121	WM-FS499	WM-FX533	WM-EX5
No. of moving parts	47	55	82	85
Maximum battery life	16 hours	22 hours	29-36 hours	62 hours

DRAIN ON BATTERY LIFE...

...by IC chip processing

...and by audio playback (mechanical)

mA=milliamps

In this infographic for *Sony Style* magazine, Nigel Holmes says he "wanted to combine realistic 'portraits' of the four Walkman models with a different, lighter approach to the people walking their dog." In the lower half of the graphic, a very straightforward bar chart shows each Walkman's drain on batteries.

32 DECEMBER 2000

above *HOW* layouts exemplify manipulation of a 3x3 grid. Here, text occupies one column and an illustration the other two. The headline and byline form the upper third of the page, the illustration and text the bottom two-thirds.

Understanding the Grid

Grids often define vertical elements—columns—at the very least, and usually also define horizontal structure. The areas where these structures cross are called grid units and are the places on the page where type and images fit. The spaces between grid units are called alleys.

When talking about a grid, designers refer to how many vertical grid units are present versus the number of horizontal units. A grid that contains two columns and three rows is considered a six-unit, or 2x3, grid. One that has three columns and four rows is a 12-unit, or 3x4, grid.

Once the grid is established, columns of text and images can vary in width or length, taking up multiple grid units, for instance, as long as they stay within the confines of the unit borders. This allows designers to be flexible while maintaining order.

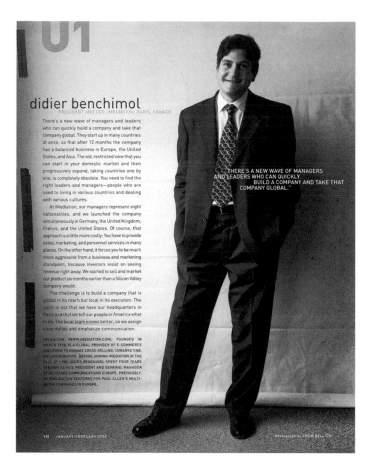

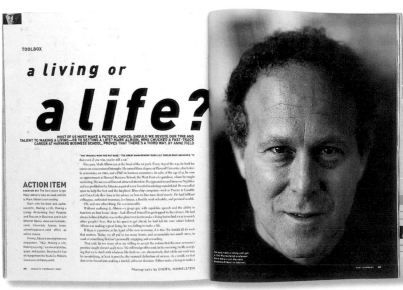

above Two *Fast Company* layouts show two ways to interpret a three-column grid. In the first, the subject of the photograph fills two columns and a column of text defines the third unit.

left In the second layout, body text stretches over two columns while an action item (a small sidebar) occupies the third. The headline and deck expand across all three units at the top of the page.

From Simple to Complex

Many magazines have different grids for different sections—departments may have a three-column grid with lots of space for small pictures (a 3x6, perhaps), while the feature well has a two-column grid that needs guides only for larger images (a 2x3 grid).

Designers often rely on simple grids and work creatively within them. As a magazine's design becomes more sophisticated, however, some designers build complicated grids with many units—sometimes even units that allow elements to overlap. The rule of thumb is that text-dominated layouts require simpler grids; as more illustrations are added, the grid may become more complex.

left This *A* layout is an example of flexibility within a simple two-column grid.

right In this *HOW* layout, text is present in all three columns, but one illustration stretches across the upper third of the page and another juts into two columns at the bottom. Note how the image borders coincide with the text borders to reveal the grid outline.

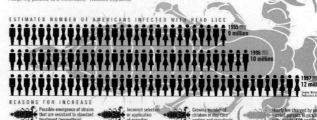

DESIGN**DISCIPLINES**

This graphic ran as a stand-alone visual story in *Success* magazine. "Since I know there would be color pictures elsewhere on the page, I kept my palette to a minimum," Holmes explains.

"An information designer should have an interest in and a tolerance for complexity, an interest in traditional graphic design, a tolerance for technology and systems, and should derive satisfaction from creating systems," Marcus says. His team members have diverse backgrounds, including programming, math and graphic design.

To sell yourself as an information designer—on a freelance basis or in a job interview—you'll have to show more than traditional design work. "It would be helpful to see examples of work that deals with the design of tables, charts, maps and diagrams," Marcus says, "and

of projects that are of a systematic nature, not just a one-shot image." He also looks for projects that emphasize navigation and typography.

Lenk often hires recent RISD grads who have interned at his firm. "We're looking for students who have a good grasp of knowledge, who have a very good liberal-arts education," he says. "We look for people who know how to link facts—how to link a timeline with a map, for example. This is much more important than the ability to visualize."

Some design educators agree with this philosophy. "Design, as we're seeing it, is the intersection of a lot of other

disciplines," says Robert O. Swinehart, professor of design at Carnegie Mellon University's School of Design in Pittsburgh. Carnegie Mellon offers a highly respected design program that emphasizes typography, information design and liberal arts. To educate a more well-rounded designer, the school has shifted its program from one where students take 80% of their classes in the School of Design, to only 62%. The rest of the classes are electives taught throughout the university.

SHOWING YOUR STUFF

If you're past the point of returning to school and have a portfolio filled with traditional design, you can still remake yourself as an information designer. "There's a lot of room in the field," Holmes says. "But the best work comes from dedication. When I worked at *Time* we saw 20 or 30 portfolios a week, and I always thought if I had one simple piece of criticism it was, 'I can't see what it is you want to do.'

"It's easy enough to give yourself assignments," Holmes advises. "Just pick up your local newspaper and look at how they've dealt with some kind of information graphic or map and say, 'Well, I live in this area. What do I really want to know about this map?'"

For example, if a new road is being built, you should ask yourself who will be affected by the construction, what 42»

Code

The Style Magazine for Men of Color

Publishing gender-specific fashion titles is a tough business. Some magazines aim to be so general that they water down topics to appeal to as many people as possible. Others wink and nudge with inside jokes that a few people get and other readers dream about someday understanding.

Code strives to change all that. The Los Angeles-based fashion magazine for African American men hit the newsstands in July 1999 and, after a year of tweaking, emerged with a smart, refreshing attitude reflected in its stylish photography and accessible layout.

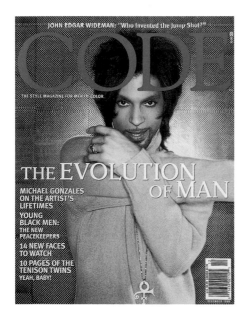
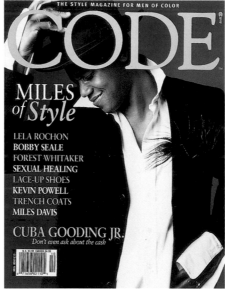

far left *Code*'s designers present photographic subjects—even international celebrities—at the reader's level. Here, a black-and-white photo of pop star Prince makes an unimposing, alluring cover. The orange logo is a bold foil to the sensual portrait.

left Decked to the nines, Cuba Gooding Jr. strikes a pose on the October 1999 cover, an image of color and movement meant to draw eyes at the newsstand.

WHY IT WORKS:

Handsome, atmospheric photography and a luxurious color palette combine for a sophisticated, masculine tone. Clean layout, consistent type usage, and realistic subjects in photographs appeal to readers' style and self-image.

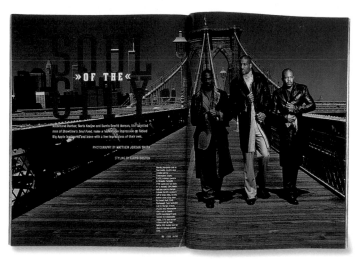

left Often reserving black-and-white photography for serious pieces, designers take a stab at it in a fashion spread. Sepia duotones portray vintage New York as costars of a Showtime drama stroll the Big Apple.

So far, the magazine has reached its target market; 90 percent of readers are African American males, while the remaining 10 percent are Asian and Hispanic men, Robinson says. The magazine is primarily about fashion, though it also covers lifestyle and celebrities, so editors and designers drew from a variety of magazine types—giving nods to titles such as *Nylon, Gear, Interview, Vibe, Elle,* and *Italian GQ* in its design.

Code reaches out editorially to establish a voice with which readers can identify. Realizing that readers appreciate illustrations that mirror their lives, the magazine's designers likewise reach out. Instead of offering traditional haute couture and lofty models, *Code* brings fashion back down to earth.

Smart and Real

Editor in chief Eugene Robinson says the magazine's founding staff strove to create a magazine for a new generation of readers. "As a medium, magazines are dealing with issues that never came up before," Robinson says. "You've got the Web, e-books. It's not the same to do magazines like the ones we dug in our youth."

Editors created a magazine that talked up to its readers, but in a way that was franker and hipper than competing titles. "We presume readers are as smart as we are," he says. "We wanted to make it smart, smart-assed, and funny without resorting to fraternity guffaws or drawing-room chuckles."

above Hip, jazzy touches, such as these blue boxes floating like musical notes across the top of an article on musicians Wynton Marsalis and Joshua Redman, stand out from the magazine's clean layout.

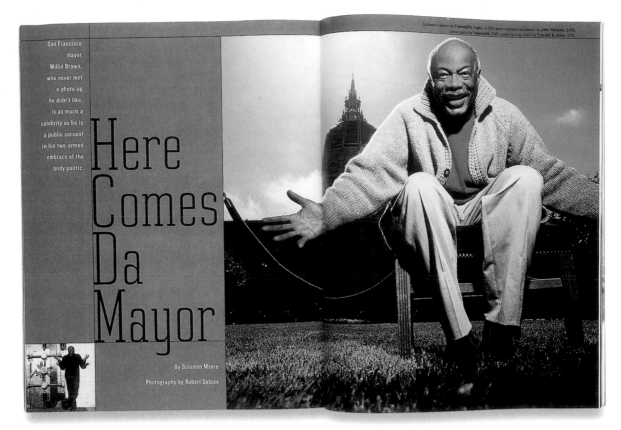

San Francisco mayor Willie Brown, who never met a photo op he didn't like, is as much a celebrity as he is a public servant in his two-armed embrace of the body politic.

Cashmere sweater by Ermenegildo Zegna, $1,525; wool-cashmere turtleneck by John Varvatos, $495; cotton pants by Fagonnable, $145; suede lace-up boots by Crockett & Jones, $415.

Here Comes Da Mayor

By Solomon Moore

Photography by Robert Sebree

above Controversial San Francisco mayor Willie Brown is the charismatic subject of this bright and playful fashion layout.

Real Men, Realistic Photos

Photography is obviously the magazine's biggest concentration because of its emphasis on fashion. *Code* raised the bar as it progressed, committing itself to photography at the level of top fashion magazines, says creative director Charles Hess. Four to five photo shoots a month with celebrities and models produce strong, striking images that dominate the book. Designers place importance on working with talented, well-known photographers and illustrators and try to emphasize artists of color.

But recently, the nature of the photography has changed. "The models are depicted as guys the audience can relate to," says Hess. "When readers look at the magazine, they see themselves." This involves not only using more natural light and realistic environments in shoots but also varying the types of models.

For example, a fashion spread in the December 2000 featured six "real working political men" sporting designer suits and posing on the Mall in Washington, D.C. "They were still good-looking, but they're more relatable than models," Hess says.

The magazine also likes to feature celebrities—actors, musicians, politicians, and designers—modeling clothing as well as providing interviews and profiles. On the covers and inside the magazine, these stars have fun with the shoots. They laugh, dance, and strike poses in the gorgeous but practical fashions they model. Even the most elusive or imposing public figures look like friendly, ordinary guys—musician Prince shyly smiling in a baby-soft turtleneck, San Francisco mayor Willie Brown grinning with arms outstretched and wearing a comfortable sweater.

right Fashion shoots take chances with experimental staging. The complexity of featured plaid fabrics is replicated in this photo, with frosted panels creating the same illusion of overlapping layers.

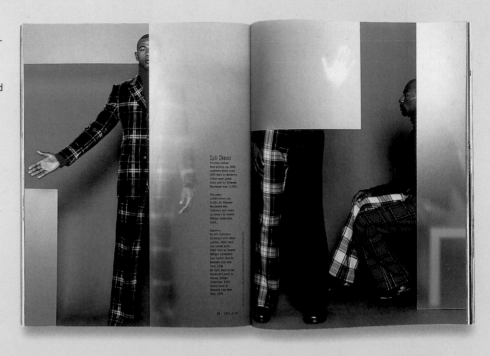

left To stand out from the competition, designers photographed up-and-coming political figures rather than models on the Mall in Washington, D.C. Midnight blue page color suits the nighttime atmosphere.

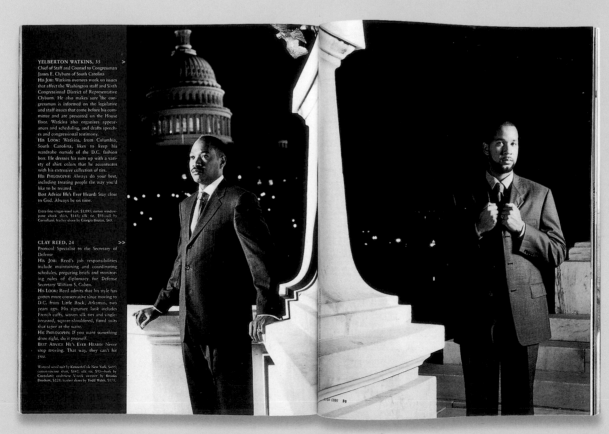

Code of Handsome Colors

An occasional excursion into black-and-white photography gives the magazine a dramatic flair. Sometimes this is reserved for investigative, serious pieces; other times it's an artistic twist on the fashion shoot. Black-and-white portraits even show up on *Code*'s cover on occasion.

An expansive palette of fourteen to sixteen colors sets the tone for the magazine no matter what shades the artwork represents. "The palette is made up of the colors of jewels—deep, rich, and masculine," says Hess. Burgundy red, pumpkin, midnight blue, and deep violet may enhance photographs as beautiful, sophisticated background colors for articles and sidebars.

Light touches of color help department headers stand out in the front and back of the book and make pull quotes diverge gently from the black-and-white formula. But, for the most part, the magazine sticks to simple black type on white pages, especially in departments. "We are trying to establish a recognizable, consistent look with enough variation so that it's not boring," Hess says.

below In an unusually colorful layout, several of the colors from the magazine's palette team up for a commentary on television, specifically MTV.

above Though used sparingly, color sets the mood for certain features. A rich pumpkin yellow with burnt orange accents—cheerful but commanding colors— opens an article about the sophisticated comedy of Chris Rock.

above Front-of-the-book departments usually maintain a consistent format: one piece of artwork and two columns of black type on a white background. However, varying the art placement, as with this lower-corner bleed, keeps readers guessing.

left A huge headline shouts comedian Chris Tucker's good fortune but is restrained by a deep green background, dark lighting, and a sober illustration of the presidential seal. (The article refers to Tucker's movie about becoming president.)

Stylish, Classic Type and Graphics

In that vein, Hess and art director Saralynne Lowrey use a handful of characteristic typefaces to build the magazine's hip personality. The newsprint-style slab-serif Constructa and a sans serif with quirky curves called Solex compete for headlines, decks, drop caps, and pull quotes. Sabon serves as easy-to-read body text; it is less fussy than faces previously used, say Hess and Lowrey.

Another technique meant to give the magazine its distinctive look involves using rules, especially in the back of the book. End departments are given bold, black vertical rules dividing a wide left margin from the left of the page.

In the margin toward the bottom of the page is the article's headline and deck, while at the top is a listing of the back's standard departments. For the article that

right Heavy vertical rules designating space for headlines and captions are a signature for the back of the book. The list at the top left marks the relevant department by pulling it to the right of the rule.

represents a given department, the department name is called out on the other side of the rule. "It's like a mini-table of contents for the back of the book," says Hess. "It works like a file drawer."

Variations on the use of the rule also appear in feature stories. For example, for a themed series of articles on political figures in the November 2000 issue, elaborate maps of double lines and boxes give headlines, rules, bylines, and captions their own playing fields. The orderly lines provide an Art Deco-style ornamental framework on an otherwise simply designed page.

These snazzy but understated design touches express the magazine's commitment to laid-back style, while the surrounding simple design showcases the magazine's friendly, funny articles. Lush but consistent design plays as big a role as editorial content in talking straightforwardly to the smart, sophisticated, style-minded reader.

above An elaborate grid of rules framing display copy breaks up the monotony of the standard three-column layout and gives a nod to retro design motifs.

Asian American Aesthetic and Lifestyle

If *feng shui,* the Chinese art of strategically placing furniture in a room, could be applied to magazine design, the artists at *A* would be masters. Like expertly furnished rooms, pages in this bimonthly lifestyle magazine flow naturally and energetically.

The deceptively simple pages communicate a complex variety of messages for the magazine's audience, mostly 20- and 30-something Asian Americans. *A*'s design blends somber, traditional tones with modern sophistication and playful irreverence—a balancing act that resembles lifestyles familiar to many of the magazine's readers.

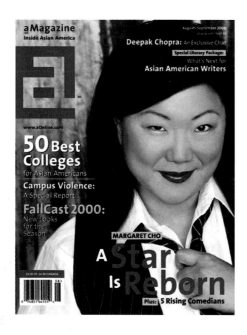

far left *A* introduces its spare, modern design concept on the cover, which incorporates minimal touches of brilliant color and a sophisticated sans-serif font for cover lines. The design appeals to young, image-conscious readers.

left The magazine's logo looks digital, a nod to the electronic world of its educated, affluent readers, but it's also a metaphor—it presents Asian Americans as "figures, not ground," says the publishing company's CEO.

WHY IT WORKS:

What *A* achieves most successfully is readability. Refined type treatment and the frequent, tasteful use of sidebars and boxes guide readers' eyes effortlessly across colorful and balanced pages.

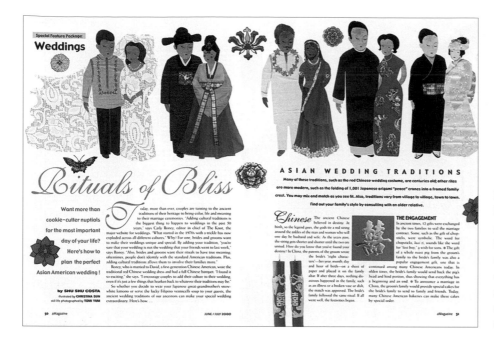

Special Feature Package:
Weddings

left and below Frequent bold subheads, colored phrases and bullets, boxes, and other graphic elements help readers' eyes move effortlessly across each page—one of *A's* most notable accomplishments.

Merging East and West

A targets upwardly mobile professionals who were born to one or two Asian parents and raised mostly in North America. The struggle to seamlessly bring the two worlds together is addressed constantly in *A*. Article topics range from politics, media, and entertainment to fashion, lifestyle, sexuality, social issues, and identity, all the while reflecting how Asian Americans are represented and perceived in every regard.

During a redesign in spring 2000, *A's* staff reevaluated the magazine's personality as expressed through design. "We had to create an Asian American aesthetic," says editor in chief Dina Gan. This is a look that, by its nature, is hard to put a finger on because it involves pulling in elements from many cultures.

The magazine's solution is to rely on design characteristics that are traditionally East Asian. The publication's look is spare and simple, with effective touches of rich, vibrant color. At the same time, it embraces the hard-edged sophistication of the Western digital age to represent not only what readers are experiencing but also where *A* is going as a company— the magazine launched its first Web site alongside the redesigned book.

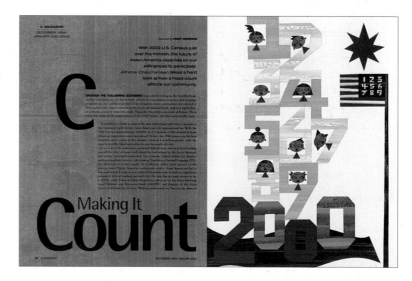

Achieving Balance

Giving the magazine a simple, minimalist look is essential, says design director John Tan. But because *A* is an issue-oriented publication, it's also heavy on feature articles, which means little room is available for white space.

Several solutions keep the pages from looking gray. First, editors and designers on *A's* small staff work closely to make sure articles get to the point in as few words as possible (ideally, 700 to 1500 words). They mix short articles, information boxes, and grids in the front of the book with feature stories under two or three pages in the well. Once the pages are designed, editors and designers often agree to take out text rather than risk a page that doesn't flow.

The treatment of the type itself also helps to break up the pages. Drop caps, frequent bold subheads, and colored text, banners, and bullets slice the pages into easily digestible bits. Brightly colored pull quotes, often positioned in the top or bottom margins, anchor pages without distracting from story text.

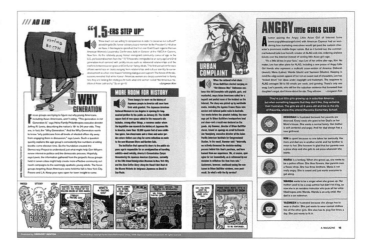

Boxes are an essential part of *A's* design and are useful tools for creating balance. Short news bites, graphs, quotes, and charts, many contained in brightly hued boxes, make up the front of the book. Few feature articles don't contain at least one sidebar, resource box, or bordered quick fact against backdrops of festive colors with banners in contrasting shades.

Boxes are often incorporated subtly into otherwise pure, black-on-white layouts. Occasionally, though, designers break away from *A's* usual grid and incorporate the box as a theme through an entire layout. Variations include checkerboards of photographs and quartered pages of panels in contrasting colors, each carrying an element of the article.

left and above The front of the book is an orderly patchwork of colorful boxes, short news items, charts and graphs, and quick quotes and facts.

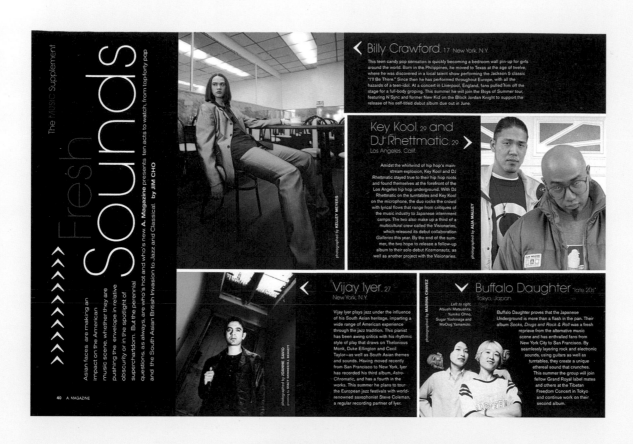

The MUSIC Supplement

Fresh Sounds

Asian faces are making an impact on the American music scene, whether they are pushing the envelope in relative obscurity or in the spotlight of superchartdom. But the perennial questions, as always, are who's hot and who's new. **A. Magazine** presents ten acts to watch, from top-forty pop and the South Asian British Invasion to Jazz and Classical. **by JIM CHO**

photographed by **KELLEY MEYERS**

‹ Billy Crawford. 17 New York, N.Y.

This teen candy pop sensation is quickly becoming a bedroom wall pin-up for girls around the world. Born in the Philippines, he moved to Texas at the age of twelve, where he was discovered in a local talent show performing the Jackson 5 classic "I'll Be There." Since then he has performed throughout Europe, with all the hazards of a teen-idol. At a concert in Liverpool, England, fans pulled him off the stage for a full-body groping. This summer he will join the Boys of Summer tour, featuring N'Sync and former New Kid on the Block Jordan Knight to support the release of his self-titled debut album due out in June.

Key Kool. 29 and DJ Rhettmatic. 29 ›
Los Angeles, Calif.

Amidst the whirlwind of hip hop's mainstream explosion, Key Kool and DJ Rhettmatic stayed true to their hip hop roots and found themselves at the forefront of the Los Angeles hip hop underground. With DJ Rhettmatic on the turntables and Key Kool on the microphone, the duo rocks the crowd with lyrical flows that range from critiques of the music industry to Japanese internment camps. The two also make up a third of a multicultural crew called the Visionaries, which released its debut collaboration *Galleries* this year. By the end of the summer, the two hope to release a follow-up album to their solo debut *Kozmonauts*, as well as another project with the Visionaries.

photographed by **ALIA MALLEY**

‹ Vijay Iyer. 27
New York, N.Y.

Vijay Iyer plays jazz under the influence of his South Asian heritage, imparting a wide range of American experience through the jazz tradition. This pianist has been awing critics with his rhythmic style of play that draws on Thelonious Monk, Duke Ellington and Cecil Taylor—as well as South Asian themes and sounds. Having moved recently from San Francisco to New York, Iyer has recorded his third album, *Astro-Chromatic*, and has a fourth in the works. This summer he plans to tour the European jazz festivals with world-renowned saxophonist Steve Coleman, a regular recording partner of Iyer.

photographed by **JOANNE SAVIO**
growing by **STACY SHIMINSKI BENNETT**

photographed by **MARINA CHAVEZ**

⌄ Buffalo Daughter. late 20s
Tokyo, Japan.

Left to right, Atsushi Matsushita, Yumiko Ohno, Sugar Yoshinaga and MoOog Yamamoto.

Buffalo Daughter proves that the Japanese Underground is more than a flash in the pan. Their album *Socks, Drugs and Rock & Roll* was a fresh reprieve from the alternative music scene and has enthralled fans from New York City to San Francisco. By seamlessly layering rock and electronic sounds, using guitars as well as turntables, they create a unique ethereal sound that crunches. This summer the group will join fellow Grand Royal label mates and others at the Tibetan Freedom Concert in Tokyo and continue work on their second album.

40 A. MAGAZINE

right and above Boxes often are inserted as sidebars to break up pages, but they can also carry an entire layout, as in the asymmetrical grid of this feature spread (above) and the paneled collage of faces (right).

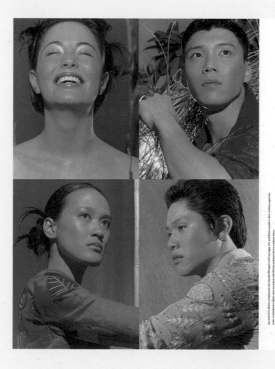

The GOLDEN CHILD

Gone are yesterday's orange streaks and blotchy tans. Four brave individuals tested a new breed of tanning gels and found the ones that best transform their winter palors into sun-kissed complexions.

by CHRISTIAN ABLANG
photographed by **ROBERTO LIGRESTI-DAVIES**
hair & makeup by **STACY MILLER/R.J. BENNETT**

Anthea
Products Tested:
Origins, Clarins, Lancôme (Medium), Clinique (Type III/IV)

What She Chose:
Lancôme (Medium)

The palest of the crop, we gave Anthea a variety of the spectrum to try. The tanning gel veteran of two winters was wowed by both Lancôme's Medium and Clarins, but preferred Lancôme's "natural brownish-yellow" color overall. Clinique, claims the Hapa editorial assistant, was a tad too "red" on her milky-white skin. Another reason that Anthea enjoys using tanning gels year round is the wonderful tingle on her skin: "When I put it on, I feel a warmth to my body, almost like sitting in the sun."

Jim
Products Tested:
Origins, Clarins, Estée Lauder Dark, Clinique (Type III/IV)

What He Chose:
Estée Lauder Dark

Jim has the darker hue of our two men and reached immediately for the darkest gels we had. Ultimately, this full-time auditor chose Estée Lauder over Clinique for the brilliant color it provides. "I feel like I just returned from a tropical island. This one turned my skin the darkest, and it is a subtle and beautiful color." Although Jim is no stranger to summer's savage tans (by catching this Korean brother off the basketball courts during warmer days), he adds an extra bounce to his dark color by reapplying the lotion every third day.

Joy
Products Tested:
Lancôme (Medium), Clarins, Estée Lauder Dark, Clinique (Type III/IV)

What She Chose:
Clinique

With her already golden complexion, Joy can venture into the darker shades without worrying about drastic results. Clinique's self-tanner "really brought out the natural, dark color my skin turns during the summer months," says the Filipina nurse. And the darker shade also adds a spring to her step. " In addition to making me look better, it also makes me feel better," adds the medically savvy Joy, who makes it a point to avoid the harsh summer sun.

Justin
Products Tested:
Origins, Clarins, Clinique (Type III/IV)

What He Chose:
Clarins

Justin's skin tone has been known to rival both the palest hues and the darkest shades. Yet he prefers the middle-ground, claiming that he "isn't ready for darker lotions." So the tanners this Filipino herbologist chose to test were of the lighter shades, and his favorite provided the middle-road coloring that appeals to most general skin types. Justin, who is married to a woman named Sunshine, feels strangely conspicuous when sporting an overnight tan. So with Clarins' subtle glow, he feels wonderfully "natural."

In the running: Origins, Clarins, Clinique (Type III/IV), Lancôme (Medium) and Estée Lauder (Dark). *listed from the lightest to the darkest tints

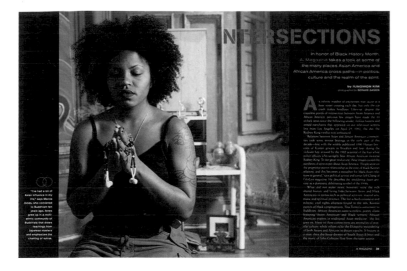

These swatches also showed up in current clothing fashions as the magazine headed into its redesign, complementing design director Tan's decision to depend less on the graphic use of color and more on photographs of people to animate pages. *A's* readers want to identify with others who have similar backgrounds and experiences, he says, and showing photos of personalities is the most powerful way to build that connection. Because the magazine includes fashion focuses in each issue, the book's color palette serves as a perfect backdrop for these shoots.

While a variety of subjects is largely the rule when designing with photography, *A* accompanies its articles, especially the more issue-oriented analyses, almost exclusively with pictures of people. Because many of the articles deal with matters of identity and communication, a straightforward look at the faces of

Asian Aesthetic

The balancing act *A's* designers create with text and boxes is all the more graceful for their liberal use of color. Careful touches of bold, eye-catching color in subheads and pull quotes, bullets and banners, headlines, and boxes are key elements of pages that move with youthful energy while remaining subtle and urbane.

Before *A's* redesign in 2000, the magazine was partial to the color red. Kisses of deep scarlet added stunning highlights to otherwise spare pages. This was consistent with *A's* adoption of the Asian aesthetic, as red is considered a lucky color in many Asian cultures. During the redesign, however, the artists decided to branch out in their use of the palette, relying more on bright tones of secondary colors for a more sophisticated look. Red can still be spotted, but now it's accompanied by rich gold, wasabi and grass green, hot pink, chocolate brown, and other vivid colors.

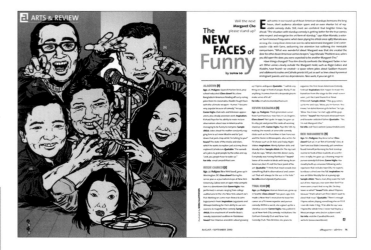

people who serve as the articles' examples is a gripping technique for drawing readers into stories. Subjects are often shot straight on, making intense eye contact with the camera.

By contrast, some topics are accompanied only by illustrations. For complex issues, these become abstract—pieces of shrouded faces or cutouts of patterned fabric, for instance. In the case of more conceptual articles, illustrations can become downright outrageous. In one article about up-and-coming Asian American comedians, a cartoon depicted five comedians crushing Margaret Cho, the Asian American comedian to whom newcomers are often compared.

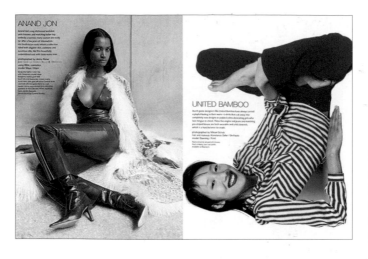

left The magazine stays on top of current fashion, and the book's color palette picks up colors from many of the current styles.

Going Digital

Like its readers, *A* is ahead of the curve in its thinking and style, so it's especially important for the magazine to look modern. One element that helps achieve this end is the type. The magazine uses a no-frills, jaunty font called The Sans throughout its pages for everything from cover lines, headlines, and subheads to story text.

By depending solely on this font and using it in various sizes and styles, designers are able to create a kind of continuity that helps the pages flow. The simple sans-serif face is easy to read and unpretentious.

Though John Tan insists the short articles and boxed blurbs that make up the magazine's design weren't influenced by trends in Web design, the Internet has played a major role in *A's* adoption of a more digital

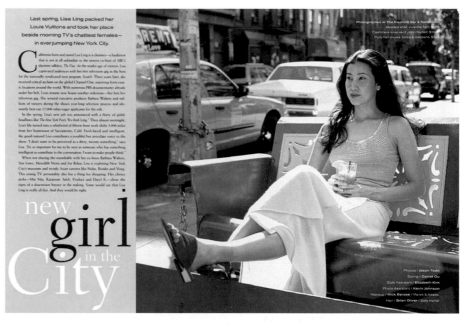

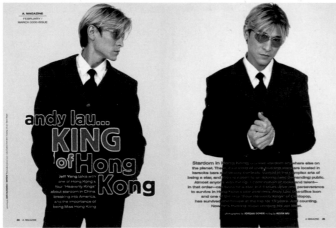

above and center The magazine often features celebrity profiles as cover stories, including these interviews with Lisa Ling and Andy Lau.

look. The magazine launched its Web site in spring 2000 at the same time as its redesign. The site features news and original features and is a separate product from the print publication, but the company searched for a way to unite the two brands.

The most obvious target was the magazine's logo. Since the magazine's beginnings, the logo was a tall uppercase A with a dot anchoring one of the letter's legs. "You couldn't even tell it was an A if you looked at it a certain way," Tan says.

The new logo is more digital-looking, a lowercase ASCII-like block *a* reversed against a colored box. On the cover, the magazine's Web site address sits below the logo, reminding readers of the reason for the lowering of the old flag and the raising of the new. The publishing company's president and founding editor, Jeff Yang, declares the logo "timeless and elegant."

Like the rest of the magazine's content and design, the new logo represents *A's* readership metaphorically. "We wanted this publication to be a place where Asian Americans are figure, not ground," Yang says.

Creative Process

Asking magazine designers how they reach their final layouts is a lot like asking painters, photographers, or novelists how they conceive and produce their masterpieces. They may be able to tell you how they begin or what inspires them, but the actual mental processes involved often remain mysterious—to the artists themselves as well as to the rest of the world.

Some university design programs focus heavily on process. In the real world, however, time for such formalities is rare as designers rush to close issues against strict printer deadlines. The design process is often guided by a helpful grid or patched together miraculously by association, sudden brainstorms, and last-minute tweaking.

Here's a look at how some designers define their own processes, plus a peek inside one designer's mind as he perfects the layout of an important magazine section.

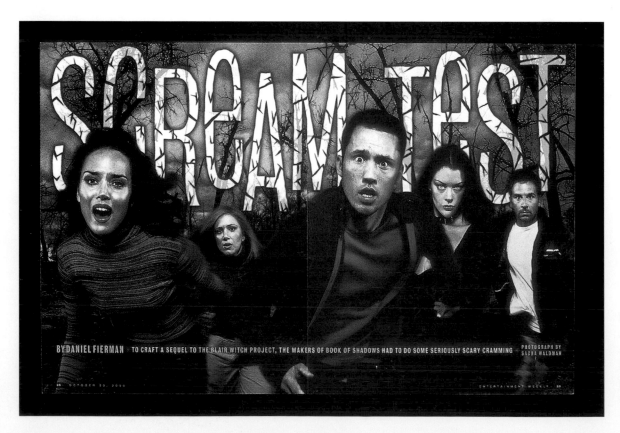

left and opposite page
At *Entertainment Weekly* and *Walking*, designers begin with the photographs or illustrations and let layouts build naturally around them.

Art Is Life

Designers usually start the page layout process with the element that most emphatically sets the tone for the magazine's personality. "Sometimes we'll start a design before the photography is in, but the design always depends on art," says Geraldine Hessler, creative director of *Entertainment Weekly*. "We make a map of the entire feature well. We may cut a page from something else if we have a good photo shoot. We allow ourselves a lot of leeway to play up good art."

An *Entertainment Weekly* layout is "reactionary," Hessler says. "We work with the editors to come up with a headline that works with the art and story." Then designers alter the type to further illustrate the topic or concept. "It's almost like geometry," Hessler says. "There is a certain set of givens, and we have to work with them."

Walking art director Lisa Sergi likewise always waits for an issue's commissioned photographs and illustrations to come in before beginning her work. As for the *Walking* designers, artwork inspires the graphics, headline fonts, layout, and colors that Sergi chooses. From there, she simply launches into a design with a natural feeling of balance and flow.

"It's instinctive," she says. "I just go with what feels right and makes sense. I don't make a huge effort to go through a formal design and review process, though I'll do printouts and look at them to make sure they look the same on paper as on the screen. But I usually go with my gut feeling, trying to put the strong stuff up front and put together a good mix of text-heavy features and sidebars."

DINNER THESE FOUR COMPLETE WEEKNIGHT DINNERS CAN BE THROWN TOGETHER WHEN YOU GET HOME FROM WORK. BY VICTORIA ABBOTT RICCARDI

PHOTOGRAPHY BY LAURA JOHANSEN

PASTA & GARLIC

Believe me, I know how it is: After a hard day of battles, we all want to sit down to a good dinner, one that incorporates today's flavorful, healthful, and exotic ingredients (not to mention a glass of wine or two). That simple pleasure should be our reward for schlepping the kids and enduring downed servers and rush-hour traffic.

But is it doable? If you read WALKING it is. Starting this issue, we've reshaped our food section to make it possible for you to make quick, easy, and affordable weeknight dinners. These are earthy, elegant meals that you can toss together at the last minute, often without even stopping at the store. In each issue we'll present a "dinner package," focusing on a particular food item and building a dinner around it. Next issue, for example, we've got weeknight recipes based on leftover holiday ham and turkey.

Besides main dish recipes, our unique dinner package features complementary side dishes, prep and cooking tips from both Victoria Abbott Riccardi (in the recipes) and Cynthia Salvato (in the new feature Test Kitchen Confidential), nutritional analysis, cost of each meal (something no food magazine does, and who doesn't want to know?), and wine recommendations—worry not, no brand-name wine talk, just a generic, what-best-suits-the-occasion suggestion.

Although we're not talking complicated Saturday night or holiday meals here, each one is a celebration. Monday through Friday we all deserve to sit down and unwind over a great meal. Right, fellow gladiators?
—*John Stark, deputy editor*

SEPTEMBER/OCTOBER 2000 • THE WALKING MAGAZINE 99

FEATURES

ENTERTAINING: HAVE A DRINK 76
HOME: A SIMPLE TABLE 84
FOOD: SHORT-ORDER GRILLING 92
STREAMLINING: PACKING LIGHT 100
CLOTHES: WASH AND WEAR 108
LOOKS: 5-MINUTE MAKEUP 116

left *Real Simple* layouts spend time pinned on a wall so artists and editors can judge them and make changes.

below When artists share in the editing process, inspired layout concepts emerge. In this layout in *Surface*, designers noticed that several featured products—sofas and benches—had to do with the idea of community, so they grouped the images to complete the theme.

Review and Revision

From the initial concepts onward, all designers have a distinctly personal process for perfecting their final versions. Always perfectionists, some tweak colors, shift text boxes, and add and delete rules in the original computer file right up to the final deadline. Others save versions of files as they make changes, then compare them before submitting the final layout. The image of how the layout should look resides almost exclusively in the designers' heads, and they constantly push themselves until they're satisfied or, more likely, run out of time.

Some designers follow a process that is a bit more formal. *Context* design director Mark Maltais, for example, allows enough time for several revisions of illustrations so art will perfectly complement layouts. "I get tons of sketches from artists," he says. "We go through three to five rounds, from thumbnails to rough sketches." He then begins laying out the story with the sketches in mind to make sure everything works together.

The review process is more democratic at *Real Simple.* "We start by pinning ideas up on the wall and choosing the one we like best," says creative director Roland Bello. Then designers route the initial layout through several stages of approval, from artists to editors. "We might change it three times from the initial layout,"

Bello says. "If we come up with a brilliant idea several steps into the process, we can still implement it."

At *Surface,* the first design review actually takes the form of editing. "Designers help in the editing process," says Riley John-donnell, one of the magazine's publishers and the creative director. "By reviewing the stories and products, we notice design trends before the editor does. Then we use those trends to create a visual dialog" by designing layouts that relate similar concepts.

First Draft, Final Draft

Shawn Hazen, senior designer for the San Francisco-based startup magazine *Dwell*, was close enough to the magazine's conception that he could document his design process. Specifically, he recalls how he came to the final version of the magazine's events calendar, a pull-out gatefold piece printed on uncoated stock.

"This format was developed to be a unique addition to the publication and also to have a distinctly different feel than the rest of the book," Hazen says. "The resulting size also makes a more interesting poster than a spread-sized sheet." The idea was that readers could pull it out and pin it on their walls as a reminder of everything going on in the design community.

Editors and designers wanted to make the calendar an important part of the magazine's brand. "Karrie Jacobs, the editor in chief, felt strongly that it should feel like controlled chaos," Hazen says. "I was told to make it a sort of random-access soup. Everyone felt it should be dynamic and kind of crazy."

It took Hazen three issues before he perfected the calendar. "The initial problem to overcome was how to achieve a wild layout that, inherently, is opposed to the modernist tenets upon which we were building the look of the rest of the magazine," he says. Hazen explains the five phases of the project in his own words.

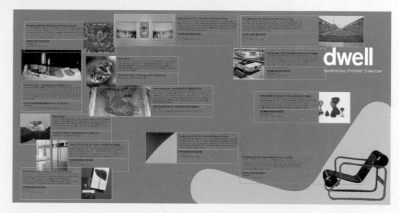

First Sketches

above "I tried a number of things initially—arraying the images in a sort of spine across the page for a horizontal layout or down the page for a vertical layout. Then all the information would bounce up and down or side to side on top of varying images. I also put some saturated colors in the background; color was becoming increasingly important to the magazine. Another early design involved making each entry its own unit, in a box, so each item was clean on its own, but they overlapped each other all over the page. After some quick reviews, both these ideas proved to be too clean—not chaotic enough."

Rethinking the First Sketches

right "I spent time rethinking how I could create a system that, when strictly ad-hered to, would create interesting relationships on the page. I decided to exploit the strongest design system there is: the grid. I gave each of the six types of entries we were featuring a grid. At this point, the question of what orientation the calendar should have popped up again. Should it be readable horizontally while still in the magazine or oriented vertically for hanging as a tall poster? I decided the type could run both ways. My grids could create interesting horizontal-vertical relationships. This would also limit the number of grids I'd need to use for both the horizontal and vertical orientation. It would look chaotic, but each type of information would have its own system or set of rules that would be consistent. The resulting grid system was cool, kind of a weird plaid when all the different column widths were overlaid."

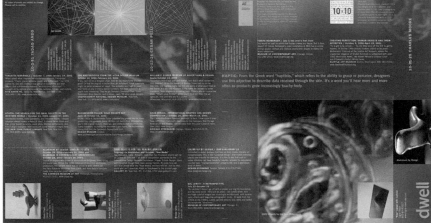

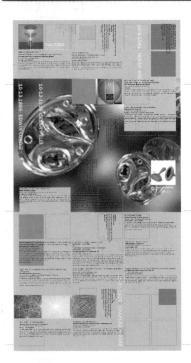

New Sketches

above and left "The next set of sketches followed my plan. Of course, I could take liberties here and there with regard to placement within the grid, but I allowed the intersecting grids to do most of the work. I felt I really had to show the grid selec-tively in order to visually explain the system—control the chaos visually. The images could fit on any of the same grids as well, and I decided, at this point, to choose just a few illustrations, as the page was becoming dense and active. After review, we realized this was heading in the right direction. I started to think that the feedback about the design being too clean might be due to the strong, solid colors I used in the background. So, in a late-night flurry of designing, I picked out a couple of my favorite images and tossed them in the background as duotones to give a more even, lower-contrast surface for the type. That created a wildly more dynamic page. I developed a subtler way of hinting at the grid—little hash marks, which had a nice architectural feel. And the four-color chunks of the background image that showed through revealed the grid and created an interesting, abstract compositional element."

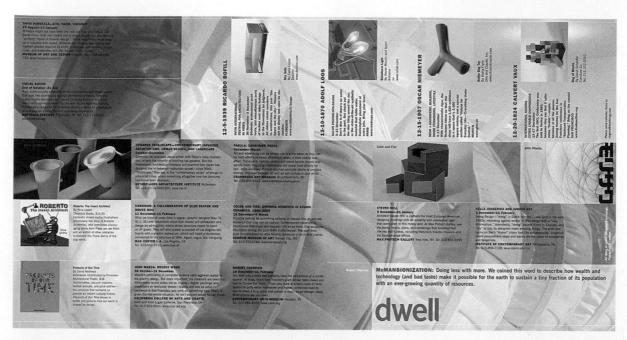

Production Adjustments

above "After the production manager got back from a tough time on press with the calendar for *Dwell*'s first issue, I decided to lighten up on the color scheme so the type could all overprint in 100 percent black or cyan, or at least builds of solid colors like red. The backgrounds would also be easier to control. I also got rid of the four-color portion of the background picture so that I could have more fun with the re-vealing and concealing of that background image, yet still put type on those areas."

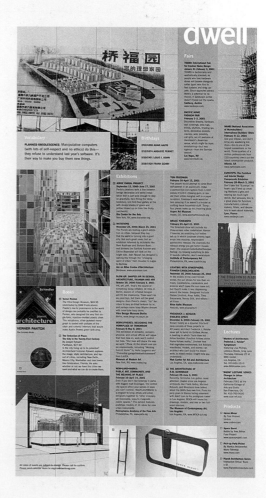

Further Refinement

right "Though we agreed it was 'mission accomplished' with the controlled chaos concept, it seemed we might be making it a little too hard to figure out what was what. I also wasn't convinced that the calendar was working as a poster. The second issue's calendar looked pretty neat when you unfurled it in the magazine, but was anyone really pulling them out? I was already far along with the third one, done in the manner of the previous two, when these realizations came to light. To further encourage their use as posters, I made one that ran all vertically. Thus, I could also clarify the information, more or less keeping each category together. I retained and perhaps strengthened the multiple grid concept by giving each category one or the other of the grids and a binding box of corresponding width, but this time I let both grids show in hairline over all the images. The images also strictly adhered to the grid. The two grids have infinite combinations, so the result still appears loose and organic—but not totally chaotic."

Real Simple

Ideas for Serenity at Home

How many adult women have not lingered enviously—or resentfully—over the grandeur of a room featured in *Town & Country* or *Elle Decor,* or been irked by the resourceful, painstaking creativity of the Martha Stewart franchise? "Sure her house looks like that, and of course she has time to make her own grapevine wreaths, wine, or jewelry," readers may sputter. "She has money, servants, time!"

Real Simple was launched as the answer to magazine consumers' frustrations. A primer on life's practical mysteries—how to buy tools or jewelry boxes, which pants are in style this season, how to put together the perfect barbecue menu—the magazine strives for uncluttered elegance while remaining realistic.

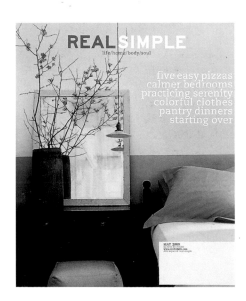

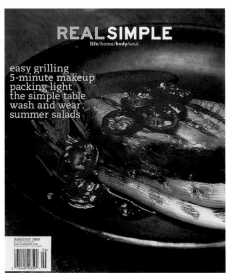

far left Natural, neutral colors with touches of light pink and orange welcome the spring on *Real Simple*'s May 2000 cover. Unlike the home decor and women's magazines saturated with color, minimalist color pops from pale backgrounds.

left Rich, robust colors saturate the front of the June/July issue, whose savory food photography reflects the grilling season. Colors are still subdued compared to the hot pinks and other brights on the newsstand.

WHY IT WORKS:

Generous white space, clean lines, and natural colors fall gently into place on pages, creating an oasis of organization, while photography keeps the magazine sympathetic and true to life.

right One of the magazine's specialties is sorting products into categories to help busy women figure out what they really need. Photographs illustrate each entry, as in this run-down of cosmetic brushes and applicators.

Accommodating Chaos

The title from Time Inc., which debuted in April 2000, received a great deal of attention by the media as it struggled to hone its original mission as "a guide to help people simplify their lives," says Roland Bello, the magazine's creative director.

Readers are mostly college educated, affluent, professional women in their 30s and 40s. About 68 percent are married and 62 percent have kids. Whether single or married, they live hectic lives but still want to relax in comfortable, stylish homes, Bello says. Editorially, the magazine offers blurbs about how readers can find easy but graceful solutions to common challenges, including contributions from other readers about their own time-tested tricks.

But though it made a splash on the newsstand, the initial format of the magazine didn't quite click with readers. "The idea of simplification was a difficult concept to bring to the mainstream," Bello says. Early criticism was that the magazine was too unrealistic—that there was no such thing as true simplicity. As *Real Simple* evolved with subsequent issues, articles became more comprehensive and substantial.

The magazine's design had to be tweaked along with the editorial concept. "It was too clean to get across the chaos of real life," Bello says. "We wanted to work in more humanity while retaining the integrity of the original idea."

left Amid the magazine's spare and orderly pages are hints of colorful chaos. In this primer on cosmetics, crumpled blush and lipstick smudge an otherwise serene layout.

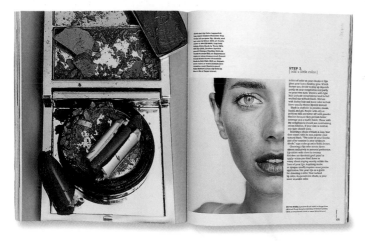

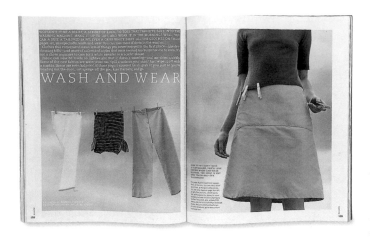

Making Negative a Positive

Simplicity still had to be a major design theme, as it was what the magazine was all about. The challenge, therefore, was to define the difference between simplicity and minimalism. The magazine needed to be straightforward and sophisticated, but not barren or aloof.

White space is one of *Real Simple's* most important tools. "It's such an essential element for communicating the clean and simple factor," Bello says. "More negative space makes type and photos much stronger."

White space doesn't graze freely on pages but rather appears in wide buffers between text and photographs to accentuate each point and picture with poise. Margin size varies between columns of text, surrounding photos,

and at the edges of pages. Column alignment, size, and placement are also flexible, so a column may start partway down a page or end partway up it. In the front of the book, which regularly includes features on how to buy tools or appliances, photos of products are crisply outlined against a pristine white background. The spacious pages help the most frenzied reader breathe more easily and begin to sort through the complexities of her life.

Because articles in the magazine thrive on short tips and blurbs to simplify information, all that white obviously doesn't serve the purpose of differentiating text. *Real Simple's* sidebars are often entire corners of pages or floating, borderless boxes filled with subtle beiges and blues. Text sits flush against the left edge of these boxes, which sometimes extend to the edge of the page, leaving a great deal of open space that calls attention to the text at its left.

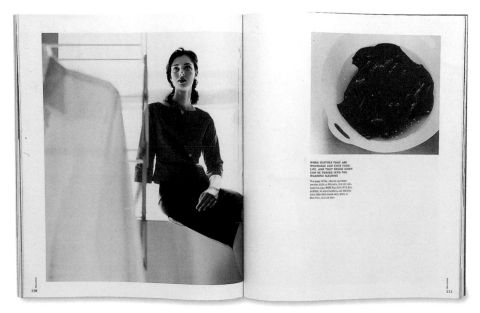

above and left A June fashion article on wash-and-wear clothing is as light as the breeze that dries the featured duds. The wispy blue backdrop and soft lines of fabric, the playful clothespins on the sweater, express the casual nature of the clothing. In startling contrast, an empty white page and a shock of red blouses on the following spread represent the tension of professional life.

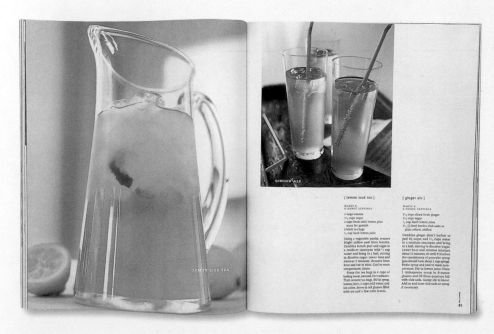

left The pale, complementary shades of these summer drinks and the surrounding negative space team up for a subtle, refreshing layout.

right Shadows speak louder than words in this play on the contrast between light and dark.

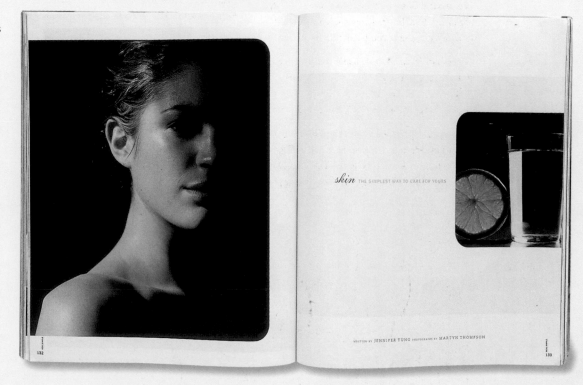

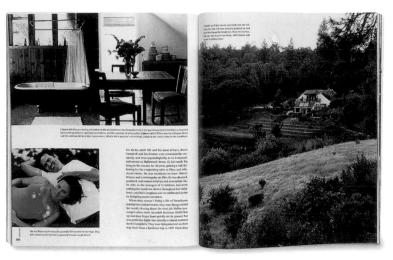

People Power

The magazine also communicates simplicity with its photography, especially in the front and back of the book. Neatly stacked white plates behind a pristine glass vase of fruit and towels folded and stacked primly—as if by a retail employee—are the stuff of which these anticlutter departments are made.

But *Real Simple* is using its photography to come down off the "too simple" high horse and reach out to real people. "Much of our photography has a serene quality, which people have reacted very well to," Bello says. "It offers peacefulness, but we're trying to widen the range. Some may be a little more hectic now."

A primary way to do this: Add people to the mix. Later issues display more shots of people in realistic

scenes—cooking with friends, hanging out with family. The photos bring the magazine down to earth and include readers rather than alienating them.

Real Simple sticks to whites and pale colors in its palette, and much of its photography hugs that end of the spectrum, but the magazine is interspersed with touches of warm, vibrant color. Colors change with the seasons, too. The rich pinks of crumbled blush and lipstick, rosy Chinese silk slippers, and deep red tomatoes enlivened the pages of summer issues, while the November issue stuck to wintry grays, beiges, whites, and occasional accents of berry red.

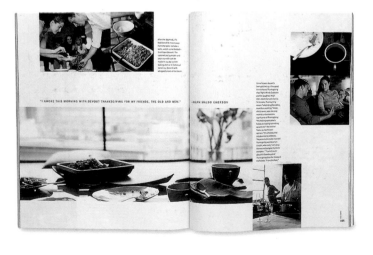

above and left As *Real Simple* evolved, artists worked to express a more human quality. In an article about entertaining in the June/July 2000 issue, the staged photograph of a prettily messy food tray served as a creative interpretation of how to handle children at dinner parties. November's article on the same topic included candid shots of friends and family alongside images of the food and table.

Consistent Type

Real Simple bookends its more in-depth content with visually driven departments in the front and back of the book. Large, full-bleed photos of luxurious scenes and detailed products reign over text in these sections. In the well, longer articles take precedence.

The magazine ties them all together with consistent typefaces. Caecilia, a square serif, serves as body text and, frequently, as headlines, decks, and subheads. The delicate Meta, specially designed in an Ultra Light face for *Real Simple*, is used for heads in the well. "It's sophisticated and refined and doesn't look horsy or vulgar if it's too large because it's not heavy," Bello says of the Meta face.

The typefaces are a perfect complement to a design that accentuates order, peace, and the beauty of fine things. Like its editorial content, *Real Simple's* design is friendly and undemanding, beautiful and brief, a haven for readers who otherwise have too much clutter in their lives.

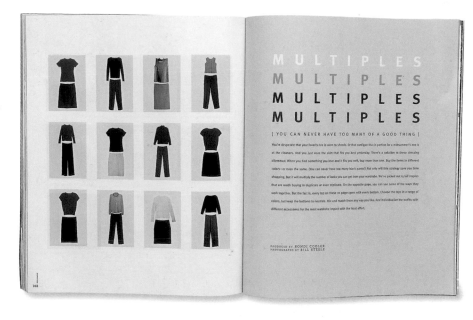

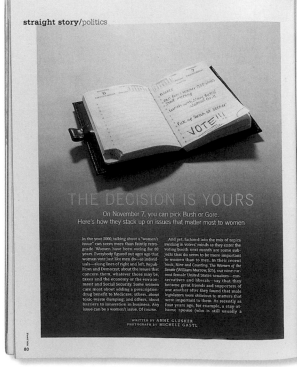

above A clever layout showing how favorite pieces mix and match layers the four colors of the article's headline, while a light blue background softens the sharp hues of the clothing.

left In a lengthy article like this one outlining presidential candidates, lightly colored information boxes and staggered column lengths break up text-heavy white pages.

Dwell

Home Design for the Modern World

The latest addition to the selection of home design titles on the newsstands is *Dwell*, which represents a radical approach to architecture and interior design publications. Debuting late in summer 2000, the magazine celebrates modernism by featuring futuristic solutions to ordinary challenges.

At the same time, *Dwell* concentrates not only on architecture and design itself but also on how people interact with space. The magazine is never aloof, a difficult achievement when tackling two typically elevated genres: the weighty study of design theory and the haughty world of home renovation and decor.

far left The cover of *Dwell*'s premiere issue set the magazine apart from its competition. The featured building is not only atypical, its foreground is shadowed while sunlight clips a far corner. The choice of angle and lighting is an example of how the magazine succeeds in showing architecture in its environment, with a natural perspective.

left On *Dwell*'s second cover, the human subject is actually standing farthest from the camera, while the rest of the room moves around him.

WHY IT WORKS:

Dwell is a richly textured weave of warm, personal images and the smooth, sleek lines associated with modern design. Refreshingly unusual photographs, with unexpected treatment of cropping, lighting, and focus, offer as many new ideas as the featured furniture pieces and rooms themselves.

right Readers find architectural plans make their heads spin, so illustrator David Fullarton offers a fun, personalized twist on the floor plan.

Modernism for the Modern Dweller

"At home in the modern world" is *Dwell's* tag line. Readers of the magazine are doing what Ikea and Target shoppers dream about—they're taking the superb design of their Scandinavian coffee tables and Michael Graves blenders to the ultimate level. Modernism will define their homes; they're hiring architects, rethinking space, redefining the old-fashioned concepts of rooms, walls, and comfortable living.

While the magazine is so new that it's still figuring out which readers will comprise its ultimate audience, creative director Jeanette Hodge Abbink believes they're young thinkers who aren't easily fooled. "This is a generation that has a love-hate relationship with corporations," she says. "It's a visual generation, one that likes to do things itself—its members don't go to stockbrokers anymore, they go online. They solve computer problems every day at work. We're not dealing with the lowest common denominator here. That's what design is all about—making people think."

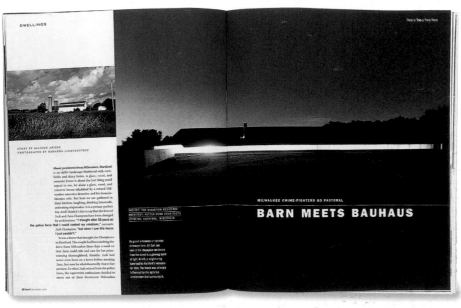

So far, the audience seems split between men and women, apartment dwellers and families with the means and style to discover architectural gems and mold them into fabulous spaces. But the magazine is also aimed at architects, which means it doubles somewhat as a trade magazine, says senior designer Shawn Hazen.

Dwell wanted a magazine that both groups could truly relate to. The editors summed up their approach in the premiere issue with what they called their "Fruit Bowl Manifesto." The idea, they explained, is that at most home design magazines, photo stylists spend entire afternoons arranging delicious-looking fruit bowls around rooms. *Dwell*, on the other hand, is aimed at people who appreciate bold architecture and well-designed products but still live normally. "If a photograph in this magazine includes a fruit bowl, it's there because the homeowners eat fruit," the article declared.

left In its first issue, *Dwell* summed up its philosophy with its "Fruit Bowl Manifesto": features would show fruit bowls only if people in the house ate fruit. This reflects the magazine's commitment in its design to showing humanistic views of home décor and architecture.

above *Dwell* stands out both for showing the exteriors of houses and for the way it shows them. In this nighttime shot by photographer Miranda Lichtenstein, a pulse of light is the only visible characteristic.

Nod to Modernism

Abbink and Hazen explored the roots of modernism when considering the design of *Dwell*, investigating magazines from the turn of the century through the early 1950s. They touched on the origins of the movement in many of their design choices; the type, grid, even the use of cyan and magenta plates to recreate the way early designers exploited the printing process are all nods to modernism, says Hazen.

The elements *Dwell* ultimately decided on were the more timeless, classic aspects of modernism applied to today's standards.

The use of type is perhaps most heavily influenced. The designers chose a revival typeface from the 1920s for body text because of its "chiseled, modern tendency" as well as its soft legibility, Hazen says. Heads and subheads are the sans-serif faces Franklin Gothic and Trade Gothic, respectively, which the designers chose because they are timeless and clean while still sporting character.

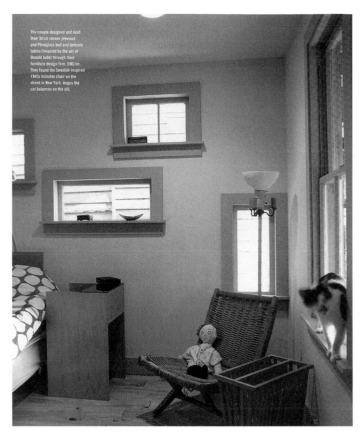

The couple designed and built their birch veneer plywood and Plexiglass bed and bedside tables (inspired by the art of Donald Judd) through their furniture design firm, EMCInc. They found the Swedish-inspired 1940s foldable chair on the street in New York. Angus the cat balances on the sill.

MY HOUSE

"WE WALKED IN AND SAW WOOD PANELING, DROPPED CEILINGS AND STAINED SHAG CARPET. BUT WE ALSO SAW THE LARGE EMPTY ROOM OF OUR DREAMS."

Quietly occupying the corner of a block surrounded by strip malls and industrial buildings in Venice, California, the Carson/Bettauer house is an unassuming little structure that looks from the outside a lot like the simple houses a first-grader might draw. Though their friends thought they were crazy, (see "before" picture left), architect Tom Carson and his wife, filmmaker Nicole Bettauer, saw the potential of the basic concrete shell. "Our first impulse was to gut it," Carson explains, and they did just that, creating an open, airy space they describe as "a modern loft crossed with a treehouse."

The decision to create a loft plan out of a traditional configuration of rooms was an easy one for the pair. After living in a 550-square foot apartment, they were eager to have as much open space as they could get and set out to create a home that would bring people and things together. The kitchen/bar area opens onto the living space, thus addressing this desire by providing a space for eating, drinking, socializing, and playing with Salty the dog. Recently they turned their parking space into a garden, providing an open-air extension of their living space. At night, the garden lights cast shadows on the house's opaque windows, creating an atmosphere the couple describes as "peaceful and livable, at once open and warm."
— ALLISON ARIEFF

october 2000 **dwell** 19

above Shots of rooms take on a warm, emotional feeling, dispelling preconceived ideas that modernism means spareness and cold.

left Photographer Todd Hido chose to shoot the living area in this San Diego condo from behind the subject. People are often incorporated into photos, but in a way that makes readers feel the subjects are really living in the spaces.

left Departments are characterized by a pattern: photographs pieced together at the top of the page, text in columns at the bottom. The pattern creates consistency throughout the magazine.

The magazine's flag, on the other hand, is a slight departure. Originally just a typed sans-serif logo, it was redrawn by an artist, who added subtle characteristics such as graduated curves. He also lopped off the corners at the letters' feet, creating an angularity that "feels fun," says Abbink. "The detail is paramount in setting the tone of the magazine," she says.

The magazine uses a grid of horizontals and verticals that fit together into an ever-changing puzzle. "The grid is malleable," says Hazen. "The relationships are always different." Yet the way they come together creates a pattern throughout the book. Interlocking photos and caption boxes sit at the top half of most pages, with three columns of text underneath. This is especially true of departments in the front and back of the book, though features stick loosely to the pattern.

Cactus green, wildflower yellow, and sky blue: colors that delight the Silvas and annoy the heck out of the neighbors.

EL PASO, TEXAS

José Silva on El Paso

Favorite Architectural Landmark
"The Toltec Building, a 1910 trapezoidal structure with an eclectic design."

Favorite Thing
"The bilingual/bicultural character, Casa Jurado (a Mexican restaurant), and the heavy influence from Mexico itself. In Latin America, Mexico, even Europe, homes are more colorful."

Least Favorite Thing
"Parochialism (probably from this side of the border)."

PROJECT: SILVA RESIDENCE
ARCHITECT: ED SOLTERO

José Silva fell in love with Crazy Cat Mountain at age eight, on a hike with friends. Looking at the 360-degree view of two states, two countries, two cities, and the Rio Grande, he thought, "What a great place to live." What Silva didn't know then was that within two decades, all the lots on Crazy Cat Mountain would become "Sierra Crest," a gated community. Nonetheless, in 1992 he bought a lot from a law partner who had tried unsuccessfully to build a house there. Silva turned his friend's defunct project over to architect Ed Soltero, who realized Silva's dream on the same footprint, with unpredictable angles and bold colors. Soltero didn't pound more foundations into the "fragile desert ecosystem"—rather he honored the ghosts of the desert wildflowers. To choose colors for the house, "Ed actually took the cactus to the paint store and said, 'Here, match this,'" says Silva.

The radiant aesthetic of the Silva house has been lost on the Sierra Crest Homeowners Association, which is suing Silva because he refuses to repaint his house taupe, beige, or any other docile tone that, according to the SCHOA, "blends into the desert." Silva has a different idea of the desert: "People think the desert doesn't have colorful plants. But it's amazing how much color comes from desert cactuses. You've got some ugly-looking cactus, it rains, and all of a sudden, bam! All kinds of brilliant colors come out."

But it's easy to ignore disgruntled neighbors and their dull conceptions of the desert when you're a car fanatic and your architect has created the garage of your dreams. No matter if some of his neighbors are grumbling behind dirt-colored walls—Silva is safe in his home, lost under the hood of his Corvette. —VIRGINIA GARDINER

68 dwell december 2000

PHOTO BY BRUCE BERMAN

There is **Too** a There There

From left: At Soho, a Medusa lamp by Luminescence, Eames chairs, and George Nelson lamps await modernist converts; a door impresses a little southern hospitality at the Flying Saucer, which serves over 160 different beers on tap to Little Rock's expanding happy hour crowd; okra and sweet potato pie that na Frappuccinos ("") at the farmer's market.

Log cabins and Greek revival architecture (right) make way for modernism in Little Rock.

CLINTON: GONE BUT NOT FORGOTTEN

Indeed, ever since Little Rock was established around 1821 (the town is named after a geographical feature on the south bank of the Arkansas River), it has possessed at best a tenuous grip on urban values of more traditional cities. It first came into existence as a cluster of cabins around a ferry crossing; a few years later legislative machinations, well lubricated with homemade whiskey, made it the territorial capital.

The three buildings that make up the Block 2 complex date from the '30s, a boom time in Little Rock, and although many of the buildings have been torn down, these three are part of the sturdy legacy.

Block 2 was made possible through the sale of tax credits granted for historic preservation, as well as HUD and Arkansas state housing-support programs. Half the units must be low income, which, calculated according to local median income of $19,800, works out to $436 rent for a one-

bedroom compared with the full price of $600–800 for Block 2 units. None of these subsidy programs has depended on the incumbency of Bill Clinton, Rice explains. But the city has enjoyed a building boom of sorts during his two terms: an expansion of the convention center on the river; a new arena in North Little Rock, across the river; dramatic expansion to the art museum.

But Little Rock is no Silicon Valley. The city is dominated by state government, law, and corporate headquarters for companies like Dillard's and TCBY. But Rice says there are younger, artier people who like to be able to walk to shopping and entertainment, and that's what this refashioned area can provide.

"It was completely dead at night down here three or four years ago," says architect Phil Purifoy, whose firm Fennell Purifoy designed Block 2's renovation. He kept the feel of the structures rough and rugged.

"We did as little as we could," Purifoy says. "We put in a fire stair to bring it to code and made it ADA accessible. But mostly we wanted to leave it as primitive and urban as possible."

The urban as primitive—it's no odd phrase for a state whose civilization is rural, whose economy is built on agriculture and tourism, the beauty of the Ozarks and the Delta, and whose license plates read "Arkansas—the Natural State." From such a perspective, urban life here may still feel a bit, well, unnatural. Imagine You Are Walking: Julian Opie's title is still a challenge in Little Rock.

Phil Patton contributes to the House and Home section of The New York Times and is a contributing editor of Esquire, Wired, and ID. He is the author of Dream Land: Travels Inside the Secret World of Roswell and Area 51.

great authors but with a twist: Plato, Shakespeare, Dr. Seuss.

Block 2 and River Market fit neatly into a group of other developments. The developers are counting on the nearby convention center, flanked by two large chain hotels and the older, restored Capital Hotel across the street. And just up the street, in the other direction, is the 26-acre site of the Clinton presidential library, under design by James Stewart Polshek.

Also nearby is the old State House, where Bill Clinton appeared to claim his victory on election night in 1992 and 1996. The 1836 Greek revival work by Gideon Shryock, a pupil of William Strickland, served as the state capitol until roughly the turn of the century, when the collapse of the ceiling in one

house of the Legislature precipitated the immediate release of funding for the new capitol. The original plan called for six columns but the territorial Legislature, careful with the taxpayers' money, settled for four columns and as a result there's a certain awkwardness to the façade. One of its rooms is dedicated to the surprising story of Bill Clinton. A vitrine displays his saxophone and sunglasses, not far away sit a pair of his New Balance 1500 running shoes.

Little Rock has been ahead of the country in one respect: It has been living in the post-Clinton era since 1993. No one is quite sure how the presidential library will fare, with Bill and Hill now making their home in Chappaqua, New York. The library is near the intersection of Interstates 30 and 40, the latter the main

east-west highway. (As any mall builder would tell you, that's good location.) Winnebagos en route to Memphis and Graceland, three hours away, could make a quick stop.

Bill Clinton's presence is inescapable in the city. There's the Excelsior Hotel, referred to in various legal depositions, looming above Markham Street. Quite by chance, signs catch the eye. There's a Tripp Building and Starr's Guitar store. The place where Clinton's dine really began continues to flourish, unchanged. Doe's Eat Place on Markham Street is famed as the place where Clinton's aides, over steaks and beers, planned his rise to national power. One visitor found himself seated at a table beneath the signed photo of another president—a flyblown image of Dwight D. Eisenhower. —P. P.

48 dwell december 2000

december 2000 dwell 49

above The shot of this El Paso, Texas, house by Bruce Berman is wonderfully divided by the house's front corner. One side of the house glows with light, the other is in shadows—another example of a man-made structure among the glory of nature.

left An intricate grid of horizontals and verticals fits together in different relationships but a common feel.

Humanistic Approach

The way *Dwell* uses photography has evolved since the first issue. Originally, a parade of tiny photos told pieces of the story from close angles, but designers responded to readers' clamor for more detailed images. In the second issue, photos got more elbow room, spreading to full pages or single photos at the tops of pages.

The photography is essential to distinguishing *Dwell* from its competition. The art staff never commissions architectural photographers; instead, they hire professionals who specialize in portraits, fine art, documentaries, or other subjects. The result is the exploration of drastically different perspectives.

The focus of a shot may be the way light plays off the side of a building or the movement of people through a house. Photographers shoot an occupied room with the people's backs to the camera, while a blurred band of light is the only distinguishable feature in the nighttime shot of a Midwestern house. Photos are sometimes shadowy or grainy, sometimes crisp and light, occasionally staged and sometimes spontaneous, but they're almost always emotional.

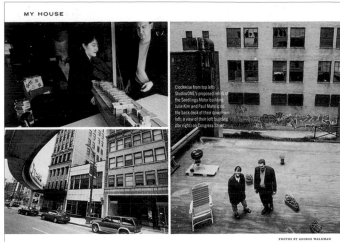

In a story about a Brooklyn house built vertically along a single staircase, photographer Kristine Larsen showed blurred children moving up stairs, a limited view of the family congregating in the living room, and angled shots of sunlight glowing through windows. "After the magazine came out, an architectural photographer sent me pictures of how he shot the same house," Abbink says. "Everything was all squared up, and the color was much more open." The contrast between natural light and the dark turns of the house's staircase, as well as the action of the family within, gave *Dwell's* version an "emotional texture," Abbink says.

above Designers like to show how people react to their space rather than just the space itself. Photographer George Waldman shows the owners of a Detroit loft, and their neighborhood, more than the loft itself.

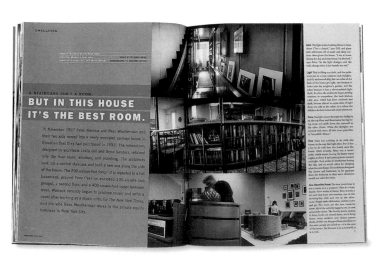

left Photographer Kristine Larsen, choosing narrow or backside views of rooms and hallways, captured light and people moving through the rooms of this Brooklyn home. The technique gives viewers a more personal and realistic view of the space.

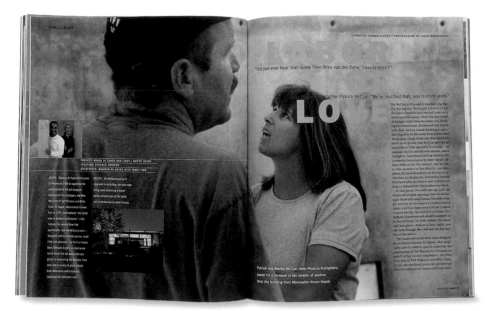

PHOTOGRAPH BY DOUG HOESCHLER

left Despite readers' expectations, many images are grainy, dark, or out of focus. In this article about an ongoing construction project, designers ran grainy images in sepia overtones. The resulting gritty, unfinished feeling complemented the story.

Taking Chances in Photography

Some readers were actually thrown off by the textured photography and pieced-together grid at first, Abbink says. "People have the idea that modernism means spare," she says. "The first issue looked dense where readers expected clean and minimal."

Dwell is actually a metaphor for what modernism is really all about: the willingness to take a chance, says Abbink. Its design also closely reflects editorial content, which is a mix of playfulness and intelligent depth. Sometimes fighting their instinct to use the most stunning or shocking of the commissioned photographs, the art directors are careful to stick closely to an article's tone and message when illustrating it.

For instance, in a feature on Arkansas, they began to design the article using dashboard shots of barren landscape out a windshield. "It gave the article a creepy, evocative tone," says Abbink. "It looked neat, but it didn't tell the story. We were responding to the interesting visual, not the narrative."

Designers also grapple with how to break up articles, which are often lengthy. One technique, discovered by accident during the layout of the first issue, is the treatment of pull quotes. Instead of excerpting them to place in the middle of columns, *Dwell* changes the size, heaviness, and sometimes face of pieces of sentences within the paragraphs themselves, calling attention to quotes without lifting them from the text.

Hazen invented the technique when laying out "The Lofting of America," a feature in the first issue. "We faced a wall of text," he says. "There were so many great nuggets that we couldn't pull them all out and put them in the middle of the article. These lead people in, and it's redundant to keep using standard pull quotes."

Touches like these turn potentially intimidating subject matter into entertaining, applicable fare. Delving into concepts that are sometimes abstract, *Dwell* approaches each subject from unique perspectives. The results are rich and engaging portraits of the modern home and its inhabitants.

below This article was the first in which designers used their modified version of the pull quote; they simply enlarge words within the body of the article to call attention to critical phrases.

*Surface

Avant-Garde Fashion and Design

A new breed of fashion magazine emerged in the 1990s. New American and European titles, including *Wallpaper* and *Dazed and Confused,* removed themselves from the societal gushing favored by their mainstream counterparts—who sponsored which benefit, who made an appearance at which cocktail party—and chucked the self-improvement articles that had crept from women's magazines into the fashion category. Instead, they returned to their roots, exploring design and fashion as art and devoting less attention to the fame of personalities behind the clothes.

Surface, a San Francisco-based publication, was among the pioneers of this new category, which inspired dozens of like-minded magazines. But there's more to the magazine than austere models donning mind-blowing frocks. Its conceptual design keeps pace with the fashions it features, so each page is a rich, engaging experience.

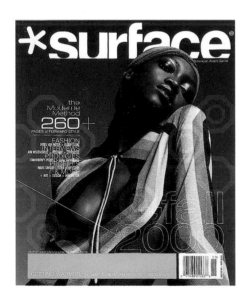

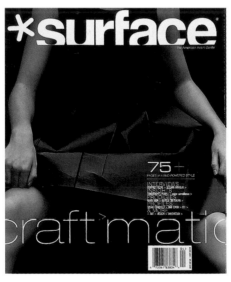

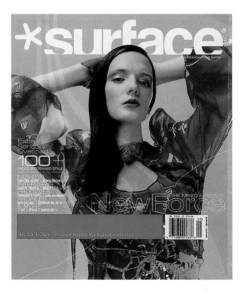

above Texture, color, and technique interact in *Surface* layouts to convey the overall feeling created by a fashion or design. On the Fall 2000 cover, frosted varnish in retro patterns overlay the page for touchable texture.

above The creases of fabric are the defining factor on this monochromatic cover.

above To introduce an issue on structure in chaos, this cover joins unlikely colors and runs squiggles across the psychedelic design of the dress, adding texture and signaling to readers that heavily patterned fashion is on its way.

WHY IT WORKS:

A report on the avant-garde movement in American fashion and design, *Surface* uses esoteric, lush photography and free-form graphic shapes to create a mood that comments on and chimes in with the designs shown in the images. One standout technique is the magazine's addition of depth and texture to pages through multilayered graphics, shadowy images, or the application of patterned coatings to pages.

Serving the Creative Wannabes

When **Surface* debuted, it targeted what was then a niche market: "Gen X that grew up," says Riley John-donnell, who shares the titles of publisher and creative director with partner Richard Klein. Readers are the young affluent, ranging from 20 to 40, with a strong aesthetic sense, media savvy, and the desire to represent themselves as creative types.

"Our readers are people from the creative industries—art directors, students, teachers, fashion designers, architects," says John-donnell. "But they're also creative wannabes. So many people in our generation, no matter what they do, want to be filmmakers, designers, writers, or artists of some kind."

**Surface* serves these readers not by featuring what's cutting-edge and hot at the moment but by discovering work that is the next wave of art and design. The magazine features a mix of progressive fashion and interior design that is more than just aesthetic—it's moral, contextual, even utopian, John-donnell says. Breakthrough work is constantly shown alongside that of established designers and photographers in an attempt to stay far ahead of the curve.

"It's about innovation—from the content to the way we present it," says John-donnell. **Surface's* forward-thinking design is an appropriate showcase for the work it features. Pages are never idle receptacles; each design contributes its own interpretation and commentary on the content.

above Explosive flowers and plants are a lusty way to showcase blush and eye shadow.

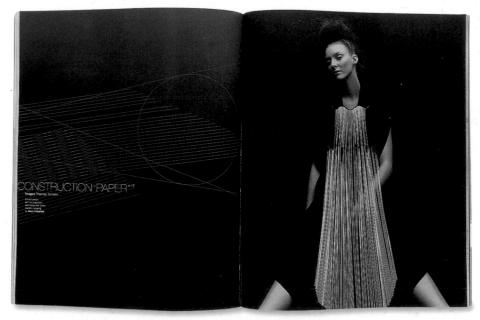

left As if the metallic beading on the front of this dress weren't eye candy enough, light gray lines are woven together on the facing page, balancing the spread and mimicking the clothing's design.

Following Fashion's Lead

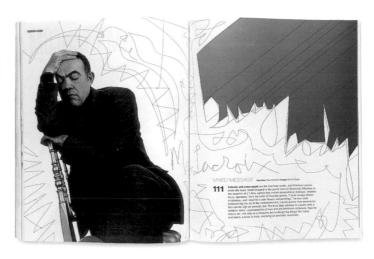

The magazine's design is constantly, subtly evolving, without the fanfare of a magazine redesign, John-donnell says. Because it reflects trends in the design world, changes can occur as often as every season. *Surface* mostly takes its cues from fashion, where new ideas tend to develop first, with architecture, interior design, and graphic design following suit more slowly.

For example, when *Surface* began in the early 1990s, fashion and design were undergoing a minimalist period featuring monochromatic fabrics, clean lines, little adornment. The magazine accordingly took on a spare look. But fashion turned around toward the end of the decade, exploring more textures and patterns.

Now, with maximalism in full swing in fashion, *Surface* pushes the boundaries of the trend without making the pages too busy. Geometric line art over

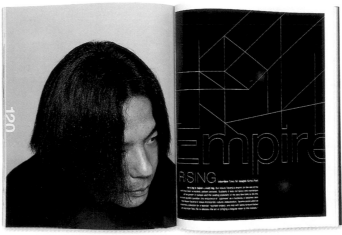

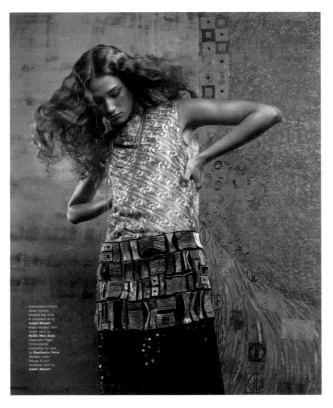

above Part of a fashion shoot in the fall 2000 issue, this image by photographer Torkil Gudnason is a wild mesh of opulent patterns and colors.

photographs adds three-dimensional depth to pages, while meandering doodles in margins replicate carefree, experimental designs. Lush, intricate backgrounds envelop fashion photographs. A clear, patterned varnish overlayed on the magazine's cover contributes to the exploration of the concepts of surface and texture.

Another constant, the hand-done look of some of the type and lines, is also adopted from fashion. "We've been noticing that many of the clothes are given hand-done treatments, such as hand stitching," says John-donnell. "It adds a sense of humanism."

Thus, many of the features in the magazine's well include handwritten headlines and captions. This not only creates an organic feeling in many of the featured clothing designs, it was a way for *Surface* to differentiate itself from competitors in the market who were beginning to look too much alike, John-donnell says. Some designs cast colorful painted shadows behind the script, complementing the colors of the photographs and adding depth to the page.

top Driving home the point about the maximalist approach in fashion, designers doodle in the margins with line art, then color in the background to add another dimension.

above Artists bring depth to pages with geometric line overlays. For this interview with a Japanese fashion designer, layered shapes emerge from the headline. This technique exemplifies *Surface's* commitment to replicating the tactile qualities of fabrics and patterns.

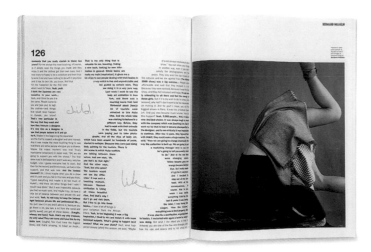

"Yet it felt familiar. It fit our design ethos and it looked good next to product. And, importantly, it look good as white and black."

Though it sticks close to a few select fonts, *Surface* does play with type in other ways. Since its inception, it has carefully cropped words. The most apparent example is its logo, whose bottom is sliced off, creating the illusion that the logo itself is sitting atop a surface. Inside the book, headlines may bleed out of a box or be cropped from any side.

The idea to crop text also gave way to the magazine's unusual treatment of its folios, which become integral parts of a page's design instead of hiding away at its bottom. Initially given reign to bleed off the edges of photographs, page numbers are a bit more conservative these days but still act more as headliners than as annoying afterthoughts, as they're treated in so many magazines.

Creative Cropping

Though it's not apparent at first glance, type is given a relatively simple treatment in *Surface*. Light sans-serif faces such as Helvetica and Franklin Gothic, always in black or white, are used throughout the book for everything from headlines to body type. Headlines are simple, standard affairs: two-word, catchy summaries that categorize the subject matter of each article.

Recently, to further distinguish itself, the magazine adopted a new font: Unit, a tiled sans serif used primarily for headlines. "It's not too retro, not too cyber, but it allows clean communication," says John-donnell.

right For an article on unconventional German designer Gabriele Strehle, designers take liberties: handwriting across a photo, cutouts in the columns, and line art in the margins.

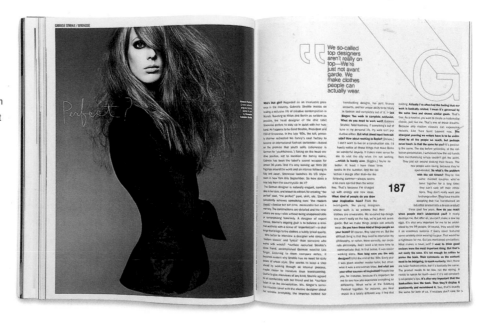

Fashion in Context

Cropping text is one way *Surface* creates tension in pages, an element that John-donnell says emulates Japanese design. Another technique that achieves this is the magazine's liberal use of negative space. Barren fields of white rule the tops of pages and creep in to cut chunks from columns and knock text off balance and out of alignment. The result feels unsettling yet strangely orderly.

That's an impression hammered down by the magazine's photography, which comes across, at first glance, as aloof and artsy, but achieves a finely balanced duality. Models twirl and bend in fast motion or shadows; featured clothing hangs in the corners of a darkened room; an art installation is photographed from the inside out to illustrate the way it envelopes the visitor. Readers get the feeling that they're looking at a new wave of truly remarkable work, yet the photographs put the pieces in context rather than simply showing them on the runways or on gallery walls.

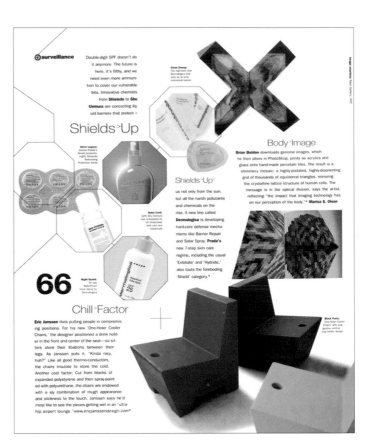

above Where are the people? the clothes? Look under the chest and in the corner. In *Surface*, nonobvious photographs not only simulate the avant-garde approach but also set a mood that helps readers understand the designs.

"We're combining humanity and modernism," John-donnell says. "Every time someone said they were being modern or cutting-edge, the design was usually hard-looking. It lacked naturalism." Even when shooting inanimate objects, such as furniture, *Surface* hires photographers who can capture the sensitivity of the subject in its setting. "One of our photographers is wonderful at catching a sensual moment with an object, when the light's a certain way," John-donnell says.

When laying out departments in the front of the book that feature furniture, art, accessories, or other kinds of design, the magazine's artists often consider the nature of the objects and how they relate to each other, and create a design theme for each page.

Surface is design that makes you think. Moreover, the dimensions of its images and graphics—the details of a scratchy fabric, the sensuality of twirling in a flowing dress—make for pages that are too lush not to reach out and touch.

above In departments that feature new products, artwork, furniture, and fabrics, designers build connecting themes. Here, octagonal frames are linked like molecules to merge stories about sunscreen, art made from genome images, and polystyrene chairs.

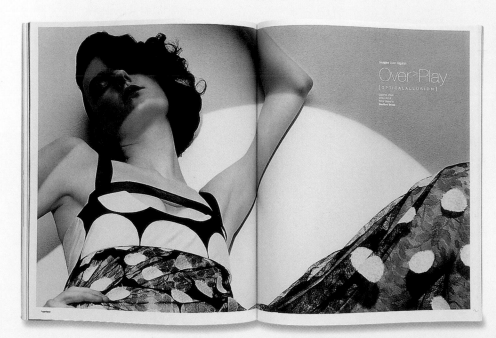

left The photo is silky, but sheer black lace and a stucco backdrop cooperate to create a grainy, too-bright feeling. Note how the shape of the spotlight coincides with the dress's white dots.

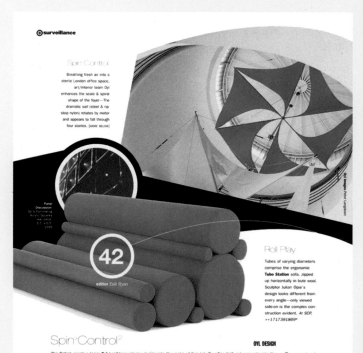

above Fashion shoots are about the clothing in action, as in these slow-shutter shots of twirling models.

left Orange circles converge in another example of a themed department—photos of a tube sofa, a piece of an acrylic sculpture given circular cropping, and a nylon sail hung in a London foyer.

Designing for Success

Q&A with Samir Husni

Dr. Samir Husni has seen his share of magazines come and go. A journalism professor at the University of Mississippi who's commonly known as Mr. Magazine, Husni publishes annual reports tracking the success of new magazines and speaks to hundreds of reporters each year regarding magazines' positions in the market.

Q: The role of design in magazine publishing has changed a great deal over the years, from a secondary consideration in many categories to top priority for most publications. How has this evolution been influenced by increasing competition on the newsstand?

A: We are a visual society. Everything—not just magazines—is driven by visuals. The magazine industry is no exception. Magazine design has always been one of the major determinants of success of any magazine. However, design, like the magazine cover, helps sell the magazine once; the content is what will help sell it a second time. In a time where potential readers are not willing to give more than two and a half seconds to decide whether to pick up your magazine or move to the next one, design is essential in grabbing the attention of the readers. It must jump at you. That is the main reason why magazine publishers pay so much attention to the design of their books. It is the icing on the cake, and if you have good cake, you better spend some time on the icing so it will be picked up. However, I am quick to add that good design with a bad cake will take you nowhere. You will be able to cheat readers once with design, but that will be the end. Remember, the cardinal rule in magazine design should be "We always sacrifice design on the altar of content." Readers will always forgive a flaw in the design; they will not in content. There are too many options out there.

Q: How quickly must a new magazine's personality make an impression in order to hook and keep a new reader? Does the cover have to say it all, or is the reader searching for something more subtle inside?

A: The cover is the starting point. People buy magazines based on a concept I call the Four Me's: See Me, Pick Me, Flip Me, and Buy Me. Therefore, the visuals on the cover are essential. That is what the reader sees first: the image. They will recognize it more than the name of the magazine, especially if the magazine is new. The image should directly lead them to the main cover lines, or what I like to call sell lines. The cover lines are the pick-me-up lines. This is what makes the reader reach to the stands and pick up a magazine. Next comes the table of contents to reflect the cover and its lines. From there, the reader will flip through the pages to make sure what was promised on the cover and the table of contents is actually there. Then a decision is made to buy or return. It is no longer one thing that sells the magazine. Readers are becoming more and more aware of all the gimmicks, and they can cut to the chase and know what to pick. New magazines must offer a complete package.

Q: How large a role does a brand-new magazine's design play in its survival?

A: Because of the number of new magazines being published each year, design plays a major role in getting your magazine noticed. In all my studies about magazine survival, design was always on the list of the major determinants of success; however, it was always on the bottom of the list. As I mentioned earlier, design is the icing on the cake, and there are plenty of cakes with no icing.

Q: Can you think of an example of a magazine that made it largely because of the way it was designed? How about a magazine that failed because of the way it looked?

A: I wish I could. I do not believe any magazine can survive solely or even largely because of design; neither will it fail because of that.

Q: The early 1990s saw an influx of new magazines in which design was the format—frenetic and somewhat illegible though it may have been. What sparked that trend, and do you think it has been tamed?

A: As with all fads, their time will come and go. Magazines designed for the sake of being hung on the wall at museums will sooner or later lose their audience and fade away. Any magazine that you cannot read is anything but a magazine. So, if you want to produce something that is illegible, just do one copy and hang it at a museum for people to look in awe at your artistic abilities. I firmly believe that some of the best designers are those who help the reader gain more information in less time utilizing less space.

Q: How much tweaking is acceptable with a new publication's design in its first year? How do readers respond to such changes?

A: Change is the only concept in magazine design and magazine publishing. You can—and should—tweak your design all the time. We tend to give readers too much credit when it comes to matters of design, while in reality they are interested in the content of the magazine. Delivering the information in a timely manner for an audience who is willing and capable of paying the price of the magazine is the secret of success. Stop worrying about the design and focus on the content. To paraphrase a presidential slogan, "It's the content, stupid."

High-Energy Sports and Culture

Teenagers—the demographic marketers are trying to tag as Generation Y—are the last untapped consumers, and, these days, plenty of industries are going after the money they earn scooping fries after school. Manufacturers romanticize everything from cell phones and pagers to PCs and CDs to the under-20 population.

There's always been a strong magazine market for the younger set—*Seventeen*-inspired fashion titles for girls, guitar and skateboarding magazines for boys. But one category aimed at this age group takes itself much more seriously. A hard-core subculture with its own international superstars, language, and gear, surfing feeds largely off kids, mostly high school-age boys. Among the titles competing for these die-hards' attention, *TransWorld Surf* stands out for its superior, edgy design.

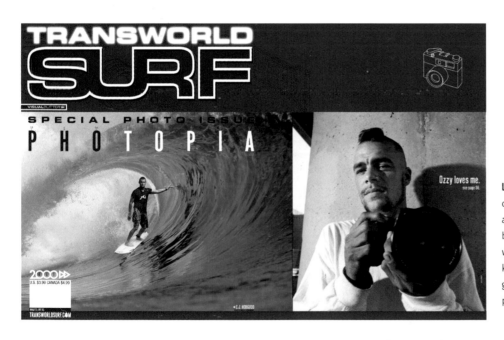

left The October 2000 cover, as usual, featured an action shot surrounded by the vivid border for which *TransWorld Surf* is known. Every cover is a gatefold; here, a surf photographer gears up.

WHY IT WORKS:

Spectacular, fast-action photography and loud backgrounds fuel the magazine's throbbing pulse, while a calculated use of color and type capture the attention of readers whose minds are always trying to tackle the next wave.

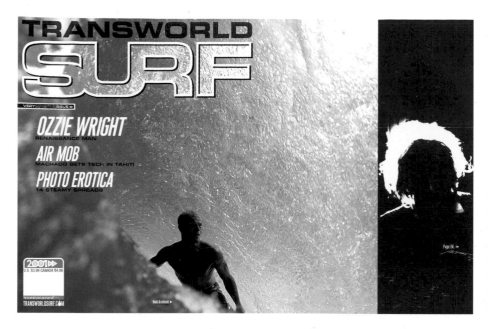

left Another gatefold cover, with the splash of surf showing through the magazine's logo, features a shadowy black-and-white image with a mysterious page number as the inside cover line.

Hooking Young Readers with Attitude

TransWorld Media, the magazine's publisher, has long been known for its design excellence and experimentation—experimental graphic designer David Carson headed up the design for *TransWorld Skateboarding* in the 1990s, for instance.

In the surf magazine's case, the focus on good design was largely competitive. "The design is key in the sense that it's one of the few vehicles we can utilize to visibly differentiate from other magazines," says art director Marc Hostetter. "Like us, our competitors have always and probably will always have great photography. The key to success here is in innovative delivery and design."

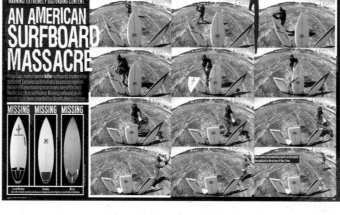

above Repetitive scenes, like in a convenience store security camera, show surfboards being "grotesquely decapitated" for the hilarious treatment of a surfboard product review.

Though *TransWorld Surf* attempts to be sensitive to a broad audience, Hostetter says the magazine's audience is primarily young males, on average around fifteen years old. Readers crave everything they can get about surfing, but they're also immersed in the offbeat culture that goes along with the sport.

So profiles and interviews are heavy with slang, attitude, and prankster features such as "Crank Call"—transcripts of actual prank phone calls to surfers. "Without being too offensive, we try to break as many rules as possible," Hostetter says.

Articles include fashion features, travelogs, contest coverage, and technique, but much of the magazine is about surfing itself. Articles pay tribute to surf professionals known well in the community—high school kids with nicknames like Ratboy—and moves that make readers gasp with envy and respect.

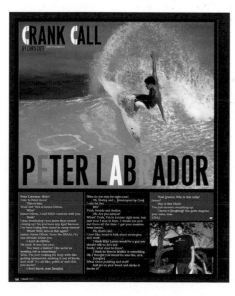

right "Crank Call" is a spoof that prints real transcripts from prank phone calls the editors make to surfers. While Hostetter uses two or three typefaces consistently, different colors make the type visually stimulating.

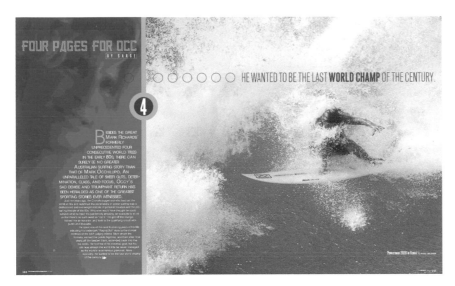

The Rich Blues of Surf Photography

Capturing these moves with photography is the staple of a surf magazine, Hostetter explains. *TransWorld Surf* gives center stage to gorgeous freeze-frame shots of surfers turning, sliding, and punting. High-speed film drinks in every droplet of the spray, every muscle and pose of the boy on the board. Images are examples of masterful, technically perfect photography and surfing at the same time.

"It's definitely meant to inspire, instruct, and, more importantly, entertain," Hostetter says. "*TransWorld Surf*

is going to showcase the moves and surfers of the future, not the beauty and purism of the sport. I like to use the analogy that other surf magazines resemble museums and ours is more like a video game."

The magazine makes it a policy not to run a surf photo smaller than one-sixth of a page. Often, main features are made up of several spread photographs or facing full-page photos with small blocks of text. Others include pages divided evenly into repetitive or progressive photos for instruction or effect.

While not all photography is breaking the waves—funny or soulful takes often find their way into fashion spreads and feature profiles—there's so much exotic blue and perfect white foam between articles and ads that, by the end of the book, readers feel exhilarated, if not a little soggy.

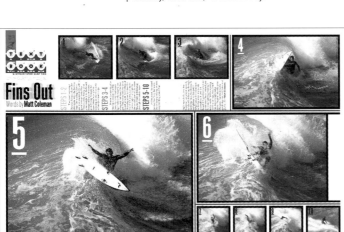

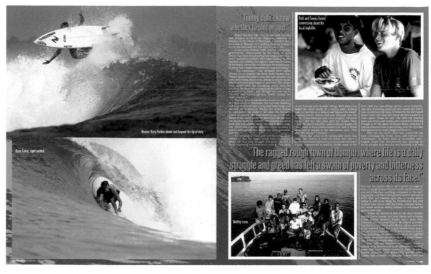

Competitive Color

That's why Hostetter spends so much effort on the design of the pages surrounding photos. "It's hard to be ultracreative and change on a monthly basis with seemingly monochromatic images," he says. "Everything is blue or blue-green in surf photography. Without diluting the photo's impact too much, I wanted to be creative around and at the edges and borders."

This is where color becomes part of the magazine's look and feel. Many of the pages surrounding or facing photographs are filled with background color. Rather than rely on a standard color palette, designers borrow from trendy colors in clothing, sports, gear, and other items popular among teens. The backdrop or rule around a photograph may be the same shades of orange, deep red, or wasabi green seen in swim trunks or boards featured in ads and articles.

Color plays a large role in helping *TransWorld Surf* assert its identity, says Hostetter. "Competing titles seem so married to the white-page, black-text, minimalist mentality," mostly because they're dedicated to the purity of surf photography and don't want to distract from the images, he says.

But Hostetter is careful to use color in such a way that it enhances the photography rather than distracts from it. One technique he applies is to limit contrast in background designs. He uses several shades of red or orange as a pattern or borders within borders, yet is careful not to create too much contrast behind the text so that it remains easy to read.

The effect is one to which *TransWorld Surf*'s audience, overstimulated by its visual world, responds well. "It think it's important to acknowledge that kids these days pay more attention to detail and color combos," Hostetter says.

above Background designs help generate the constant buzz and activity that keep readers hooked. To facilitate legibility, Hostetter limits these images to shades only slightly different from the rest of the background color.

left Hostetter finds color and graphic inspiration in gear and clothing. Here, green and yellow merge and divide across the page. A digital dot motif and kanji-like characters—both popular symbols in youth culture—decorate the head.

far left Art director Marc Hostetter applies shades of color to borders to emphasize photos and keep younger readers stimulated. Here, rounded borders mix with right angles to bump and slide readers through the layout.

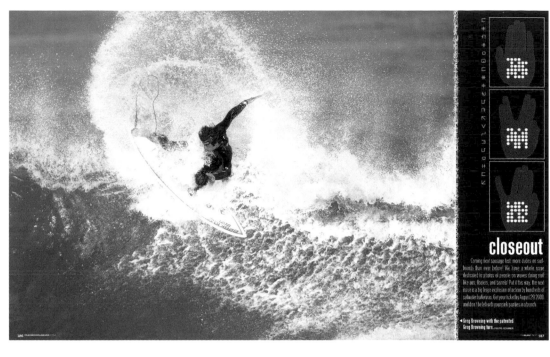

closeout

Coming next sausage fest: more dudes on surfboards than ever before! We have a whole issue dedicated to photos of people on waves doing stuff like airs, floaters, and barrels. Put it this way, the next issue is a big huge explosion of action by hundreds of saltwater ballerinas. Get your ticket by August 29, 2000, and don the left with your pink panties on a bunch.

◄ Greg Browning with the patented Greg Browning turn. PHOTO: SCANER

left Once again, cryptic symbols—popular motifs in clothing, accessories, and gear for teenagers—make their way into a layout.

Pounding Energy and Movement

Further charging the buzz created by the magazine's content is the edge-to-edge design. Pages are busy from one end to another, without negative space or spacious margins. Because the magazine runs surf photos so large, designers often must crowd images and blocks of text together into a single layout.

Kids have a short attention span, Hostetter says, so the constant movement and energy in the pages keeps them excited. The audience's wandering minds can also be a negative factor, though; if the pages are too hard to read, the magazine will lose them.

The color combinations are Hostetter's way to create harmony within a layout, therefore making pages more accessible. "I consider each element, including text, an ingredient of a complete graphic," he says. "This method tends to look less intimidating."

Designers also stick to a few consistent typefaces: the serif Caecilia as a body font and sans serifs Optivenus and Eurostile as headlines. "I feel like continuity and simplicity with type styles maintain a critical element of control," Hostetter says. "They also strengthen the magazine's identity."

Measured but energetic design not only sets *TransWorld Surf* apart on the newsstand, it creates page-turners that glorify each incredible surf shot featured in the magazine. The high-impact but consistent and thoughtful layouts go a long way toward hooking young readers—even if they're so lost in the moves they don't realize what's going on around them.

right This profile is another example of the use of bold color with sensible combinations.

left Rules and borders separate the articles in this department. A non-sensical scribble accompanies the department head to represent the subtitle "Random Acts of Senseless Information."

right Features, such as the tongue-in-cheek "Dictionary of Medical Terminology," are built around spectacular photographic spreads. Readers buy the magazine for the surf shots but stay for the funny writing and sharp design.

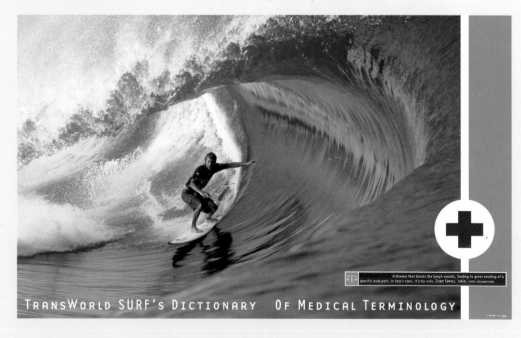

Yoga Journal

Yoga Instruction for the Body and Spirit

America has become hooked on yoga as a relaxation technique, but this centuries-old exercise is just as much about control, balance, and energy as it is about winding down. True to its subject, *Yoga Journal* combines these fundamentals to create a soothing yet fluent design.

In fact, the magazine strives for a reading experience that mirrors the topic it covers. "We want to create the feeling of walking into a yoga studio," says art director Jonathan Wieder. "The look must be one of calm and serenity, but we don't want it to be soporific. There has to be a balance between calmness and energy."

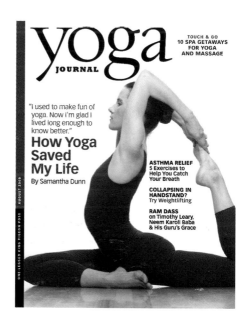

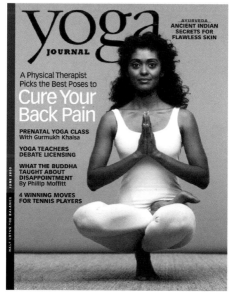

far left The human body forms elegant frames for *Yoga Journal's* covers. Among fitness magazines promising perfect bodies with blaring colors and cover lines, *Yoga Journal* maintains the serenity of its subject.

left The font used for the word *yoga* in the magazine's flag resembles the graceful curves of the body in a yoga position. The logo is a distinct part of the magazine's brand.

WHY IT WORKS:

Handsome, understated layouts and a palette of nature-inspired colors create a serene setting and build a strong, continuous flow analogous to yoga positions themselves. The artists let photographs carry the design, clearly proving their understanding of the magazine's most valuable design asset: the gorgeous human form.

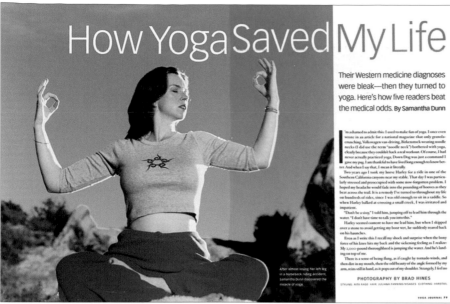

How Yoga Saved My Life

Their Western medicine diagnoses were bleak—then they turned to yoga. Here's how five readers beat the medical odds. By Samantha Dunn

I'm ashamed to admit this: I used to make fun of yoga. I once even wrote in an article for a national magazine that only granola-crunching, Volkswagen van-driving, Birkenstock-wearing noodle-necks (I did use the term "noodle-neck") bothered with yoga, clearly because they couldn't hack a real workout. Of course, I had never actually practiced yoga. Down Dog was just a command I gave my pug. I am thankful to have lived long enough to know better. And when I say that, I mean it literally.

Two years ago I took my horse Harley for a ride in one of the Southern California canyons near my stable. That day I was particularly stressed and preoccupied with some now-forgotten problem. I hoped my headache would fade into the pounding of hooves as they beat across the trail. It is a remedy I've turned to throughout my life on hundreds of rides, since I was old enough to sit in a saddle. So when Harley balked at crossing a small creek, I was irritated and impatient.

"Don't be a sissy," I told him, jumping off to lead him through the water. "I don't have time to talk you into this."

Harley seemed content to have me lead him, but when I skipped over a stone to avoid getting my boot wet, he suddenly reared back on his haunches.

Even as I write this I recall my shock and surprise when the bony force of his knee hits my back and the sickening feeling as I realize: My 2,000-pound thoroughbred is jumping the water. And he's landing on top of me.

There is a sense of being flung, as if caught by tornado winds, and then dirt in my mouth, then the odd beauty of the angle formed by my arm, reins still in hand, as it pops out of my shoulder. Strangely, I feel no

PHOTOGRAPHY BY BRAD HINES

STYLING: RITA RAGG. HAIR: JULIANA FANNING/VISAGES. CLOTHING: HARDTAIL.

YOGA JOURNAL 79

After almost losing her left leg in a horseback riding accident, Samantha Dunn discovered the miracle of yoga.

left Yoga poses are not always shown straight-forwardly. Yoga-focused features, such as this one about yoga and health, are accompanied by artistic, emotional photographs that showcase the beauty of positions.

A Yoga-Focused Magazine

The magazine has had quite a history. First quite literally a journal for yoga teachers and school owners, it quickly became a special-interest magazine for new-age interests, covering everything from war and poverty to life after death. Yoga itself was the main focus when the magazine started in 1975, but few people were practicing in the United States then, so it moved quickly to the back burner.

With the practice's resurgence in recent years, *Yoga Journal* needed to reinvent itself, so it relaunched in 2000 as a yoga-only magazine and let the technique regain center stage. Articles are instructional, discussing how to succeed at different poses, but also cover benefits and related topics—health, spirituality, and the like.

Who's the reader? "She's me," says editor in chief Kathryn Arnold. The magazine's readership is 80 percent female, Arnold says, and is, on average, 47 years old. Readers generally have high income levels, travel a lot, and are sophisticated, which means they have an eye for fine design.

However, readers vary widely in their connection to and familiarity with yoga. Readership is growing by leaps and bounds and ranges from long-time yoga practitioners who see it as a way of life to people who have just started taking classes at the gym. Therefore,

the magazine's redesign had to appeal to a broad audience, attracting them to the pages with a look that was familiar, accessible, and attractive.

More people are turning to yoga as a physical exercise rather than a spiritual or meditative one, too, now that magazines and health professionals advocate it as therapy for pain, back problems, and overall flexibility and fitness. So layouts focus more on the physical act of yoga—performing and improving poses—and address their potential effects on specific physical problems. Illustrations of people in yoga poses are used in more issues-oriented articles as well as instructional ones, creating an ongoing challenge for artists to keep each page looking new and interesting.

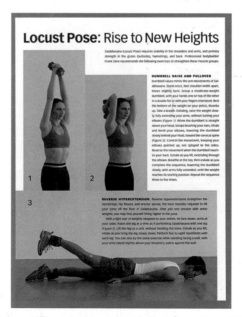

Locust Pose: Rise to New Heights

Salabhasana (Locust Pose) requires stability in the shoulders and arms, and primary strength in the glutes (buttocks), hamstrings, and back. Professional bodybuilder Frank Zane recommends the following exercises to strengthen these muscle groups.

DUMBBELL RAISE AND PULLOVER

Dumbbell raises mimic the arm movements of Salabhasana. Stand erect, feet shoulder-width apart, knees slightly bent. Grasp a moderate-weight dumbbell, with your hands one on top of the other in a double fist or with your fingers interlaced. Rest the bottom of the weight on your pelvis, thumbs up. Take a breath. Exhaling, raise the weight slowly, fully extending your arms, without locking your elbows (Figure 1). When the dumbbell is straight above your head, biceps brushing your ears, inhale and bend your elbows, lowering the dumbbell slowly behind your head, toward the cervical spine (Figure 2). Control the movement, keeping your elbows pointed up, not splayed to the sides. Reverse the movement when the dumbbell touches your back. Exhale as you lift, extending through the elbows. Breathe at the top, then exhale as you complete the sequence, lowering the dumbbell slowly, with arms fully extended, until the weight reaches its starting position. Repeat the sequence three to five times.

REVERSE HYPEREXTENSION. Reverse hyperextensions strengthen the hamstrings, hip flexors, and erector spinae, the back muscles required to lift your torso off the floor in Salabhasana. After just one session with ankle weights, you may find yourself lifting higher in the pose.

With a light pair of weights strapped to your ankles, lie face-down, arms at your sides. Raise one leg at a time as if performing Salabhasana with one leg (Figure 3). Lift the leg as a unit, without bending the knee. Exhale as you lift; inhale as you bring the leg slowly down. Perform five to eight repetitions with each leg. You can also try the same exercise while standing facing a wall, with your arms raised slightly above your shoulders, palms against the wall.

left Some departments are framed with a softly colored border, which sets them apart from other sections and gives them their own personality.

right The shapes of yoga poses dictate the flow of pages. Photographs of poses against white backgrounds divide the page into geometric negative space, a strong feature of the magazine's design.

Flow and Continuity

Luckily, the subjects of the photographs themselves are inherently diverse. The curves and angles of the body in a yoga pose make for interesting negative space, while pointing and leaning bodies give pages direction and flow. Graceful, sensual poses are balanced with ones that are more tense or strenuous, creating a natural ebb and flow. Designers let the provocative shapes alone frame the magazine's covers.

Inside, photography comes in two forms. Instructional photos must be accurate, so readers imitating the poses won't hurt themselves, says Wieder. Editors and

yoga spotters usually attend these shoots, and photographs are appropriately straightforward, usually shot at eye level with little background so the lines of the subject are clear and obvious. For features articles, it's less important that the yoga is exact, so portraits tend to be more atmospheric and evocative, shot with various perspectives and lighting to illustrate the feel of each article.

A technique that *Yoga Journal* originally adopted to save money also helps the magazine's overall feeling of continuity. Because the publication relies so heavily on original photography, it's more affordable to shoot a whole year's worth of photos for certain departments,

left To ensure that models in instructional photos are positioned correctly, a year's worth of photos are shot with a yoga expert on hand. Seeing the same model repeatedly is comforting to readers, designers say.

Awakened Athlete BY DIMITY MCDOWELL

Are You Weak in the Knees?

Regular yoga practice can turn your knees from one of the more delicate structures in your body to one of the most reliable.

ATHLETES DEMAND MORE from their knees than an infant does from its mother—or at least it seems that way. Support me while I pound the pavement during a run, we ask them, or while I kick a soccer ball or pivot quickly on the tennis court or land hard after a layup.

Fortunately, most of the time, the knees agree, twisting, turning, and absorbing shock so that you can keep playing. The mere thought of them failing is enough to make any athlete, um, weak in the knees—the joint is so vital to all athletic endeavors, from aerobics to water-skiing, that when it hurts, the game is over.

While all knee injuries demand attention, the severity of the problem dictates what action to take. Obviously, a carry-me-off-the-field or I-

heard-it-pop injury requires a qualified doctor to diagnose the exact condition and recommend treatment. Once the knee is back to a functional state, yoga can prevent further injury by stretching and strengthening the muscles that surround the joint and promoting correct body alignment. For common problems, like arthritis and small sprains and strains, yoga is equally beneficial.

First, a little anatomy lesson. The framework for the knee is surprisingly fragile. The joint, which connects the femur (thigh bone) and the tibia (shin bone), is a hinge which doesn't fit perfectly together, unlike other joints like the hip, a ball-in-socket configuration, or the ankle, which slides together like two puzzle pieces. Instead of

NAVASANA
(Boat Pose)
Builds core strength in the abdomen and back, thereby alleviating some of the weight carried in the knees. Begin seated, knees bent, feet flat on the floor, holding onto the backs of your thighs. Rock gently from side to side to feel the sit bones at the base of your pelvis. Lean backwards to balance on the back edge of the sit bones and the tips of your toes. Keeping your pelvis neutral (tipped neither forwards nor backwards), draw your navel in and elongate your spine. Straighten your legs. Reach your arms, palms in, alongside your legs parallel to the floor and gaze toward your toes. If your back rounds, bend your knees.

For Beginners BY SHIVA REA

Bhujangasana

Like many backbends, Cobra Pose is a "heart opener," subtly releasing held emotions within the rib cage to bring greater joy within the body.

"FEW OF US HAVE LOST OUR MINDS, but many of us have long ago lost our bodies," says transpersonal psychologist Ken Wilber. It is quite common for human beings to live in a disembodied state – for our thoughts to be separate from the experience of our bodies. This loss of the body takes many forms, from not being able to stop the train of thinking mind to catching ourselves hunched over or sick because we haven't paid attention to the many warning signs we were given by our bodies. One of yoga's many benefits is the experience of greater embodiment.

Embodiment is the spreading of one's consciousness throughout the body, from the crown of the head to the toes, the surface to the core. It is learning to listen and understand the language of the body. It is remembering ourselves by exploring and excavating who we are: in our own skin. When you begin to take a yoga class or learn from a book or video, the instructor will invite you to move places in yourself that may have been forgotten or never realized: big toes, kneecaps,

thigh bones, sternum, and kidneys, as well as places that you may be very aware of due to tightness or pain, such as the lower back or the sides of the neck. The asana that we will explore, Bhujangasana (Cobra Pose), is fundamental not only for embodying your spine but for learning to move as an integrated whole. Bhujangasana is an essential pose for developing the strength and flexibility of the entire back, while toning the legs and buttocks, increasing circulation, and assisting in kidney function. Like many backbends, it is a "heart opener," subtly releasing held emotions within the rib cage to bring greater joy within the body.

Familiar Landmarks
BEFORE WE BEGIN TO DO THE POSE, let's trace some of the important landmarks within the body that are key to activating not only Cobra but many of the

Shiva Rea teaches Cobra Pose to help her students develop strong and flexible backs.

What's old is new again. **CHANTING** is a hot ticket in yoga studios across the country.
By Phil Catalfo

Can You Say Om Namaha Shivaya?

ON A COOL SUMMER EVENING, several dozen people gather in a modest-sized room at Piedmont Yoga, Rodney Yee's bustling studio in an upscale neighborhood near downtown Oakland, California. They doff their shoes and jackets, grab blankets and bolsters, and find places on the floor. But they're not here to do asanas. They've come to dip into the same spiritual well that spawned yoga, only this time they're intent on doing it not through twists, inversions, or backbends, but by opening their mouths and singing in a language none of them speaks.

Along one wall sit three people: a short woman with long hair, waiting quietly before a microphone; a wiry fellow, setting up a pair of tabla drums; and a tall, bearded, bear of a guy popping lozenges into his mouth and taking a few slugs of bottled water. As the crowd settles in, he noodles on a harmonium, a mini-keyboard that generates sound by means of a hand-operated bellows. He pumps the bellows with his left hand while his right hand plays the keys. His name is Krishna Das, and he has come to lead this group in an evening of *kirtan*, devotional chants from the Hindu tradition.

PHOTOGRAPH BY **ROBERT OLDING**

88 YOGA JOURNAL

Now playing at a yoga studio near you: Kirtan master Jai Uttal leads a group of yogis in chant.

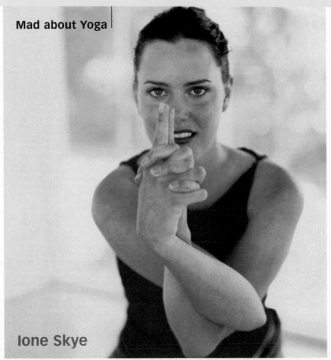

Mad about Yoga

Ione Skye

IONE SKYE, daughter of '60s folk-rocker Donovan, has acted in 25 movies including *Say Anything* and *Gas Food Lodging*. She was first introduced to yoga, at the tender age of 4, by her Jewish, New York City cab driver grandfather. At first she didn't like it very much because he frightened her, especially when he moved into Lion Pose! Now 30, she has tried different classes but "never really got into it" until a friend invited her to a Kundalini Yoga class in Los Angeles with teacher Gurmukh Khalsa. "I fell in love with doing yoga. The chanting was very deep for me. It was as if I remembered it. It was like a real surrender." Skye, in the midst of her busy life acting (she just finished filming *The Recycler* with musician Beck, to be released next year), painting, and writing a screenplay, always makes time for yoga. "I like doing a challenging class because it makes me more brave in life. My perception of hardships is now completely different. I'm not whining and moaning inside as much." When she travels, she stays committed to her practice. She especially loves doing Sun Salutations. "Every morning if I go in the sun and do them by myself, it's such protection.... Yoga is a life-saver." —*Dya Englert*

such as the "Asana" section for beginners, in one sitting with a single model, says Wieder. Therefore, faces are the same from issue to issue—as if a reader was returning to a regular yoga class. Readers appreciate the consistency, he says.

Shooting its own photographs also gives *Yoga Journal* some control over colors and patterns used in backgrounds, so they often pick up shades of the magazine's palette. The wood floors or painted walls of a setting often match or complement one of the 30 colors used throughout the book—the muted maroons, pale greens, chocolate browns, maize yellows, and soft grays and beiges that the magazine uses for a unified look. Illustrations also reflect the color choices.

The rich, subdued colors play a major role in creating a sense of calm throughout the magazine, but they're also modern, a reflection of shades universally popular in interior design, fashion, advertising, and other branches of the design world. Therefore, they're familiar and appealing to culturally aware readers.

Panchakarma is not a detox program. This is only its side benefit. It is a transformation in consciousness—replacing stress with silence.

left Articles flow naturally, helped along by unobtrusive callouts and free-floating captions. This easy movement throughout layouts is one of *Yoga Journal's* greatest successes and is instrumental in building the magazine's fluid feeling.

Quiet Flow with Personal Touches

Besides color, matte paper stock adds to a feeling of serenity. Chosen foremost as a more reader-friendly paper that better represents photos, the matte finish gives pages a subtle, poised feeling.

Type plays its own role in giving *Yoga Journal* its unassuming look. Designers chose sans-serif faces of various weights for heads, department headers, cover lines, and some sidebars, offering simplicity and readability. Body text is a small serif font called Journal, a light, elegant face with curves defined by straight lines.

The magazine's logo is a perfect use of type, true to the entire magazine's nature and personality. Designers decided the word yoga should be printed in lowercase letters for a discreet and modern style. It dominates the word journal, which is printed below in all caps. Yoga is portrayed in the font Village—which itself carries the fluid lines and curves of a posing human body. Displayed on top of *Yoga Journal's* cover photographs, the magazine's flag is the essence of yoga.

The magazine achieves continuity from the front of the book to the back, but inside, it manages to allow some pages and sections to assert themselves. The book rarely strays from its three-column grid, but the usual elements are given original twists.

Sidebars defy the box standard, for instance. Some are contained in entire columns with subtle background colors that bleed off the edge of the page. Text sits flush against the left edge of the column. Other side-

bars feature floating text separated from body text only by a single bottom rule. Margins and distinctive typefaces act as natural borders, once again communicating the design's quiet confidence.

Another technique is the use of colored borders around certain pages or sections. These indicate regular departments or separate instructional portions of an article from the rest of the text. Borders give sections their own personalities, says Wieder. Because border colors are usually pale, the borders are more comforting than oppressive and help call attention to pages that otherwise might get lost in the flow.

These elements blend to create a reading experience that is calming, complete, and constantly moving. Even away from the yoga studio, *Yoga Journal's* design can inspire the spirit of this physical and spiritual exercise.

Off the Couch BY MARK EPSTEIN, M.D.

Sitting with Depression

Depressed people think they know themselves,
but maybe they only know depression.

A WOMAN NAMED SALLY called me not long ago seeking advice. I had seen her for a single session in consultation months before, and we had talked about a variety of therapeutic and spiritual issues. Like many people with an interest in spirituality, she was suspicious of the role of psychiatric medications in today's culture. It seemed like the mark of some kind of Brave New World to have mood-altering drugs so readily available. But like many others, Sally wondered if there might be a medicine that could help her. She had been plagued with chronic feelings of anxiety and depression for much of her adult life, and despite a healthy investment in psychotherapy, she still felt that there was something the matter with her. When I spoke with Sally the second time, she had been taking a small dose of an antidepressant for several weeks, 25 milligrams of Zoloft, and she was finding that she felt calmer, less irritable, and, dare she say, happier. She was going on a two-week meditation retreat later that month. Something about taking her medication while on retreat made Sally uncomfortable, and that was the reason for her call. "Perhaps I should go more deeply into my problems while I'm away," she said. She worried that the antidepressant would impede that process by making her problems less accessible to her. What do you think? she asked.

Let me be clear right from the start that there is no universal answer in a situation like this. Some people notice when they take drugs like Prozac, Paxil, or Zoloft, antidepressants of the SSRI (Selective Serotonin Reuptake Inhibitor) variety, that they feel cut-off from themselves as a result. They don't feel their feelings quite so acutely and sometimes report feeling numb. Some, both men and women, find that the drugs interfere with their ability to reach orgasm. Many others find that the damping down of their feelings is more subtle. One of my patients notices she no longer cries in movies, for example, but she is willing to accept this because she also no longer worries to the point of exhaustion about things she can do nothing about.

I was relieved to hear that Sally was feeling better. People who respond well to these antidepressants often have none of the side effects mentioned above. Instead they feel restored, healed of the depressive symptoms that they were expending so much of their energy trying to fend off. Less preoccupied with their internal states, they are freer to participate in their own lives, yet they often wonder if they are cheating. "This isn't the real me," they protest. "I'm the tired, cranky, no-good one you remember from a couple of weeks ago." As a psychiatrist, I am often in the position to encourage people to question those identifications. Depressed people think they know themselves, but maybe they only know depression.

Sally's question was interesting not only because of the drug issue but because of her assumptions about

WellBeing

Tummy Tonic
The ayurvedic cure-all triphala can boost sluggish digestion.

IN AN EFFORT TO stay healthy, you probably take strides to keep organs such as the lungs and heart in top form, through practices like pranayama and meditation. But it might pay to set your sights lower.

"Some 80 percent of all degenerative, chronic diseases have their origin in inefficient digestion, assimilation, or metabolism," says Dr. Rama Kant Mishra, an Indian-born ayurvedic physician who is currently director of research and product development at Maharishi Ayur-Ved Products International in Colorado Springs, Colorado. "If we are unable to properly digest and assimilate the food we eat, the body will not receive the nourishment it needs to maintain and regenerate itself. Moreover, digestive dysfunction creates *ama*, a toxic byproduct, which can wreak havoc on normal bodily functioning if allowed to accumulate over time."

To strengthen the digestive fires, ayurvedic physicians traditionally recommend a potent herbal mixture called triphala. A combination of amalaki, haritaki, and bibhitaki, triphala strengthens the digestive process, provides nutrients, and pushes out toxins from the body. With a mild laxative effect, it enhances the health of the gastrointestinal tract by rejuvenating the membrane lining of the intestines and by stimulating bile production. Triphala improves liver function, helps purify the blood, and removes accumulated toxins. It is also high in vitamin C and linoleic oil.

Triphala also helps address a wide range of disorders, from irritable bowel syndrome, ulcerative colitis, constipation, and diarrhea, to anemia, eye disease, skin disorders, yeast infections, and problems related to the female cycle. According to Dr. Mishra, most anyone can benefit from taking triphala, although it is contraindicated for pregnant women, people with chronic liver conditions, and for those taking blood-thinning drugs. In rare cases, if a lot of ama has accumulated in the body, nausea or a skin rash may develop when you first begin taking triphala as impurities are pushed out. If that happens, stop taking the herb and consult with an ayurvedic doctor before taking it again.

Take the herb for about six months at a time, and then take a four-week break before continuing. If you take triphala in powder form, ½ teaspoon every evening before bedtime is recommended. If you take it in pill form, follow the recommendations on the bottle. Monitor your daily bowel movements. If they get too loose, it's time to cut back on the dose.

—*Eva Herriott*

HEALTH**WATCH**

For the past several years, we've been hearing reports about the benefits of green tea, particularly its role in preventing cancer and other serious conditions. But those who've made drinking it part of their daily routine might wonder: If steeping tea a little releases powerful antioxidants, will steeping it longer produce more of a punch? Probably not, say researchers at the University of Hawaii. In testing the ability of green tea to inhibit colon cancer, the biochemists found that most of the antimutagenic components were released in the first couple minutes of brewing.
Source: Mutation Research

The aromatic bark of the cinnamon tree has more going for it than just great taste. Microbiologists have recently confirmed the spice's age-old reputation as a versatile food preservative—in this case, as a potent match for *E. coli* bacteria. Kansas State University researchers added a teaspoon of cinnamon to apple juice that contained 100 times the level of *E. coli* typically found in contaminated food. In three days, the spice had killed off 99.5 percent of the bacteria. Considering that 10,000 to 20,000 of us get sick each year from food-borne illness, it's good to know that we can turn to the most common of kitchen staples for protection.
Source: Chemical Market Reporter, HerbClip

Could dry cleaning be killing us? That's a question Representative Carolyn B. Maloney (New York City) would like the Department of Health and Human Services to start investigating. A recent study of 1,350 Boston-area women between the ages of 35 and 75 suggested a link between the use of professional dry cleaning and a greater incidence of breast cancer. "Although the study looked at only a limited segment of the population, it raises troubling questions for women nationwide," Maloney says.
Source: Office of Carolyn B. Maloney, Washington, D.C.

left Sidebars contribute color to pages without making them look boxy. One favorite technique is eliminating a margin on one side, running text against the edge of the column.

above Colors in illustrations correspond with the magazine's palette, a selection of quiet, soothing greens, blues, golds, deep reds, and beiges.

The Magazine of Smart Health and Fitness

In a competitive market of women's and fitness titles, the meek *Walking* inherits the earth. While its fellow titles shout aggressively from the newsstand, *Walking* manages to stand out with its gentle colors, easy flow, and creative photography.

Walking's goal is to remain friendly and accessible to readers who are learning to love exercise. This is achieved through simple design accented with strategic touches that build moods individual to each article.

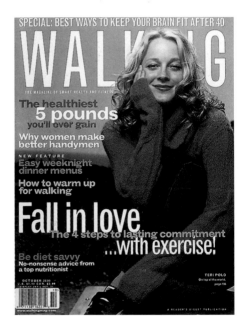
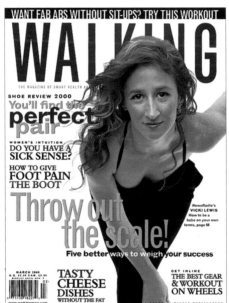

far left *Walking* uses celebrity covers to sell issues. Recently, portraits have been shot in outdoor settings—natural, casual themes, consistent with the rest of the magazine.

left Another example of a celebrity cover, this March 2000 shot of actress Vicki Lewis pops colorfully with complementary cover lines against a clean, white background.

WHY IT WORKS:

Unique and spontaneous use of photographs and type keeps readers on their toes and makes the magazine an enjoyable, easy read. Airy layout creates the feeling of freedom and space, even in a magazine packed heavily with articles and ads.

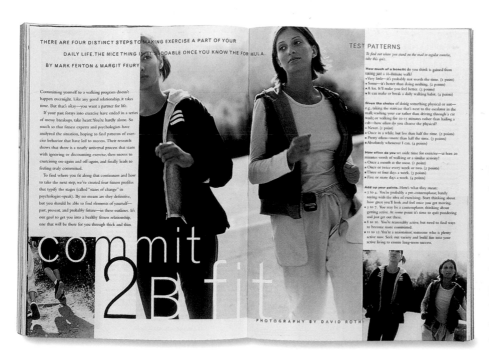

left The magazine is all about keeping readers moving, but its approach is not hard core. Action shots, such as these photographs by David Roth, are casual and easygoing.

below A checkerboard of floral pictures sprinkles color across a spread on contemplation gardens.

People Mover

Walking's tag line is "The magazine of smart health and fitness." "We want to get people moving," says art director Lisa Sergi. "People aren't active enough. Their lives get complicated, and it's even harder to squeeze in exercise. We help them overcome the obstacles."

Starting to walk regularly is a starting point for many of these people, though it can evolve into a true sport. (Race walking, after all, was a new Olympic event in 2000.) "It's one of the easiest things people can do," Sergi says. Therefore, the magazine takes less of the hard body approach adopted by titles such as *Fitness* and *Shape* and focuses on an audience that is a bit older.

Walking started as a magazine for both men and women, but ultimately evolved into a women's magazine—more than 80 percent of readers are women. The average age is 42, though core readership ranges from 20s to 50s. Interestingly, a high percentage of the magazine's circulation is subscription based, Sergi says, and renewal rates are exceptionally high.

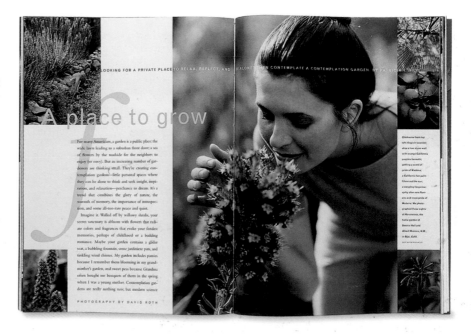

Because she herself fits in the demographics of the magazine's readership, Sergi says she feels confident designing a magazine that she and her friends would like to read. She aims to make pages clean and attractive, but she still enjoys adding twists and going with her gut when making art and type work together.

The design is upbeat; images are energetic and positive, and the writing is light and quick, even in longer articles. "Exercise isn't the most exciting thing for everybody; we have to make it cool for everybody," Sergi says. "We're dealing with a subject matter that doesn't have a down side."

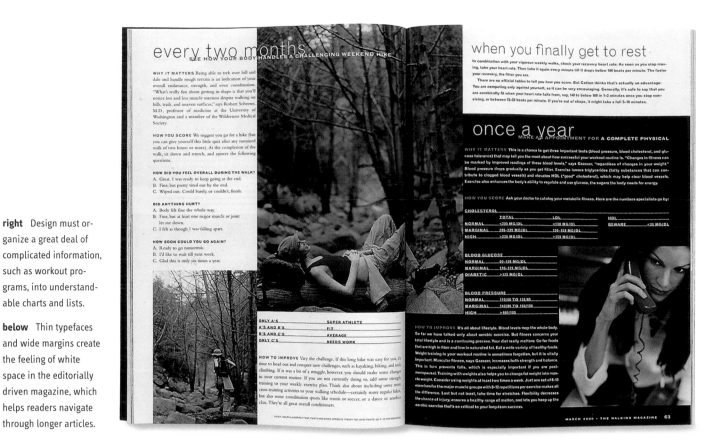

right Design must organize a great deal of complicated information, such as workout programs, into understandable charts and lists.

below Thin typefaces and wide margins create the feeling of white space in the editorially driven magazine, which helps readers navigate through longer articles.

The Illusion of Spaciousness

Getting moving is the point, and *Walking's* design drives it home with articles that flow smoothly from one page to the next. Yet the magazine is never urgent or frenzied. Instead, there's a calm, self-possessed mood among the pages that creates a steady pace.

For instance, Sergi lets the text and photographs, laid out in a loose grid, play off of each other without using devices such as rules, dingbats, or boxes. Instead, she lays out the photographs first and builds type around them, concentrating on the way the two basic elements feel together.

The way she achieves a balance is instinctive, she says. Complicated topics must be easy to understand, calling for frequent sidebars, tables (which are usually white and borderless, leaving an open feeling to pages), and numbered photographs. Editors break up text-heavy

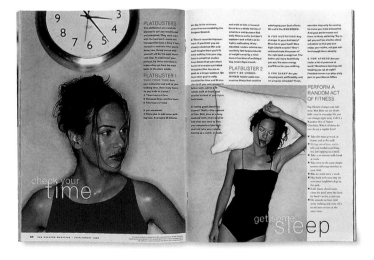

features with subheads, so designers can allow text to flow evenly without chopping it into chunks.

The magazine is actually quite content-heavy, but it doesn't feel that way. Pages are liberal, with wide margins at the tops, edges, and gutters. Sergi plays with spacing, especially in the introductions of articles, so there's breathing room between lines of text. Sidebars and tables don't have borders. Typefaces are open with thin strokes. All of these elements come together to build the illusion that *Walking* cherishes its white space.

left Portraits of models' faces and hands give this article on aging a moving, heartwarming quality.

below Designer Lisa Sergi crops photographs in interesting ways. This portrait of actress Jamie Luner is cut in pieces, sprinkling color and texture across the spread. Such playfulness appeals to the 30- and 40-something female reader.

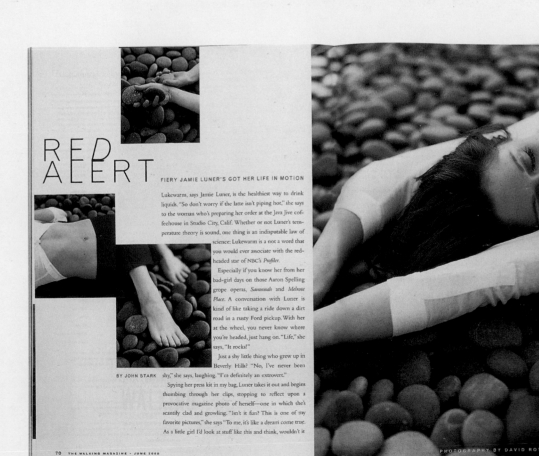

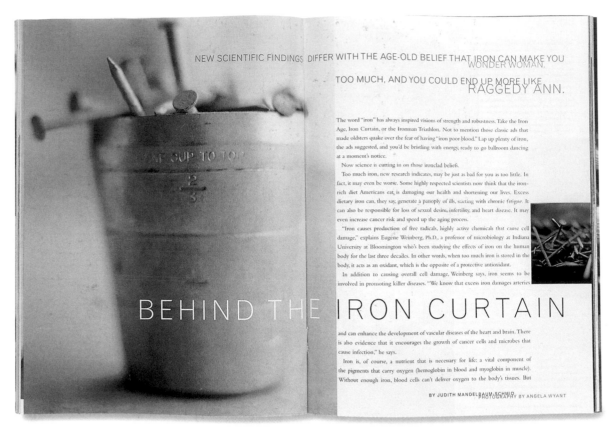

NEW SCIENTIFIC FINDINGS DIFFER WITH THE AGE-OLD BELIEF THAT IRON CAN MAKE YOU WONDER WOMAN.

TOO MUCH, AND YOU COULD END UP MORE LIKE RAGGEDY ANN.

The word "iron" has always inspired visions of strength and robustness. Take the Iron Age, Iron Curtain, or the Ironman Triathlon. Not to mention those classic ads that made oldsters quake over the fear of having "iron poor blood." Lap up plenty of iron, the ads suggested, and you'd be bristling with energy, ready to go ballroom dancing at a moment's notice.

Now science is cutting in on those ironclad beliefs.

Too much iron, new research indicates, may be just as bad for you as too little. In fact, it may even be worse. Some highly respected scientists now think that the iron-rich diet Americans eat, is damaging our health and shortening our lives. Excess dietary iron can, they say, generate a panoply of ills, starting with chronic fatigue. It can also be responsible for loss of sexual desire, infertility, and heart disease. It may even increase cancer risk and speed up the aging process.

"Iron causes production of free radicals, highly active chemicals that cause cell damage," explains Eugene Weinberg, Ph.D., a professor of microbiology at Indiana University at Bloomington who's been studying the effects of iron on the human body for the last three decades. In other words, when too much iron is stored in the body, it acts as an oxidant, which is the opposite of a protective antioxidant.

In addition to causing overall cell damage, Weinberg says, iron seems to be involved in promoting killer diseases. "We know that excess iron damages arteries

BEHIND THE IRON CURTAIN

and can enhance the development of vascular diseases of the heart and brain. There is also evidence that it encourages the growth of cancer cells and microbes that cause infection," he says.

Iron is, of course, a nutrient that is necessary for life: a vital component of the pigments that carry oxygen (hemoglobin in blood and myoglobin in muscle). Without enough iron, blood cells can't deliver oxygen to the body's tissues. But

BY JUDITH MANDELBAUM-SCHMID PHOTOGRAPHY BY ANGELA WYANT

left How do you illustrate a story on iron, a vitamin hidden in vegetables and other foods? Silvery images of nail buckets and frying pans create this exquisite, visually alluring spread.

below Another common technique is to run very different photos side by side. Close movement through a blur of fall leaves balances with a stark black-and-white picture shot from afar.

Playful Use of Images and Type

Meanwhile, the magazine has an interesting, artistic quality that sets it apart from the rest. Sergi thrives on spontaneity when she lays out pages, allowing herself to play a bit with images and type.

On top of its instructional photography, *Walking* commissions noteworthy photographers to illustrate feature pieces on health and well-being topics. Therefore, the magazine often chooses from a selection of captivating portraits.

Sergi sometimes makes the photos even more interesting by cropping them in unexpected places. "We've had a lot of trouble convincing people that it's okay if the top of someone's head is cropped off," she says.

Like many designers, Sergi says she's been influenced by the early 1990s movement toward frenetic magazine design. "There was a time I never would have mixed black and white and color," she says. "But so many barriers aren't there anymore. Magazine design became so avant-garde a few years ago. It really opened some doors."

Type is another playground. *Walking* uses Bembo, a serif face, as text, and either Bembo or Grotesque, a sans serif, for heads and subheads. "They're both big families," Sergi says. The faces range from heavy to light, and she lets the art dictate which styles to use. She may mix styles in a single layout, depending on the tone of the story and how the type looks with the photo. At their heaviest, though, both faces are still lightweight, with interesting features that give them personality. They feel young, trim, and modern.

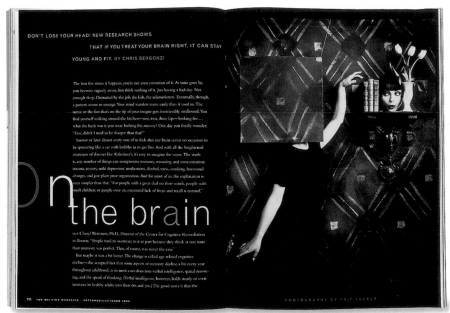

PHOTOGRAPHY BY ERIC TUCKER

below Another example of unusual cropping: Two angles of the same fruit salad illustrate the regular food feature.

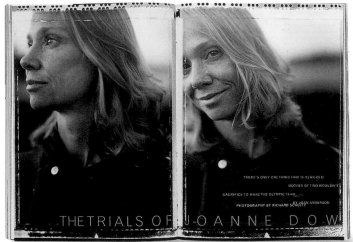

As with photos, the use of type is unpredictable. Text may butt against the borders of sidebar boxes or even against the edges of pages. Pull quotes may jut into columns of text or float, unjustified, over pictures. But it's never disruptive; instead, it adds a perfect bit of tilt to pages. And Sergi draws a strict line between art and type; she rarely adds color to text, let alone dresses it up to become part of the illustration.

In fact, there isn't a great deal of color in the magazine. When Sergi does use color, such as on the cover and in departments, she leans toward monochromatic variations—several shades of blue rather than blue mixed with yellows and reds, for example. *Walking* doesn't have a palette to speak of, though the magazine tends to pick up muted, pretty colors, including soft pastels, subdued reds, and sophisticated browns and beiges.

Complementary colors and contrasting typefaces merge on the magazine's cover, another place where experimental layout is at work. In fact, this is espe-

cially true for the cover, which had grown apart from the rest of the magazine. For two years, *Walking* always placed a celebrity on its cover to boost newsstand sales. "It had the potential to get monotonous," Sergi says. "We wanted to make the cover more like the inside of the magazine, a little more natural and interesting."

Because *Walking* doesn't rely on newsstand sales for its circulation, the magazine decided it could get away with trying new ideas on its face. Cover shots in late 2000 issues toy with showing celebrities in outdoor environments.

Walking's constant experimentation with design, as well as its comfortable understanding of its audience, produces a magazine that is tasteful, artistic, yet smooth and well-organized—truly a departure from one's expectation of sporty fitness magazines.

top and above Sergi mixes black-and-white photography into the colorful world of fitness. The reversed type accentuates a kooky staged photograph (top) for a startling effect, while softer contrast in the portrait (above) provides an emotional texture.

Evolution of a Magazine

The way a magazine's design changes over its life can be a sign of the times—a reflection of trendy fonts and colors or developments in printing technology, for example.

But publication insiders know that a magazine's evolution also reflects more personal development. The comings and goings of editors, publishers, and art directors, gradual shifts in audiences' needs, changing ownership of publishing companies, and the magazine's financial growth or decline have a great impact on how each magazine looks from year to year.

Magazine staffers may look back proudly over the work and love poured into their publication over its history, whether it's one year old or 50. But they also may shake their heads in amazement at how far they've come.

Here's a look at three magazines and how they've changed over their lives.

above Early *Yoga Journal* covers, such as this one in 1988, concentrated on personalities and illustration of new-age issues rather than yoga itself, a reflection of the magazine's editorial mission.

above As the magazine encompassed a wider range of new-age topics and readership grew, layouts became more high concept. On this 1998 cover, a model poses against a blurred background of moving people.

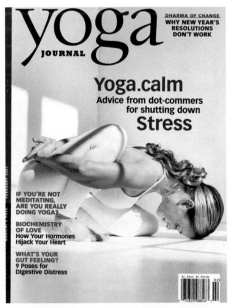

above After a redesign in 2000, yoga once again took center stage. Photographs of people posed against plain backgrounds create a natural balance and movement for covers.

Yoga Journal

New Age Reader to Slick Consumer Health Magazine

When *Yoga Journal* was launched in 1975, yoga was a fringe practice in the United States, generally reserved for the truly spiritual.

A mouthpiece of the California Yoga Teachers Association for more than 20 years, the magazine was a modest affair in its first decade. Pages were black-and-white and no-frills, laid out in simple grids with little variation in the placement of headlines, photos, and captions.

Because *Yoga Journal* catered to a specialized audience with many common interests besides yoga, however, the magazine's singular focus unraveled. "The subject matter strayed far afield," says editor in chief

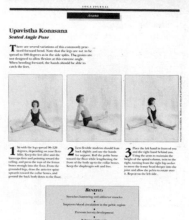

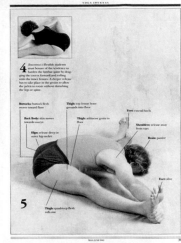

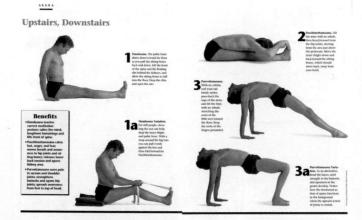

Kathryn Arnold. "It covered new-age topics of all kinds, reaching out to a readership of cultural creatives." As the magazine's topics branched out and attracted more readers, design became more complex. Artists began taking more liberty with page design, breaking away from simple columns of text running around photo boxes and using color.

By 1998, the magazine's nonprofit owners decided to sell *Yoga Journal* to a publishing company, and newly available resources helped the magazine grow. Editors and designers revisited the publication's purpose. In recent years, yoga had become an American lifestyle—more as exercise than spiritual expression.

It made sense, therefore, that *Yoga Journal* should once again focus on the topic that started it all. "We had to make the magazine accessible, editorially and visually, to attract a broader audience," says design director Jonathan Wieder.

The relaunch of *Yoga Journal* in 2000 included a redesign that accentuated yoga. On the covers, graceful yoga positions speak for themselves without backgrounds or novelty fonts. Inside, instructional and inspirational photographs drive the book's simple, natural flow. Pages changed from glossy to matte for a more modern look and to better represent photographs.

The pure, serene covers help *Yoga Journal* stand out against more cluttered faces on the newsstand, which, along with a new direct-mail marketing campaign and the nation's overall obsession with yoga, has driven readership. Subscriptions rose 50 percent between 1999 and 2000.

above Departments and features were still running in black and white in 1990, including the "Asana" section on beginning yoga poses. Pages were generally two- or three-grid layouts with text wrapped around boxed photographs.

left above Designs began to transcend their usual boundaries. For instance, photographs of poses in the "Asana" section moved out of their small boxes to help balance of the department's two pages.

left below A constant throughout *Yoga Journal's* changing history, the "Asana" department came into its own with the redesign. Richly colorful photographs of bending, flowing shapes create effective negative space, which helps balance pages.

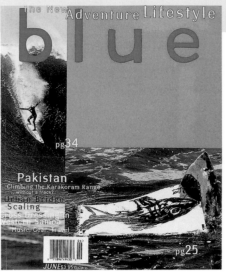

the New Adventure Lifestyle
blue
pg34
Pakistan
Climbing the Karakoram Range
without a trace?
Urban Bridge
Scaling
Cross Dressing in
Western Samoa
Music, Gear, Travel
JUNE $3.95
pg25

left An early cover is a grid of interesting images and blocked color.

Readers also clamored for larger pictures, so although *Blue* still experiments with cropping and sizing, it allows some gorgeous images to spread their wings across entire pages. This is also noticeable on the covers, which began to feature strong, single images as time passed.

Blue's trademark is its use of boxes to contain text or simply add a mark of color. This is another trait that's matured since the magazine's inception, developing from choppy, awkward squares to natural inserts that facilitate an easy dialog with the reader.

The alterations to *Blue's* design satisfied the demands of readers and attracted new ones. Newsstand sales immediately shot up 10% when the magazine introduced its first cover using the "more commercial approach"—literal adventure subject matter combined with innovative graphics, according to editor in chief Amy Schrier.

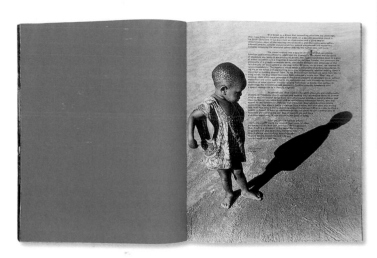

above The first issue of *Blue* reinforced its theme with symbolic images, such as this all-blue letter from the editor. Type was tiny and sometimes illegible against color or images in the background.

Blue

Experimental Puzzle to Adventurous, Attractive Layout

Blue emerged during a monumental era in magazine design—the mid-1990s, which birthed the transcendent pages of such magazines as *Wired* and *Raygun*. The travel magazine's founding art director was David Carson, the famous magazine designer (and *Raygun* art director), known for his experimental use of text.

True to this model, *Blue's* layouts always pushed boundaries. Text boxes shoved and jutted into each other, while type lay against light images, and photos were reduced to tiny slivers. Crazed pages fit with uneven pieces were followed by startlingly lucid layouts. Just like the best adventures, pages always kept readers guessing—even if they were also squinting to read type.

"If you look at the first issues, you will see type that is too small to read and text is running over images, which also challenged readability," says art director Christa Skinner. *Blue* even defied such conventions as folios, so readers had a hard time finding articles from the table of contents.

The magazine won several awards for its groundbreaking design, but some readers complained that it was hard to read. In *Blue's* second issue, Skinner made a few changes, such as incorporating page numbers into the middle of layouts. By the next few issues, care had been taken to make text legible while still allowing it to subvert the norm.

below Legibility became a priority. Here, dark blue contrasts with the white spray of the surf image and the black body copy; lighter blue department heads stand out from the darker part of the photo.

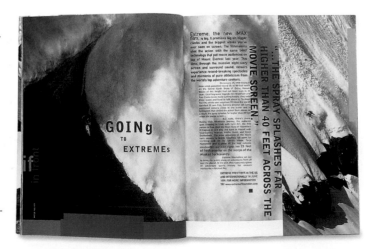

GOINg TO EXTREMEs

"...THE SPRAY SPLASHES FAR HIGHER THAN 40 FEET ACROSS THE MOVIE SCREEN."

right Single spectacular images found their way onto *Blue's* covers in later issues.

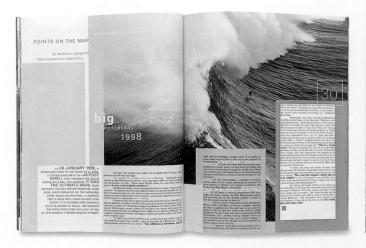

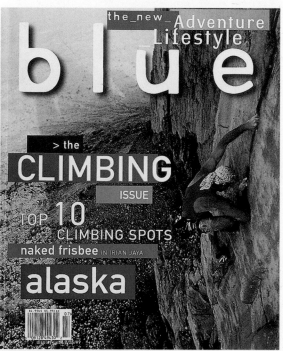

above Early use of boxes was choppy.

right In more recent issues, the boxes have come into their own and are now a modern, elegant feature of the layout.

Code

Busy and Bright to Suave and Sophisticated

Code is a good example of how a brand-new magazine finds itself during its first years of publication. Debuting in mid-1999, the magazine was passed among creative directors before finally arriving at its final look—for the time being, at least.

In its first several issues, the magazine alternated between wild breakouts of color and sleek, conservative layouts. The front-of-the-book department, "Decode," was perhaps the most experimental. It used cut-out colored text boxes against images or different colored backgrounds and bright layers of color behind entire pages. Type varied from a smooth sans serif to a serif with extremely tight leading. Pages were busy, bright, and varied.

The well stuck to black and white, with two columns of body copy and beautiful full-page fashion shoots. Features experimented with type, to some extent, but usually stayed with a tiny serif face. Back departments also evolved from a simple two-column format to pages surrounded by heavy double black rules.

In the summer of 2000, a new creative director stepped in and altered the magazine's look. Patterned after European style for a hipper, younger look, the new design wiped out the frenetic color in the front of the magazine and replaced it with clean pages, lots of white space, and a chunky all-caps sans-serif typeface. The back of the book shed the smothering black border and used thinner, open-ended rules.

above Early issues of *Code* frequently experimented with type. In this profile of actor Forest Whitaker, font size, color, leading, and style are all over the board throughout the body of the article.

above Tabs of color behind headlines and body copy were characteristic of the department "Decode," the section in the front of the book, in *Code's* first issues.

left Designers began sectioning off back-of-the-book departments with heavy double rules along the margins.

Finally, in early fall, creative director Charlie Hess took over and redesigned again, this time for good. "All the sections of the book were kind of getting lost, so they needed to be defined and give a presence," Hess says.

Hess and the design staff boiled down the fonts to a handful of mature but casual and distinctive fonts. The clean, sophisticated look of the previous redesign remained, with a commitment to neat white pages with tasteful touches of color, cool photography, and playful illustrations. The back and front of the book got the most attention. "Decode," the front department, was set apart with a sans-serif typeface, wide margins, and a hip, clubby look. Back departments fell into identical templates, with a heavy side rule distinguishing them from the rest of the book.

The many changes made little difference in the magazine's acceptance by consumers and the publishing industry, though—in summer 2000, in the midst of all the tweaking, *Code* walked away with four Maggie awards, not the least of which was Best Overall Design/Consumer.

decode
PROFILE

IN SEARCH OF PAUL BEATTY

HIS OBSERVATIONS ON RACE IN CONTEMPORARY SOCIETY ARE SO PROFOUND THAT LAKERS COACH PHIL JACKSON PASSES THEM ON TO HIS PLAYERS. WHO IS THE PAUL BEHIND THE PROSE? BY ADELE SLAUGHTER

IT'S ONE O'CLOCK. THE PHONE RINGS IN PAUL BEATTY'S NEW York apartment. He crosses the floor and reaches his long arm for the receiver. "Hello," he murmurs, worried, to the voice of a reporter he has never met. His pad is void of background noise; no television set. The voice asks a brief, polite opening question.

Just short of six feet tall, Beatty pauses, as if rubbing his shaved head. He feels off-kilter talking to reporters. Especially an unseen one, with a disembodied voice. But he has already agreed to this interview. Frequently, brilliant writers are kind of stiff, even though their written language is rich and exuberant. Paul Beatty does not disappoint.

After writing two books of poetry, Beatty emerged onto the literary scene with *The White Boy Shuffle* (Houghton Mifflin Co.) in 1996. It was a well-received first novel, and got reviews in the *New York Times*, the *Los Angeles Times* and the *Nation*.

In May of 2000, his second novel, *Tuff* (Alfred A. Knopf), hit

bookshelves. It's a picaresque work of Twainian wit, whose 320-pound teenage hero roams Spanish Harlem, taking on parenthood, identity politics, Japanese film, fast food and sumo wrestling.

Beatty is a genius. At least that's what writers such as Alan Cheuse, Jessica Hagedorn and E. Ethelbert Miller assert. *He* is far too humble to make such a claim. His work is, however, undeniably funny. His influences seem to come from the likes of Ishmael Reed and Richard Pryor. Beatty's work is like the comics—*Boondocks*, perhaps—or maybe it's like Chris Rock writing a novel.

Asked how he feels about the media today, Beatty pulls no punches. "On the whole, most journalists are lazy. Everything's soup of the day," he says. "Everything's written the same way. You could substitute skateboarding for poetry and it wouldn't make a difference. At the same time, there is a lot of good investigative journalism. Some of these live TV documentary shows are kinda good, I have to say. They're a little less manufactured than the things you get on the news."

The voice clears its throat, perhaps in a spot.

20 CODE JULY 2000

top right In the summer of 2000, "Decode" got a new look, with department heads that changed colors according to the department section.

right A change in art direction prompted a younger look. Type on the July 2000 cover was chunkier and metallic, with playful plus signs and hyphens to spice it up.

right Finally settling comfortably into its design, *Code* adopted a limited lineup of typefaces, including this sophisticated sans serif used on the November 2000 cover.

Travel & Leisure

A Picturesque Guide to Luxury Travel

When people are young, they dream of the things they'll have when they grow older: a nice house, luxury car, perhaps a boat or farm or other place to escape to when the daily grind overwhelms them. Inevitably, exotic vacations become part of the fantasy. Whether it's an amenities-rich villa in Italy or a tropical beach on an island, many adults save for the day when they can discover the finer things beyond the borders of their own town.

Travel & Leisure fuels this wanderlust. American Express's travel magazine presents travelogs of trips to places that are attainable, yet dreamlike and gorgeous.

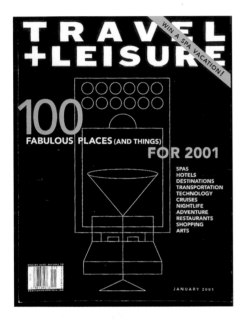

above Covers usually feature photographs from stories but, for the January 2001 issue, simple line art became a cosmopolitan introduction to *Travel & Leisure's* new millennium. Modern type and illustrations appeal to affluent, image-minded readers.

above Breathtaking scenes and vistas open most issues. Here, the awe-inspiring size and hush of a Marrakesh hall acts as a gateway to the June 2000 issue.

above In this issue, on the other hand, the photographer draws back for an aerial shot of a seascape in southern France.

WHY IT WORKS:

Spectacular photographic collages tell the intriguing stories and fire readers' imaginations. A simple layout sets a quiet and marked pace that reminds readers it's time to slow down.

Adventure with Luxury

The magazine's audience is educated, affluent, and an average of 45 years old—a crowd that may be adventurous but still appreciates comfort and luxury, says creative director Pamela Berry.

"We pick places that are realistic to go to," she says. "We wouldn't do a profile on a sacred trek through Bhutan." Instead, features are focused on how readers can fill their days and nights during trips to cities and tourist-friendly countryside—Canada's Gulf Islands, the south of France, the small towns of England. Emphasizing self-guided trips rather than bus tours or

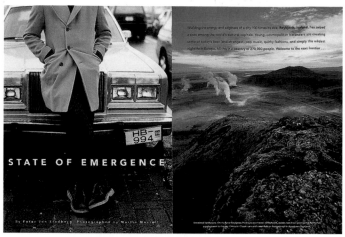

package deals, articles often twist together the author's own experience with the usual information about accommodations and food.

The *Travel & Leisure* crowd is also one that cares a great deal about what's fashionable and stylish. "There's a big style aspect to the magazine," Berry says. Of course, its just as important to impress others with your tales and photos of original vacation spots as it is to enjoy the places while you're there, so places that are luxurious but still off the beaten path are favorites of these readers.

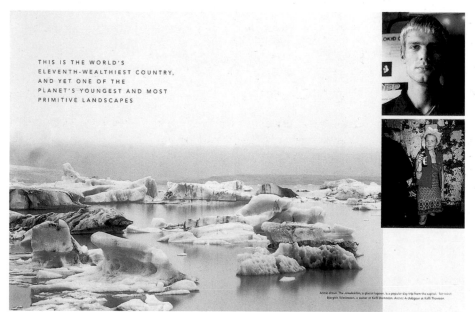

above , center, and left
Creative director Pamela Berry is quick to point out that feature layouts come in packages—they generally span six to eight pages and don't allow for fractionals. Images prevail even beyond the first couple of spreads. In this feature on Iceland, photos run the gamut from scenes of the picturesque, secluded countryside to warm, vibrant images of city life.

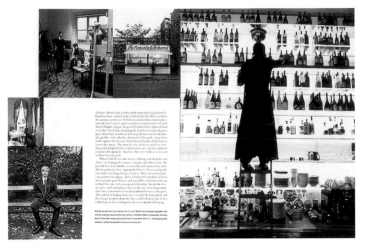

Intermingled with these are equally beautiful and interesting perspectives: the fish offered at an outdoor market in Marseilles, a cactus fence in Costa Rica, surfboards stacked against a palm tree in Honolulu.

Photo essays never fail to include people, whether they're models running through fields or swimming in pools or locals posing for the camera. The human factor gives the magazine its personal touch, allowing readers to more readily imagine themselves in similar scenarios.

Building the Dream

The design must therefore be modern and fresh but retain a folksy feeling that suggests a personalized experience. Berry relies heavily on photographs to create this balance—in fact, to dictate most of the magazine's look and feel. "We let the pictures speak for themselves," she says. "I let photographers do most of the work, because this magazine is about the dream of the images."

Travel & Leisure turns to a versatile cadre of photographers to shoot its breathtaking scenes, using travel photographers but also hiring professionals specializing in fashion and other disciplines. This allows the magazine not only to break the mold of traditional travel photography but also to stay in tune with style.

A typical travelog may include remarkable bird's-eye views of a town, a corner of masterful architecture, or a cloudless blue sky behind a mountainous landscape.

next great neighborhoods

It starts with a whisper and crescendoes to a buzz …

These four up-and-coming districts—in Tokyo, Sydney, Chicago, and London—are suddenly the talk of the town

photographed by marie hennechart

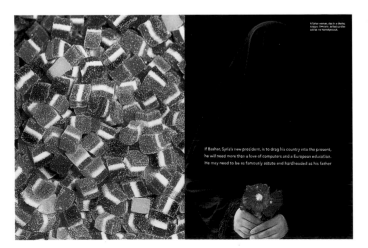

THE BEST OF
madrid

by anya von bremzen photographed by martin morrell

In the mood for Madrid: dancing in guest room 109 at the Hotel AC Santo Mauro, a 19th-century palace that is now a celebrity retreat. Opposite: A view down Madrid's Calle Goya.

left and below Another example of the packaging of features, this article on Madrid dedicates four full pages to photographs, while smaller images dominate the rest of the pages. Body text in these spreads is limited, though feature articles are often longer.

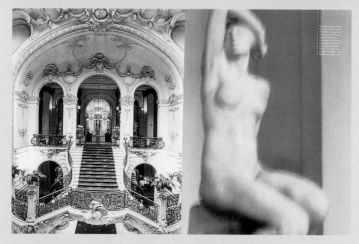

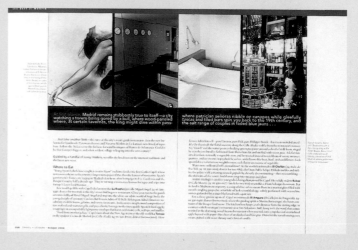

Photographic Emphasis

Luscious, full-page photos often open feature spreads, but within articles and departments, a patchwork of smaller photos marches across pages. The format creates a visual array, but it originated largely for utilitarian reasons.

"Our wonderful photography is great and difficult at the same time," Berry says. "It's so exciting the first time a box of photographs comes in from a photographer. There are so many good shots, you could make a book! It's hard to condense it into a few pictures."

That's why every picture is as captivating as the next. The photographs are festive with color, light, and detail. Light plays off the deep red and pale green of furniture, fruits, and flower arrangements in a collage of photos from Japan; landscapes blur wildly in an article about driving through Costa Rica. Black-and-white shots contrast dramatically from softer color images.

To give photographs the most play, Berry refrains from overdesigning the rest of the magazine. "I try to maintain a consistency in the design," she says. "I don't encourage a different way of seeing things through design but instead let the photographs do the work."

Designers rely on a basic grid and try to keep pages as clean as possible. Berry uses as much white space as possible to achieve this, often surrounding photographs, though her ability to use a great deal of it is limited by the thin paper *Travel & Leisure* is printed on. "We get a lot of see-through," she says.

The magazine doesn't try to add too much color to the already bright photo montages; the occasional subhead, drop cap, or pull quote may contain a touch of color, but that's about as far as it goes. Photographs are often detailed, and the addition of color would put pages at risk of looking too busy, Berry explains.

above An opening spread for a story on Kyoto conveys serenity and painstaking beauty with ethereally lighted photos, slightly out of focus. *Travel & Leisure* recreates the mood of a place through photographic layout.

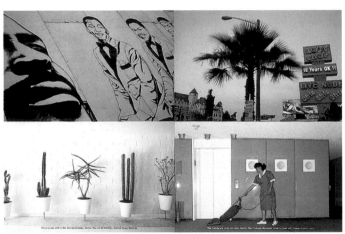

above To recreate a mood, designers stack images from a photographer's shoot on top of and against each other. Here, a mural of the Standard Hotel's history combines with images of its orderly interior, seedy exterior, and daily life.

right Sometimes there are so many great photographs of a subject that designers have a hard time choosing, which is how the checkerboard technique common in *Travel & Leisure* came to be.

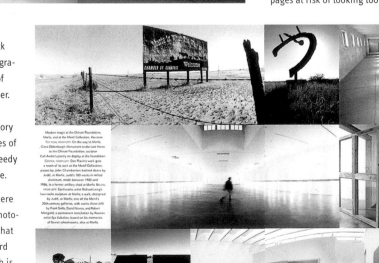

in the 1920's, the french novelist fell in love with the côte d'azur and
with a much younger man. you can still find the house they bought
in the hills above st.-tropez—and the mountain villages, brilliant
colors, and secluded coves that so seduced her by judith thurman

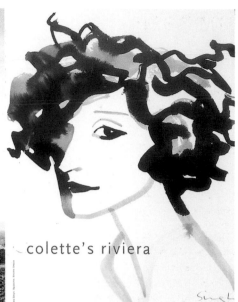

colette's riviera

left A mood of romance
and intrigue is set by this
opening spread, a barren
black-and-white scene
set against the generous
brushstrokes of a retro-
style painting.

Modern Type and Personality

One section is set apart by an innovative use of the
black-on-white motif. The middle of the magazine
houses the "Update" section, a news analysis of issues
surrounding travel or other countries. To give this sec-
tion a more serious tone and to invoke the look of
newsprint, designers surround the articles with black
rules of various weights.

"It's the only section in the magazine that isn't about
what to buy or where to shop," Berry says. "It's about
what's happening in Lebanon, for example. [The black
rules are] an attempt to make it more newsy."

The rest of the pages, though, are simple layouts of
columns of text on pure white pages. A custom-designed
serif face provides a delicate touch to body text. Sans-
serif fonts such as Interstate and Meta express the
magazine's personality. "We were looking for some-
thing fun," Berry says.

Similarly, the magazine's newly redesigned logo helps
set *Travel & Leisure's* modern tone. Wide and chunky
block letters stretch across the page, with a plus sign

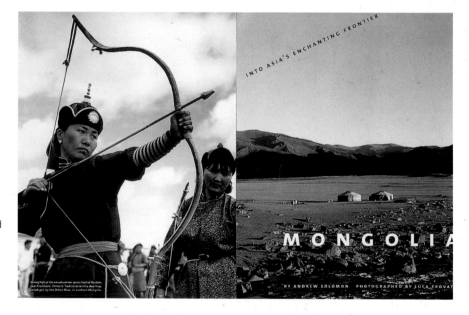

substituted for the old ampersand. Berry notes that the
new logo is "a little more modern, and it pops out on
the newsstand."

Travel & Leisure caters to a range of travel-happy
readers, from dreamers who want to let their imagina-
tions run wild to sophisticated travelers who aren't
easily bowled over. The design serves them well with
tasteful, modern elements and a photoscape that ful-
fills their most exquisite travel fantasies.

above Though type
and graphics are usually
straightforward, occa-
sionally designers be-
come playful. In this
opener for an article on
Mongolia, the deck on
the right-hand page tilts
toward the subject's
arrow on the left.

Blue

The Adventurer's Travel Magazine

For some people, nothing is daunting. They're the ones you see on TV commercials plowing through rivers of mud on mountain bikes and hanging from the sides of rugged cliffs. *Blue* was created for these adventurers—or those who aspire to be them.

The travel magazine's design never rests, yet, since its birth in 1997, *Blue* has learned to balance its daring design with the need to be legible and accessible to readers. The result is a controlled chaos of sorts, a boundless exploration without getting lost in the forest.

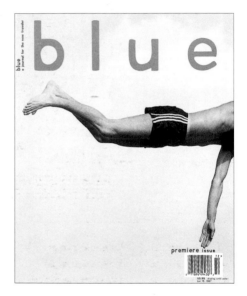

above *Blue's* is about freedom and exploration. The photograph on its first cover suggested readers should dive in without seeing what's ahead—an unconventional approach for a travel magazine. The cover prompted sales 200 percent higher than average launches.

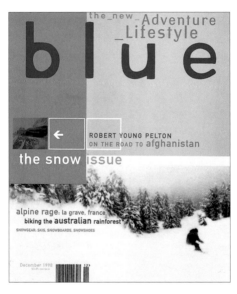

above This cover combined a blurred skiing shot and icy blue boxes. A tiny, dark photograph of trucks would blend into the background if not for the boxed arrow directing attention its way.

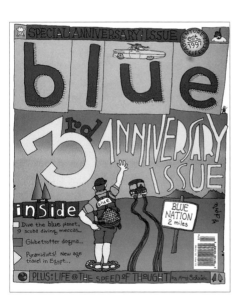

above Hobo artist Dan Price adds a folksy, cartoonish slant with his hand-lettered designs. He designed the cover for the magazine's third anniversary issue.

WHY IT WORKS:

Pages are exhilarating, edgy, and alive with color. Around every corner is an unexpected perspective; every space is assigned an unconventional purpose. Layouts play off images rather than merely incorporating them. Like its readers, *Blue* is constantly pushing the limits.

right There's no dull moments in layouts like this one for a focus on Alaska. Photos run together and overlap, boxes contain bits of text, and empty spaces become cells of color that project the article's mood.

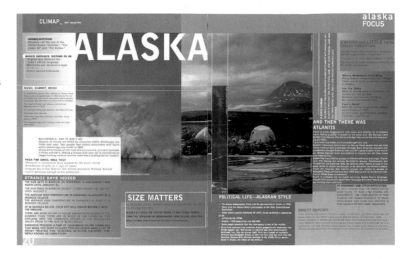

The Adventure Generation

Blue's philosophy is that space, despite what science fiction fans believe, is not necessarily the final frontier—there are plenty of adventures to be had right here on our own planet. A metaphor for "blue sky, blue sea, blue planet," *Blue* aims to inspire its already ambitious readers with tales of thrilling expeditions into barely chartered territories.

The magazine targets 19- to 35-year-old readers who aren't interested in the mainstream options that were available to previous generations. When they travel, they're less likely to choose a French getaway with the finest champagne and the most luxurious hotel, says publisher and editor in chief Amy Schrier.

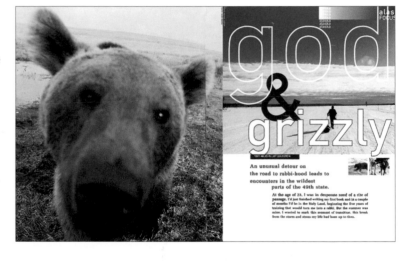

Instead, they're more aware of their access to remote locations and choose to get there in less conventional ways—hiking, biking, kayaking, and camping their way through Malaysia or Peru instead of riding tour buses and staying at inns recommended by the guidebooks.

Design plays a critical role in speaking to these readers. "If you look at other titles in the travel category, you see them in traditional columns of type with rigid photography," says Schrier. Pages are usually white and clean, and photographs depict blue skies, friendly environments, exquisitely prepared feasts, and charming, peaceful settings. This formula has little to do with the way *Blue's* readers view their own adventures.

"We wanted to bring the travel experience to life," Schrier says. "The pages had to recreate the intensity and freedom of traveling."

above Photographs aren't always the distant, technically perfect achievements they are in other magazines. Sometimes out of focus, motion-blurred, grainy, or dark, they portray a realistic, imperfect view of adventure.

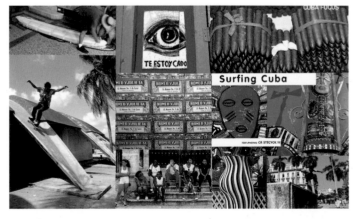

above Assembling photographs of very different subjects and in varying styles builds off-balance, stunning montages, such as in this article on Cuba.

Flexible, Frenetic Layout

Transmitting the vicarious thrill of adventure travel through design is a twofold process. "On one hand, we have to convey the frenzy of travel," says Schrier. "On the other, we try to provide a crystal-clear, fresh view, a clean window to the world."

At first glance, the frenetic vision seems to be uppermost. Layouts are packed with stacked photographs, overlapping boxes, changing typefaces, and experimental dingbats. Varying shades of color fill empty areas, eliminating romantic notions of white space. The pages buzz with a nonchalant energy and the awareness that rules, in travel, design, and life, are meant to be broken.

Blue has never used a grid. "Every page is a hand-done page," says Schrier. Design ideas begin at a meeting between Schrier and art director Christa Skinner, who designs about 90 percent of the pages herself. By starting from scratch, Skinner can run with ideas inspired by the stories and artwork. "It slows me down, but also allows for more flexibility and surprises in the layout," she says.

For example, Skinner may pick up a shape in a photograph and repeat it graphically, as in a story on the Egyptian pyramids that overlaps perpendicular triangles and multiple photos of the architectural wonders in the desert. Photographs are repeated, cropped for a different perspective, or sliced into pieces and spread intermittently among other images. A single color in a photograph, such as the green of a surfboard in an otherwise white and brown surfing shot, is picked up and used in boxes and banners throughout the rest of the layout.

At *Blue's* inception, defiance of convention was a bit more extreme. Type was tiny and ran over images, which made it hard to read. Even page numbers were eliminated. The magazine earned a reputation for illegibility. In response to reader feedback, more recent issues are subversive and energetic while still making sense.

"It's a tough problem to solve, keeping it from being too boring," Skinner says. "Everyone is trying to be so simple. I don't think it is *Blue's* place to jump on the simple bandwagon due to its subject matter. *Blue* is about energy, exploration, mystery, and fun."

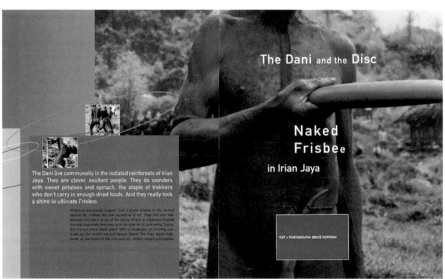

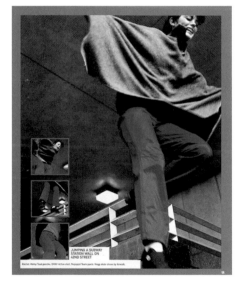

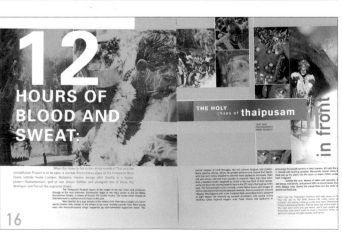

top left Photos also get up close and personal, as in this layout for an article on a rainforest tribe.

top right In an unusual approach to fashion shoots, this layout shows models of sports gear in action.

left Once again, unusually cropped photos are sprinkled across a layout for a constantly changing perspective.

below Without a grid, art director Christa Skinner can surprise herself with sudden ideas. She begins with the photographs and builds layouts around them.

right Another fashion layout shows the clothes in action.

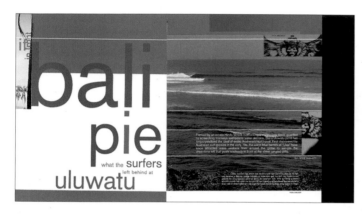

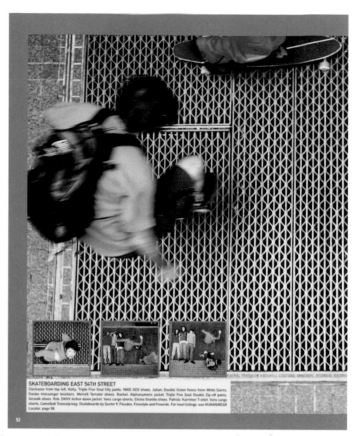

Boxed Text for Legibility

One way *Blue* solves the readability problem is with its habitual use of boxes. Text boxes, often laid over photographs or each other, stack together to make up entire articles. They're useful as captions, as labels for maps, or even as a way to break up paragraphs in stories.

The box technique emerged naturally as a way to communicate to the Internet generation, says Schrier. "We've been compared to a Web site, but we did it instinctively."

"It's a good way to get text and a lot of color on a page," says Skinner. "I began doing it early on and have continued as part of the *Blue* look."

Boxes are stacked with photos of all sizes to create a sort of montage. The magazine doesn't buy into the idyllic idea of letting stunning, blown-up images speak for themselves; there are too many other things to see. A scenic mountaintop view may border a grungy closeup of a mud-splattered mountain bike. When a colorful ocean floor or gorgeous sunset is given prominence on a page, it isn't allowed to steal the spotlight. A series of tiny action shots or whimsical graphic dingbats may be laid over it.

Text frequently is layered over photos too. Pages mix a variety of typefaces and colors; Skinner likes to experiment with many fonts, often within single layouts. Occasionally, headlines, captions, callouts, and even body text is contained in boxes or long strips filled with colors, which suggests the photos have been labeled. Pages hum with activity while emphasizing important text, which keeps the pages readable.

Rugged, Realistic Photography

In the midst of the controlled chaos, *Blue* also tries to provide moments of lucidity. The magazine's window on the world is its photography, from panoramic landscapes to in-the-trenches action shots. Photographs never fail to offer an unusual perspective: the underside of a school of fish or the bottom of a surfer's upturned board, a runner's legs, the shadows of people on the wall of a cave.

Interestingly, while the images are beautiful in their own way, they are rarely the technically perfect photos so prominent in other travel magazines. They're often grainy, sometimes dark and out of focus; occasionally, they're even magnified for intentional blurriness. But they may run alongside crisp and richly colorful photos that more conventional magazines would covet, exhibiting the magazine's wide range.

The technique helps the magazine look gritty and in the moment, a realistic approach to depicting trips that aren't always clean, pleasant, and uneventful. The photography reflects travel that is rugged and high-impact while allowing for moments of deep breaths and exquisite clarity.

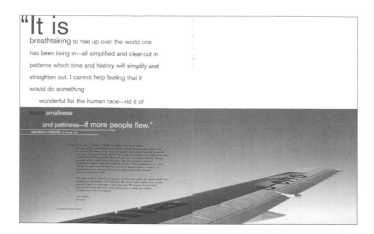

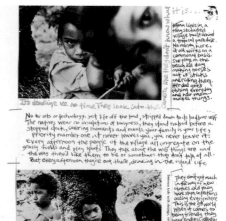

top This letter from the editor illustrates a rare moment of quiet simplicity, yet the curiously cropped airplane wing gives the layout a twist.

right Layered images are plotted over a map of the world in the table of contents.

far right Hand lettering is used to convey a critical tone in this journal-like article on Samoa.

CONT[in]ENTS_

IN FRONT _12
Bali Pie: What the Surfers
Left Behind at Uluwatu, Indonesia
Twelve Hours of Blood and Sweat: Caught up in the
Fervor of Malaysia's Thaipusam Festival

TRIPS _18
WHEN PASSIVE OBSERVATION IS NOT ENOUGH
Dive into the blue planet.

ASPHALT _66
DECIDE TO RIDE
It's time to dust off a timeless piece of cool.
by Tim Parr

Blue occasionally complements photography with illustrations. Maps are a significant part of the magazine's mission. Readers can step away for a moment from the impact of in-your-face photographs and get a wider, more grounded view of a place from an illustrated map. They play such an integral role in design that maps of the world are always used in the background of the magazine's table of contents.

Other illustrations may encompass entire articles. One regular contributor is Dan Price, a so-called hobo artist who hand-prints the text of articles alongside fanciful sketches as if he's writing in a travel journal. The illustrations add a folksiness to the magazine.

The use of color is another way *Blue* expresses a clear vision. "In many ways, *Blue* is about color," says Schrier. Shades range from nature-inspired tones to magnificent, original blends that Skinner invents herself.

"I don't have a particular palette in place," says Skinner, "But I often use a lot of blues, greens, and yellows, usually many shades of one color throughout an individual article. I usually try to match the majority of the photographs and let that decide."

Color itself is a great communicator. "Color is important because it gives each article an identity of its own," Skinner says. "It gives it a mood, sometimes more energy than the photos provide alone." The result is so stunning, it reminds readers of one of the simple truths of travel: that most things seem more beautiful when viewed from a fresh perspective. In pursuing that truth, *Blue* has designed a magazine that's wide awake, exciting, and true-to-life.

Advertising Age

The most conflicted relationship in magazine publishing is the one between advertising and editorial. Journalism professors and old-school editors preach the separation of church and state, struggling day in and day out to remain objective in the face of financial sponsorship.

Yet it's hard to ignore the fact that magazines depend on advertisers to stay alive. Though subscriptions and newsstand sales remain crucial, staggering circulation costs dilute this income. So unless readers are willing to support the magazine's cause with expensive annual subscriptions (as in the case of *Ms.* and *Adbusters,* socially aware titles that shun advertising's influence), advertising is a necessary ally—or evil, depending on how you look at it.

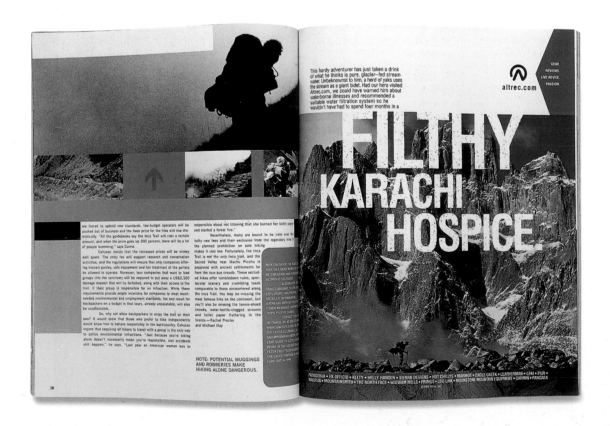

Advertising's Influence

With ads, magazines constantly have to draw the line in the sand between customer satisfaction and editorial integrity. But without ads, they may be forced to cut back on the resources used to establish that integrity. Look, for instance, at the case of new economy business magazines such as *Red Herring*, which was forced to lay off reporters, designers, and editors when its high-tech advertisers started tightening their purse strings.

One issue rarely addressed in journalism schools is the effect advertising has on a magazine's look and feel. Art directors at trade magazines and smaller journals grapple with this problem often, usually because their sales teams tend to sell a large number of fractional ads, or ads that take up only a quarter or half of the page, to lower-budget advertisers in order to serve a targeted industry or niche. But even high-powered titles face the concern. What happens when a valued advertiser places an ugly ad? When an ad contrasts sharply with the layout on the facing page?

The designers and art directors interviewed for this book differ in their approach to the advertising-design challenge. Some develop elaborate philosophies about it; others deal with it on the fly. But they are almost all alike in that they rarely leave the result to chance.

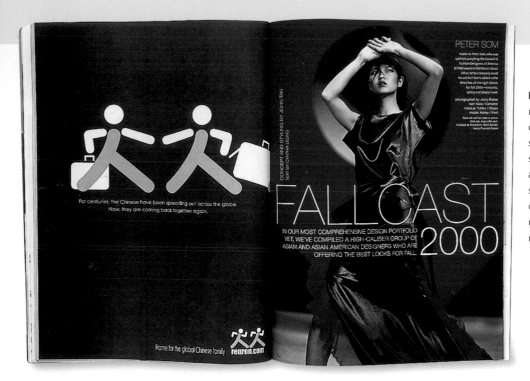

Staying Involved in Ad Placement

Many designers, at the very least, work a glance-over of the magazine into their production process. This involves close cooperation with the ad production department, not only because ads often come in at the last minute and are often placed in layouts last but also because the placement of ads is a sensitive issue.

"We look at the ads and see how they'll look against an article," says Dina Gan, editor in chief of *A*. "Some companies only want to be in the front of the book. Advertisers have their own concerns. Some ads aren't the prettiest in the world, and if they're really bad, we may request a different ad."

Other editors monitor ads closely so they can staunchly defend the magazine's brand. *Surface*, for example, positions itself as a magazine that's so far ahead of the design and fashion curve that it doesn't need to stoop to trendy or novelty concepts. "We need to set a certain tone in order to stay in the black," says

Riley John-donnell, the magazine's co-publisher and co-creative director.

If an advertiser submits an ad that's not in line with this tone, the magazine may turn it away. "We draw the line at anything offensive," says John-donnell. "Those kinds of things are visually not helping the client. Sometimes younger advertisers go for shock value, either visually or contentwise. They're trying to be cutting edge."

left and below *Yoga Journal* makes an effort to use attractive full-page ads in the front of the book, reserving the back for fractionals.

In the case of *Yoga Journal,* revising the ad layout policy helped the magazine take a big step toward reinventing a visual brand. The 25-year-old magazine had evolved into a new-age journal with dozens of fractionals—many of which were black-and-white ads for environmental products or health foods—scattered throughout the book. As part of the redesign, art director Jonathan Wieder elected to move all fractionals to the back of the book. "This allows us to group the best-looking ads toward the front," he says.

This policy contributed to the magazine's attempt, with its elegant redesign, to develop a broader consumer scope. "It wouldn't do us any good to backslide in terms of design," Wieder says. "A number of advertisers have even created new ads and come up with new ideas based on our new look."

Working in Harmony

Wieder isn't the only designer who sees advertisers changing their strategies based on the magazine's look. "Advertisers imitate us, sometimes," says John-donnell of *Surface. "They want to turn in something that represents them well in the context of our design."

In truth, the lines between advertising and editorial are increasingly blurred. Greater competition and the struggle to make a profit have brought the camps closer together. The invention of new revenue models on the Web also prompted change. In the race to make money, suddenly the fences didn't matter as much, and online content constantly was being packaged and sold.

This, for example, is why contract magazines—editorially driven publications created to promote international brands—constitute the fastest-growing division of magazine publishing these days. It's also why some designers look to the ads to help establish the overall picture of the magazine.

Blue editor in chief Amy Schrier makes no bones about artists sometimes playing off the ads they run. "We really do think about where they best integrate into

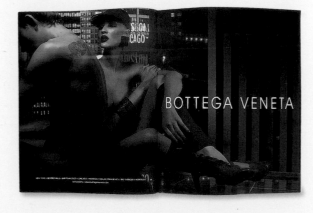

the layout," she says. "For example, we had this ad for a gin company. We put it opposite an article about a notorious alcoholic." Likewise, *Blue* may place ads for climbing shoes next to an article about rock climbing.

Editors and designers are careful not to pander to advertisers unnecessarily; they simply pair concepts to help readers get the most out of the grouping. "It's always clear that the ads and editorial are different," Schrier says. "We make them sufficiently distinct."

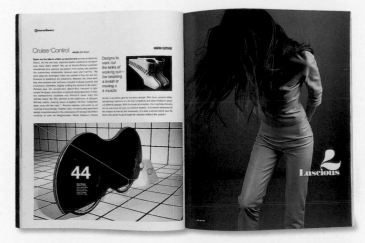

Advertisers' exhilaration at such placement often pays off for *Blue's* editors and artists, who see better synergy with their design in the ads that clients submit. "We promote adventurous graphic design, and that rubs off on the advertiser," Schrier says.

The most important thing to remember when grappling with this problem at your own magazine is to make sure all staff members understand and agree about what it takes to build and maintain a branded design—even if it means turning away an ad that doesn't fit with the look.

Graphic Design Ideas at Work

Trade magazines have always gotten a bad rap in the design department. Though they may easily make as much money as their consumer counterparts, they historically do not place as much emphasis on glamour and style. One reason is that they're more utilitarian—meant to be read and used rather than flipped through passively. Another is that, which the exception of a few, they don't depend as much on the draw of their covers on the newsstand.

But when you're a magazine for the design industry, your pages should look as good as the work you showcase. That was the idea behind *HOW* magazine's redesign in February 2000, which the design ideas magazine rolled out with a chronicle of its redesign process.

above *HOW*'s cover art always reflects the theme of the issue and recognizes skillful art and design at the same time. Here, the cover introduces a personality—illustrator Luba Lukova, who is profiled in that issue—while incorporating her vision for simple, colorful design patterns.

above Artistic depictions of well-designed objects often whimsically illustrate concepts on the covers. For the digital design theme issue, a simple electrical plug takes on a motion, light, and mood of its own.

above "Hire Me!" pleads a quaint bumper sticker on the bumper of an old car—the lines and shapes of which create an eye-catching cover for *HOW's* October 2000 issue.

WHY IT WORKS:

The new design combines creative uses of color and type with a simple, organized layout that is pleasant to read and complements the artwork used to tell its stories.

right To introduce a feature on design contest winners, this spread integrates the judges' profiles into the pages' design. Overlapping boxes with rounded edges converge to create a Web-minded layout.

Learning Experience

Actually, *HOW* is a newsstand magazine, though it largely reaches toward a specific audience. Targeted readers are design professionals, from the principals of firms to the creative team members who populate them.

Designers, like all artists, are by nature influenced and inspired by other designers' work, and they learn from each other in every aspect of their business. *HOW* collects the ideas of successful firms and highlights what they're doing correctly so readers can learn from each other. The magazine is as much about the people and business practices of the graphic design world as it is about the work designers do.

Each bimonthly issue has a theme—promotion, creativity, and so on. Like the other titles by publisher F&W Publications—also known for *Writer's Digest* and several artists' magazines—the issues are packed with resources, ideas, and a host of takes surrounding each theme. Articles are meant to get readers thinking, then send them to the drawing board with the proper tools.

left *HOW* unleashes its own creativity in the "Thumbnails" department, here featuring an apocalyptic journal, crude labels, and photos of survival products invented by graphic design firms. The mixed-media layout experiment takes a humorous dig at paranoid Y2K watchers.

Grid for Structure and Variety

However, with all the tips and resource boxes that went into putting articles together, *HOW*'s designers noticed layouts were getting too boxy. During the redesign, headed by outside designer Alexander Isley of Isley Design in Redding, Connecticut, the magazine went back to a smoother look to communicate concepts more completely.

The magazine usually runs articles over six to eight pages in the well, rarely divided by ads. "Nearly all features open on a spread," says editor in chief Bryn Mooth. "Those opening spreads require a big idea, a central concept that's supported by both the opening image and the headline and deck."

The design employs a flexible six-column grid; departments and features alike stick to the grid, but art director Amy Hawk may vary the number of text columns she uses. For instance, departments usually have three columns, but opening pages may include only one column, which may shift location but must still adhere to the grid. "The idea was to create a grid that gives structure but doesn't lock us into a cookie-cutter format," says Mooth.

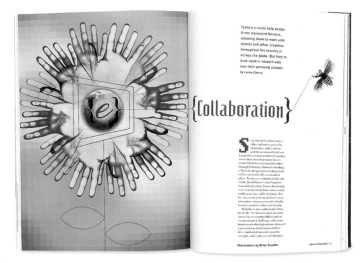

Feature articles are typically long, around 1500 to 2500 words. A single article may include several case studies or nuances related to a given topic. Colored text subheads divide articles frequently, every few paragraphs or so. By spreading articles over several pages, Hawk also dodges the danger of their looking too heavy.

As part of the redesign, *HOW* also standardized the types of sidebar it uses throughout the magazine. Lists of tips or other sidebar articles occupy parts of columns and are left open, without borders; instead, they're differentiated by a sans-serif font and a typeface of a different color. A colored "Source Box" typically bleeds off the bottom of a page and contains phone numbers and e-mail addresses for people quoted in an article.

above *HOW*'s artist interprets the grid and uses type to create a mood. Here, the pixilated headline font suggests computerization while the illustrations express organic nature—the contrast between technology and human interaction explored in the article itself.

left A checkerboard of duotones—tinted according to the magazine's palette—introduces an article on the effect of color on design.

left Subheads, information boxes, and pull quotes are helpful in determining the pages' flow. Boxes frequently bleed off the page, as with this sidebar on "Creativity Survival Tips."

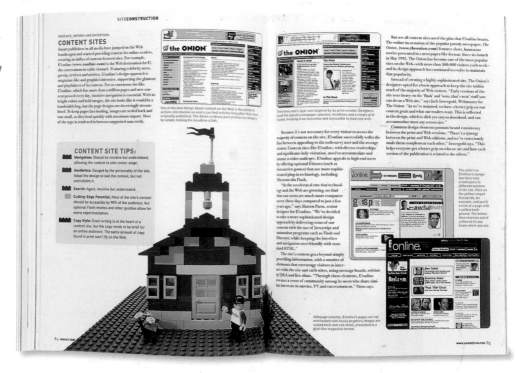

right This layout integrates *HOW*'s own ideas with other companies' featured designs. A story on building Web sites utilizes Lego blocks surrounded by colorful screen shots. Individual Legos act as keys for information boxes.

left *HOW* seeks good design everywhere, even in everyday objects. In this "Thumbnails," the floral pattern of the perforated envelope and the subtleties of retail receipts form a pleasant backdrop for a feminine, retro illustration.

Restrained Design to Showcase Work

HOW's main objective was to avoid overshadowing the work it featured by getting carried away with its own design. Photographs are spread throughout the long features to allow for white space and pay tribute to featured art. "Prior to the redesign, features often were jam-packed," says Mooth.

Photos alternate between scenes of designers in their workspace and the work itself—Web sites, brochures, ads, and multimedia screenshots. The sophisticated, stylish colors of many of the products often reflect those of the walls with which designers surround themselves for inspiration, so photographs naturally tend to sprinkle diverse bits of color throughout the white pages.

While restraining herself to let these photographs carry much of the show, Hawk does use *HOW's* own palette to add personality and to complement the shades that shine through in photography. Subtle but snazzy red oranges, violet blues, grass greens, and rich golds touch up text, specifically headlines, captions, subheads, and sidebars.

Color in section headers also separates departments from features. Front-of-the-book columns each are assigned their own color, and two-word headers run together, one word in vivid color, the other black. However, colored bars—sometimes with textured backgrounds that reflect the types of paper designers love to use—run across the tops of pages in the feature well.

above Callout circles and small photos dissect a complex design piece that won countless awards. The soft background color, gold type, and crowning graphic touch atop the headline set a refined tone while illuminating the white pages of the featured brochure.

left "Design Stuff," a regular department in the back of the book, is a colorful but simple gathering of short product reviews. Note how the magazine's palette is used to distinguish each short write-up.

Unity Through Type

Another way *HOW* makes sure the magazine reflects the design excellence it showcases is through type. During the redesign, the team chose faces that were modern, flexible, and interesting, yet would be consistent and identifiable from issue to issue.

ITC Bodoni serves as *HOW's* no-nonsense body text, while a medium-weight, versatile sans-serif font called DIN stands in as headlines, subheads, and sidebar copy. Hawk takes liberties with the copy, switching

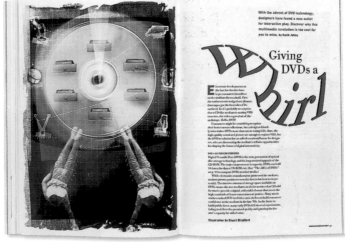

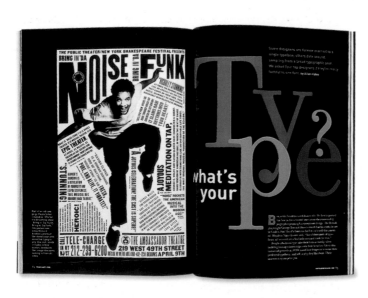

back and forth between all caps and initial caps with the sans serif, for instance, or manipulating the serif face with shadows and outlines for themed headlines.

All in all, experimentation with design is subtle, but *HOW's* touches result in a unified look, from issue to issue, that meets its purpose: to preserve the achievements of the graphic designers the magazine serves.

The International Design Magazine

Does design make the world go round? That's debatable, of course, depending on whose world you're talking about—but from the perspective of *I.D.* magazine, design is the core around which an entire universe revolves.

Making the pages of this magazine is a prestigious accomplishment for graphic, furniture, industrial, architectural and digital designers. *I.D.* successfully strives to find the most elegant and innovative ways to display examples of design excellence, building tasteful, smart layouts around simple images of products.

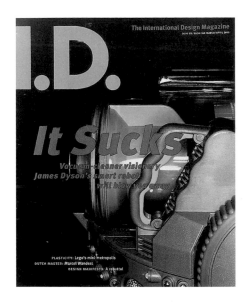

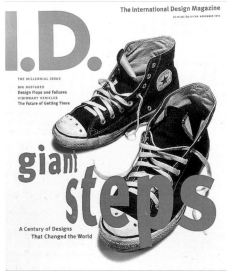

far left Funny and startling, the bright pink cover line for a focus on robotic vacuum cleaners leans toward streaks of light for a flashy product portrait. Color and type create an electric atmosphere that animates products.

left A battered pair of Converse sneakers is a comfortable symbol of influential design. Literally interpreting the theme of the article, cover lines with apparent distance and depth play off the headline "Giant Steps."

WHY IT WORKS:

Brilliantly simple backgrounds, creative photo editing and placement, and electrically charged colors and type team up for a sleek, modern gallery of designers' work.

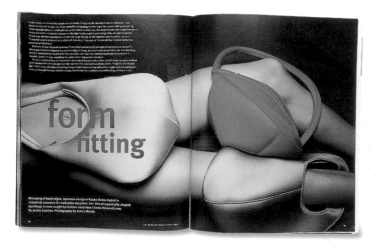

left What body parts are we looking at, and what are those padded things on top of them? The strangely staged photograph nets some long stares before readers turn to the article about the award-winning Japanese handbags.

Global Design Focus

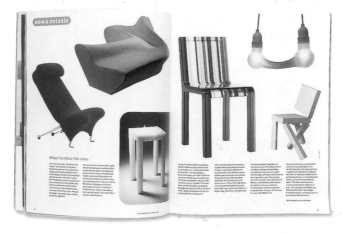

Published since 1954 and originally a trade publication focused on industrial design, *I.D.* has evolved to cover the "art, business, and culture of design" around the world. "In its early years, *I.D.* mirrored the excitement of the post-World War II American design scene," says executive editor Jenny Wohlfarth. "Since then, the magazine has blossomed to become more international and eclectic in its scope,"

In 1988, the magazine shed its strictly trade image and revised its tagline to read "International Design Magazine," reflecting both its global reach and its coverage of a wide scope of design topics ranging from architecture, industrial design, and graphics to fashion, interiors, technology, and design culture. As a hybrid trade/general-interest magazine, *I.D.* is as accessible to the design-curious consumer as it is to trained artists.

Long based in New York City, the magazine was purchased by F&W Publications in 1999 and moved its editorial headquarters to Cincinnati, Ohio, in 2001. *I.D.* continues to stretch its tentacles around the globe; furniture and gadgets from Milan and Berlin mingle with those from the vibrant Manhattan design community.

"*I.D.* is to the design industry what *Wired* is to technology," Wohlfarth says. "It pushes the proverbial envelope—both in content coverage and design—exploring the most primitive and fascinating kernels of design-related topics while philosophically scrutinizing their significant implications on culture and society. Its greatest strength is its own dichotomy: It's both provocative and simplistic, serious and sassy, focused on details while always revealing the bigger picture."

I.D.'s readers fall into three categories: designers who want information about the art and culture of the design industry; business executives who want to take advantage of the positive impact that innovative design has on their business; and design aficionados—nondesigners who love great design and who understand and appreciate the importance of aesthetics.

above The sensual curves and angles of Italian furniture are silhouetted dramatically against white space, not only showcasing the products' design but also creating a lilting white space across the spread.

right This article showcases an interactive Web game, a choose-your-own-adventure idea using simple lines and text. Rather than enclosing a screen shot in a picture box, designers transformed the layout using the site's colors and images.

Playful Image Placement

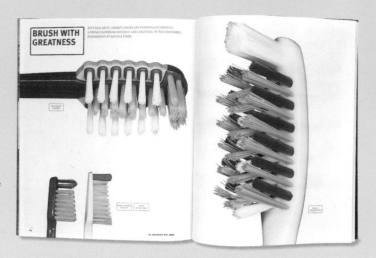

In fact, products or design work often take on lives of their own. Many pages simply feature silhouetted photos on blank white or tinted pages, with small blocks of text placed strategically.

The way *I.D.*'s designers manipulate these images makes them truly effective. For example, designers may blow up an image until it's absurdly out of proportion to its perceived importance—vacuum cleaners, sneakers, and humidifiers all get their day in the sun. Or they may use repetition to parade products across a spread, as they did with an army of toothbrushes magnified beyond life-size proportions. The pages are reminiscent of an old science fiction film or a surrealist painting in which inanimate objects come to life—but the images are frankly, purely true to form.

In other instances, cropping, magnification, or angular approaches accentuate features of objects that may be overlooked when they're shot straight on. Photos home in on the sly curves of a cord on a hanging lamp, the delicate texture of a woven chair, the humble design of a control panel for a common household appliance.

"Images define and drive the design in *I.D.*, reemphasizing the magazine's mission to bring attention to the designs of products being featured and not the design of the magazine itself," Wohlfarth says. "*I.D.*'s design seeks to be noteworthy without being too noticeable."

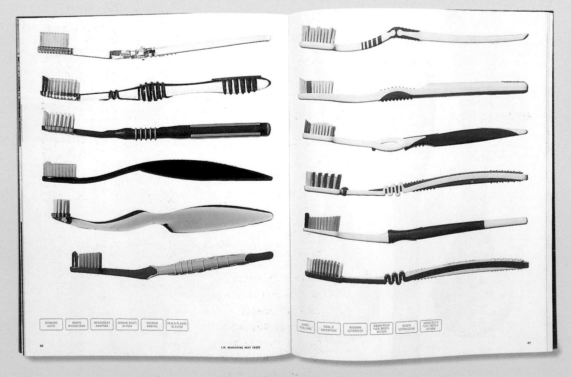

above and left The intricacy of an everyday product is the theme of this feature on high-tech toothbrushes. The first spread gets in your face with blown-up photos of the contoured bristles and gentle curves, while the second uses even repetition to impress readers with the inventiveness of design.

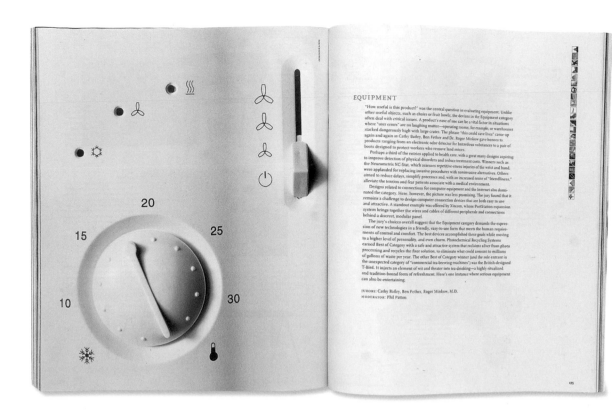

EQUIPMENT

"How useful is this product?" was the central question in evaluating equipment. Unlike other useful objects, such as chairs or fruit bowls, the devices in the Equipment category often deal with critical issues. A product's ease of use can be a vital factor in situations where "user errors" are no laughing matter—operating rooms, for example, or warehouses stacked dangerously high with large crates. The phrase "this could save lives" came up again and again as Cathy Bailey, Ben Fether and Dr. Roger Minkow gave honors to products ranging from an electronic odor detector for hazardous substances to a pair of boots designed to protect workers who remove land mines.

Perhaps a third of the entries applied to health care, with a great many designs aspiring to improve detection of physical disorders and reduce treatment costs. Winners such as the Neurometrix NC-Stat, which assesses repetitive-stress injuries of the wrist and hand, were applauded for replacing invasive procedures with noninvasive alternatives. Others aimed to reduce delays, simplify processes and, with an increased sense of "friendliness," alleviate the tension and fear patients associate with a medical environment.

Designs related to connections for computer equipment and the internet also dominated the category. Here, however, the picture was less promising. The jury found that it remains a challenge to design computer connection devices that are both easy to use and attractive. A standout example was offered by Xircom, whose PortStation expansion system brings together the wires and cables of different peripherals and connections behind a discreet, modular panel.

The jury's choices overall suggest that the Equipment category demands the expression of new technologies in a friendly, easy-to-use form that meets the human requirements of control and comfort. The best devices accomplished these goals while moving to a higher level of personality, and even charm. Photochemical Recycling Systems earned Best of Category with a safe and attractive system that reclaims silver from photo processing and recycles the fixer solution, to eliminate what could amount to millions of gallons of waste per year. The other Best of Category winner (and the sole entrant in the unexpected category of "commercial tea-brewing machines") was the British-designed T-Bird. It injects an element of wit and theater into tea-drinking—a highly ritualized and tradition-bound form of refreshment. Here's one instance where serious equipment can also be entertaining.

JURORS: Cathy Bailey, Ben Fether, Roger Minkow, M.D.
MODERATOR: Phil Patton

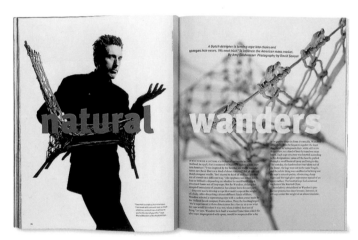

above In the hands of Marcel Wanders, this chair looks like ordinary furniture—but on the opposite page, it's a web hanging behind the text. *I.D.*'s propensity for imaginatively magnifying, cropping, and organizing photos creates unexpected perspectives.

above Andy Warhol would be proud: This layout pays tribute to a packaging concept that's ordinary and rarely recognized. A bright red box with white type reverses the modest red printing on curved salt packets.

new & notable

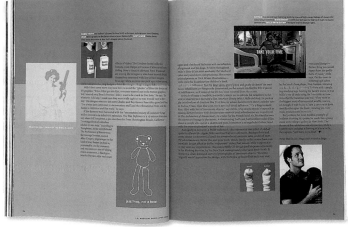

far left Bright orange dramatically backlights the snaking cords on these Italian lamps, another example of *I.D.'s* use of contrast.

left Adding black background color to negative space gives these products a space-age look. *I.D.* is especially strong at using negative space to build dramatic contrast.

Contrast Through Space

The use of contrast is an important technique for calling attention to the excellent design of featured products. This is accomplished largely through the use of negative space.

The front of the book is more compact than the expansive feature well. "Expo," a roundup of design and technology news, projects, exhibits, and excursions, is compartmentalized using different colored backgrounds to create simple divisions of short articles. Next is "New & Notable," an exquisitely designed exploration of the latest and best-designed products for work, home, and play.

In the feature well, editors keep article length to a minimum, so text never dominates a spread. Short blocks of text swim in a sea of negative space, surrounded by a few large images. Despite the liberal use of negative space, however, pages stick closely to a grid, again keeping in tune with a classic, Swiss design approach. Images take on interesting and diverse relationships with text, but they are always neatly disciplined.

above Plastic-happy colors act as backdrops for an article on designer and filmmaker Mike Mills, who is inspired by American suburbia. The background color adds a campiness that helps readers understand the tone of the article.

left Designers could have gotten carried away with an article about Las Vegas (specifically, about magician Penn Jillette), but in this restrained layout, a jigsaw of old-fashioned postcards faces a headline of tiny, tasteful "lights."

below Illustrators who take their cue from street culture are the focus of this colorful feature. Heavily outlined type in the headline plays off the dark, resolute lines of Maxine Law's fashion ad illustrations.

Digital Color and Typefaces

Contrast is also accomplished through color. *I.D.* has an affinity for the use of straightforward white and black interrupted by sudden outbreaks of digital ecstasy—hot pinks and bright blue-greens, fluorescent greens and oranges. For the most part, though, articles stick to black text on white or pale-colored backgrounds, with frequent reversed white on black pages for variation.

The modernistic and digital feel created in the layout of images is perpetuated in the choice of typefaces. Type usage also continues the magazine's goal of letting the images of products prevail. "*I.D.* is deliberately sparse in its font usage, almost exclusively sticking with the Scala and Meta families throughout each issue," Wohlfarth says. "Diversions are rare, but purposeful. This strict adhesion to two classic font families helps preserve the magazine's overall design mission: to be beautifully unobtrusive."

In this way, *I.D.* achieves what good design is about—putting function before form. The magazine's design establishes a mindset and acts as inspiration while never failing to remember that the featured designer's work is the star of the show.

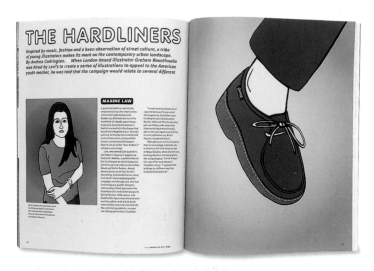

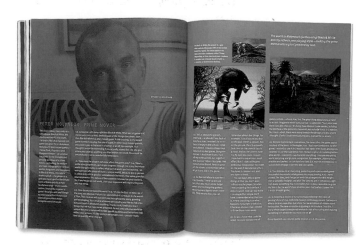

right Reflecting on what digital imaging can do, a colorized negative of game designer Peter Molyneux sits alongside photos of the scenarios he creates, complete with an electric blue background.

Sony Style

Innovative Art, Entertainment, and Products

With new technology hitting the market every day, it's important for electronic and digital equipment to look the part. Personal computers morph into transparent cubes, wireless phones explode in psychedelic colors, and personal stereos resemble the fancy running shoes they usually accompany. Stereo systems and TV sets are refined and stylized to blend with modern furnishings while manufacturers compete to make the tiniest, wildest, or grooviest product in their categories.

It's only natural that a magazine promoting and analyzing these products be equally well designed, but *Sony Style* pushes the boundaries. Its page design competes with the most innovative playthings featured in the back of the magazine. A marketing vehicle for Japanese-owned electronics giant Sony Corporation, the magazine is a funky blend of smart photography and state-of-the-art graphics that reflect the pace and color of life in a digital era.

far left The background behind the logo changes every issue, part of *Sony Style's* experimentation with patterns and shapes. For the Holiday 1999 cover, a plaid motif contrasts with an ornate silk pattern behind actress Milla Jovovich.

left Another photograph allowed to stand on its own merit, a skillful triple exposure of hip-hop musician Wyclef Jean is a stunning cover for the Fall 2000 issue.

WHY IT WORKS:

To uncover Sony as the electronics leader with its finger on the pulse of the latest scene, the magazine refers to typefaces, fonts, and graphic motifs associated with urban and digital culture. Text and images are built around retro-hip shapes and dominant negative space for truly innovative and modern layout style.

Lifestyle Magazine, Marketing Piece

Sony Style is an example of an increasing trend in the magazine world: custom publishing, or the production of magazines to promote a company's brand. Time Inc. Custom Publishing, the division also responsible for Target's in-store magazine and a periodical for the New York Stock Exchange, began publishing *Sony Style* in 1998.

"The philosophy is that in today's world, everything is interconnected," says Terry Koppel, the magazine's creative director. "Sony does the best job of anybody of interconnectivity."

But the magazine's editorial team had a challenge to address. "The magazine had to be more than just selling for Sony," Koppel says. At the same time that the magazine promoted Sony products, it needed to reach the thousands of consumers who have learned to tune out the advertising that bombards them.

So the editors decided to create a lifestyle magazine with Sony's name on it that, throughout the front of the book, makes little mention of the company's products. Instead, it covers the entertainment that

Sony specializes in bringing to the world through its production studios and electronics equipment.

As its name implies, the magazine is also about style—clothing, interior design, and art. Interspersed throughout are articles about Sony technology, most touching on a recurring theme in the high-tech world: how to express yourself through your electronic equipment.

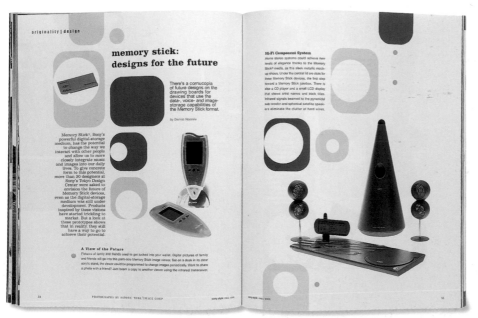

above A tic-tac-toe board of shapes momentarily disguises the article's title—making a game out of *Sony Style*'s usual geometry.

left Because it is a custom publication, *Sony Style* reviews Sony products. The branded look of surrounding shapes continues in these sections; here, 1960s-inspired squares with circular cutouts define placement of other elements on the page.

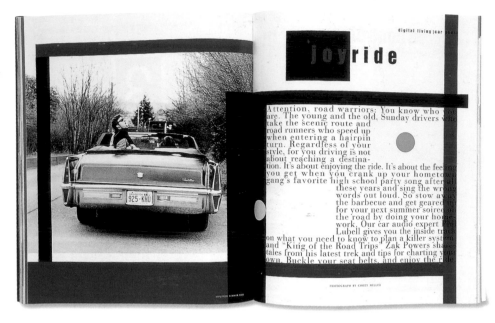

Instead of beginning with the type and building pages around it, Koppel and *Sony Style* designers Jennifer Muller and Julie Claire work backward. "We start with color blocks and block out cutouts and geometric shapes on the pages, like a modern painting," Koppel says. Artists then work in type around these shapes.

The experiment was Koppel's way of creating something original. "If I come at things from the same angle every time, I take bad habits with me to every magazine," he says. "By starting backward, I can come up with something fresh."

The result is that color and white space share the limelight with text and photos. Design may take on an Art Deco playfulness with skewed geometry as cutouts flail across colored backgrounds or cut abruptly into evenly flowing blocks of text. Pink and blue rectangles get equal billing alongside photographs; thin rules chart tangled road maps across the pages' terrain and colorful dots bounce across top and bottom margins.

The Building Blocks of Design

Sony Style's personality emerges through its windows of bright colors and spontaneous text layout. The graphic design projects the feeling of a fast-paced life that's still measured and self-aware enough to maintain a cool, edgy style.

Koppel, the former creative director of *Esquire,* who frequently teaches college classes on publication design, had the seed of a design idea formulating in his mind. When Sony approached Time Inc. Custom Publishing about doing a new publication, Koppel knew the magazine would be a perfect fit with his idea.

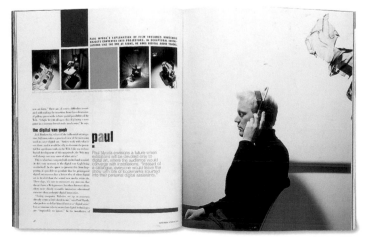

Designers—they each play with their own color palette—aren't shy about using vivid, electric colors: hot pink, watery blue, and butterscotch gold, for example. Color may divide pages into boxes, which is perfect for departments where short blurbs are key. It also acts as a border around full-page pictures or articles, or it may simply add touches of interest in the form of shapes and lines.

White is treated as a block of color too, sometimes one of the most important uses of the cutout technique. A neat field of white may surround a single floating column of text or cut in, from time to time, to make a polygon with many more sides than the traditional rectangle. Starting with one-inch margins, designers often drop the beginnings of text boxes to the middle of a page or shift them off center, with a playground of white space at one side.

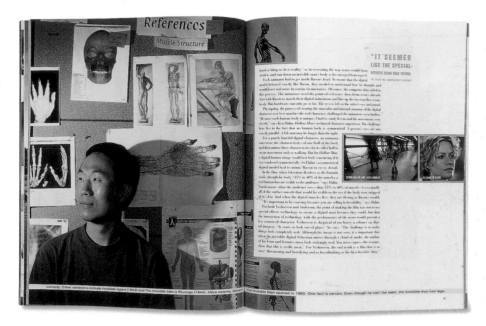

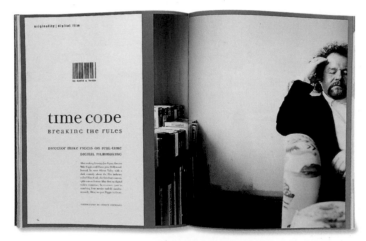

above This photograph jumps the fold into a lesson in proportion—a big image, an overlapping rectangle of negative space, and a sliver of more images. The layout exemplifies how *Sony Style's* designers experiment with shapes and their relationships.

left The way photographer Andrew Cotterill cropped this portrait replicates the magazine's varied placement and experimentation with negative space; the opening paragraph is offset slightly to the right underneath the deck.

below Overlapping boxes and jutting white space comprise a mod opener for a photo shoot of actress Mena Suvari and her retro-chic wardrobe. Everything from the photography to the abstractly organized layout suggests the magazine's edginess.

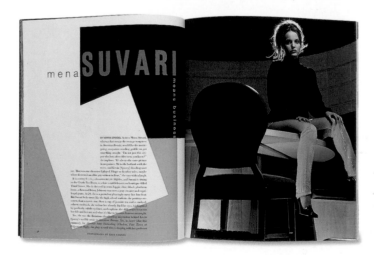

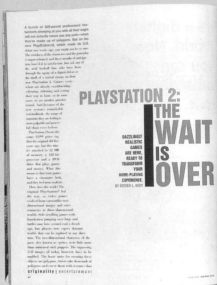

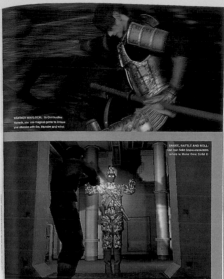

Playground for Type

The technique renders ever-changing layouts, but it creates a structure on which the entire magazine's design is built, Koppel says. This allows for continuity throughout the magazine despite the artists' tinkering with margins, white space, and even type.

Sony Style's designers draw from a well of typefaces with character. Text alternates between sans-serif and serif faces on a single page. Heads or subheads in one story may be represented by a light sans serif with pleasantly curved feet, while in another they appear in a blockier, more severe face. One frequently used typeface, a serif used for heads and body text alike, includes a mixture of capital and lowercase letters within words.

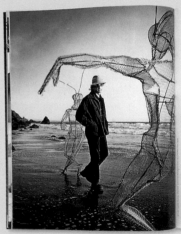

The addition of color to text adds to its effect; artists play with adding color to single words, assigning each letter its own color or choosing to color one letter each time it recurs, such as making all the *O*'s orange in callouts.

"I'm a big believer in using as many typefaces as you want," Koppel says. "I take the *Rolling Stone* approach, where you work type depending on the subject. What holds the magazine together is the energy, spirit, and feeling of the magazine as a whole—not using one typeface throughout."

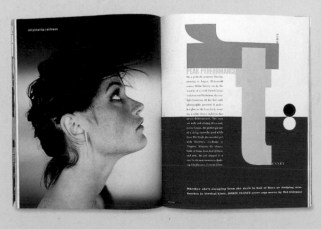

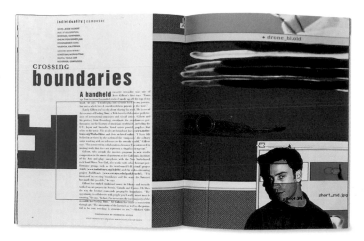

left Creative director Terry Koppel boasts that the magazine never graphically alters photographs. Here, a Web company founder stands in the beam of a Power Point projector. The surreal overlapping shapes repeat in blue on the facing page.

Emphasis on Photography

The element that most contributes to that consistent energy is *Sony Style's* photography. Most often, this consists of portraits, usually of musicians, actors, artists, innovators, or other quasicelebrities. "I have always placed an emphasis on good photography," Koppel says. "Eighty percent of any magazine is its photography and 20 percent is design. If you have great design but lousy photos, then it's going to look lousy. Good photography has to be there."

Koppel stresses that he likes to showcase photography in its pure form. Photographers like to work for *Sony Style* because "they know we're not going to butcher" their work by cropping it in ways the photographer didn't intend. The magazine looks for photographers who experiment with exposure, light, focus, and form on film instead of in computer software.

Therefore, portraits tend to have similar qualities; they are informal scenes that appeal to the emotions and senses. An actress sits in shadows against a backdrop of unnatural colored light; jugglers sweep torches

across a long exposure to create blurred fire against desert twilight; a filmmaker sits pondering intently in a grainy closeup.

These are the faces of the digital age: unstaged, unpretentious, and unprecedented in their ability to affect the media consumer. The surrealism of the portraits is in marked contrast to the other kind of photography in *Sony Style*—the crisp, detailed shots of the company's electronics products in the back of the book.

By combining engaging editorial and unapologetic marketing, *Sony Style* subliminally aligns the Sony brand with the cohesive theme of high-quality design, good ideas, and inspired pioneering. Nonconformist design draws in the reader seeking all these things and reinforces the message that Sony stands for style.

below Candid day-in-the-life snapshots of an up-and-coming band are scattered as in a photo album, accentuated by heavy black lines and divided by pastels. The motif of colored rectangles is carried through the four-page layout.

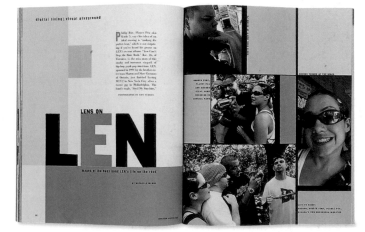

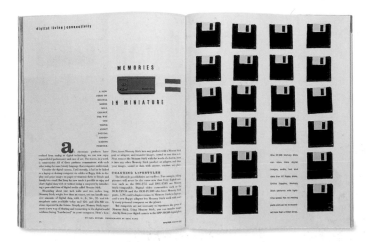

left Repetition tells the story. The simple purple product, shown in isolation on the left page, can hold as much data as the 22 floppy disks in formation on the right.

Eleven Steps...

to a Successful Redesign

A redesign can be the best—or worst—thing to happen to your magazine in years. Two design consultants who speak frequently about redesigns at publishing industry events discuss how to navigate the process for the best results.

Periodically evaluate the magazine's design.

Rob Sugar, president of Auras Design in Silver Spring, Maryland, recommends that clients evaluate the design of their publications about every five years. It's time for an overhaul if (1) editorial changes create a new structure for the publication, (2) the publisher wants to reach a different audience, (3) technological or cultural advances alter editorial content, (4) a new business plan repositions the media strategy, (5) new competitors require the magazine to reposition itself in a niche, or (6) the creative team begins experiencing boredom, repetition, or difficulty fitting new ideas into the current format.

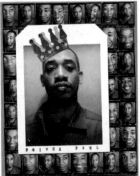

left *GQ*'s redesign allowed designers to refocus emphasis on imagery and make layouts less about the type, which helped reinstate a feeling of consistency.

Evaluate the magazine's mission.

If you don't have a written mission statement for your magazine, develop one that defines content, structure, and plans for growth, says Sugar. Then study the magazine according to the mission, asking how well the current design serves the reader and what needs to be changed to engage the reader better. Also, identify what it is about your publication that sets you apart from your competition. "Editors and designers ought to ask, 'What unique content and structure in features and departments define our vision?'" says Sugar.

Align the editorial, design, and business teams.

A redesign shouldn't cover the magazine's look and feel only. It should reflect a reevaluation of the magazine's editorial content and business plan as well, says John Johanek, coprincipal of Ayers/Johanek Publication Design in Bozeman, Montana. A new palette, grid, and set of typefaces mean little if they don't mirror updates in editorial focus or marketing and demographics. "If you haven't fully analyzed your objectives, you're just putting a new look on old problems," Johanek says. Use the redesign as a way to rethink the magazine as a whole, and hold frequent meetings with editorial and business departments to be sure everybody is headed in the same direction.

Put function before form.

Make all decisions about your design for concrete reasons based on research and knowledge of the magazine's goals. "A clear idea of the publication's function is often the source of inspiration for me," says Sugar. "There is a distinct difference between design as ornamentation and design as structure—just like in architecture—and revealing the structure of a publication is the designer's first duty. A new reader should be able to pick up any copy of the magazine and understand it from a glance through the book, even without looking at the contents page."

Cull inspiration from other sources.

You learn a great deal about the niche you serve by studying your competition during a redesign—but be careful when looking to other magazines for design ideas. "I call it the ugly duckling syndrome," says Johanek. "It's an easy trap to look at other magazines and grab the things you like for your own design. But you end up with a hodgepodge of elements that don't work well out of context." A healthier way to find inspiration, he says, is to look outside publishing for design ideas—to fashion, art, architecture, or advertising, for example.

Consider outside design firms.

If you're like most art departments, you barely have enough time to close your latest issue, let alone plan and implement a full redesign. But time isn't the only reason for bringing in design consultants. "A lot of magazines are strapped with company history and feel limited by what they've never been allowed to do," says Johanek. "Outside companies may feel the freedom to be more experimental." When interviewing outside design firms, Sugar recommends looking closely at their previous work—before and after samples, the questions they consider, and the order the redesign takes. Also ask about their philosophy of redesigns in general and how much they're willing to tackle. "It should be expected that a design firm will be involved with editorial structure, even to the level of suggesting departments and editorial initiatives," Sugar says.

Get your inside designers involved.

Of course, artists who have worked on a magazine for years may feel territorial about letting consultants take the reins. "You're going to run into a problem if the art department isn't made part of the redesign," says Johanek. "Everyone needs to be part of the final product." Hold frequent meetings between in-house artists and contracted designers. Let everybody review each style sheet and mockup as it's finished and allow them to discuss the meaning behind design choices with consultants. Then, when it's time for the art staff to take over the new design for regular implementation, they can interpret the design as it was intended.

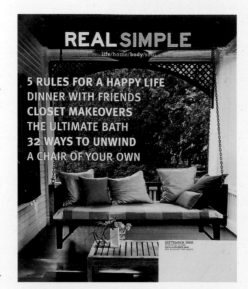

above Design tweaks during *Real Simple*'s first year of publication were responses to comments by readers that the magazine was too simple to apply to readers with chaotic lives. The magazine's designers made efforts to include more personal images and unexpected departures in visuals.

Prepare readers for the redesign.

It's important to let readers know the redesign is coming and why. At the least, an editorial should explain the reasoning and emphasize the positive aspects of the new look. "Remembering that a magazine is an ongoing conversation with its readership, a relaunch ought to invite the readership behind the scenes to encourage their continued participation," says Sugar. Some magazines do teasers, showing half the new logo and half the old one on the cover of the issue previous to the redesign. No matter how you approach the subject, stay positive. "You want to avoid anything that smacks of apologizing," says Johanek.

Market the redesign to your advertisers.

The launch of a redesign is a good opportunity to sell extra ad space. "Sales reps should use the redesign as a tool," says Johanek. "They can promote it as a special issue, talking up the fact that it will have a longer shelf life and a bigger press run. The ideal situation is that you generate enough bonus revenue to offset the cost of the redesign." Also don't forget to communicate the occasion to the rest of the world, Johanek says. Send press releases to *Folio:* and other trade journals or newspapers.

Do your research.

If time and budget allow, you may want to conduct focus groups and surveys with long-time readers, the magazine's staff, and a few people who are unfamiliar with the magazine. "The goals of the survey are to find out how much people remember the structure of the publication and what they found the most—and least—intriguing," says Sugar. One problem with groups is that readers often pinpoint problems without suggesting solutions. Another is that feedback may stray radically from the designers' original intent. "You have to balance the focus groups with good judgment and not be totally swayed by opinions," says Johanek.

Stick with the redesign once it's launched.

Roll out the redesign all at once in a single issue, accepting that you will inevitably hear negative comments from at least a few readers. If you've done your research, the new design should be right on target and only minor changes should be necessary. "Tweaking is an unavoidable part of redesigns," says Sugar. "Some ideas simply don't work when applied to real-world deadlines or budgets." But unless readers lash out violently against the new design, make your adjustments without announcing you're doing it. "Letting the conversation play itself out in a letters department is a good approach to keeping reader input alive but confined and, after a few issues, even that can be dispensed with," Sugar says.

The Best in Entrepreneurial Ideas

"It's more than a magazine—it's a movement."

You'd expect this kind of statement from a grassroots title like *Utne Reader,* but it seems a strange assertion from a business magazine. Yet that's the groundwork on which *Fast Company* is built and, among loyal readers, the six-year-old title is a staple of the changing business culture. From its inception, the design has been integral in the "movement" by screaming for change through bold covers, unconventional images, and a propensity for breaking the rules.

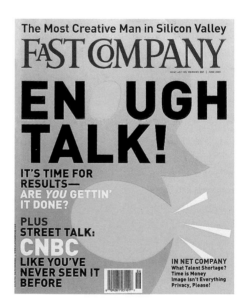

far left The cover of *Fast Company* is emblazoned with the brilliant ideas and quotes of people profiled inside. Loud colors, humorous graphics, and sensational type reflect the creative energy of these entrepreneurs and experts.

left When they're not all-text proclamations, covers often feature funny illustrations. Here, the March 2000 cover portrays the "battle for the soul" of the economy, in which the devil has spray painted over the original headline.

WHY IT WORKS:

Fast Company incites readers to embrace new ideas with bold, illustrative type and intrigues them with insightful, entertaining photography. Once covers and opening spreads draw them in, basic layout and a careful use of white space keep them hooked through long articles.

Radical Business Ideas

Fast Company positions itself as the mouthpiece for a radical new breed of businesspeople who invent the rules as they go along. "*Fast Company* was the first business magazine to fully realize that the Internet was about to change everything," says creative director Patrick Mitchell. "For our audience, it changed the way people worked, where they worked, the way they managed people, the way they communicated."

Founded in 1995 by two former editors from *Harvard Business Review,* the magazine has grown to include a well-known Web site, an organization of readers called Community of Friends, and an education program as part of its brand.

The formula has been wildly popular and, amid competition from other new economy titles, it experienced exponential growth. Paid subscriptions soared 500 percent since the magazine's inception, while newsstand sales increased 155 percent.

The magazine targets businesspeople who have big ideas, uninhibited energy, and the strength and positioning to make a difference. Readers tend to be in positions of power at established or startup companies, yet young and open-minded enough to plow through convention. According to the magazine's media kit, "Their goal is to overthrow the status quo."

Fast Company's design reflects this maverick way of doing business. "The goal of the design was to capture the excitement and almost revolutionary undertones of what was happening in business and society," says Mitchell.

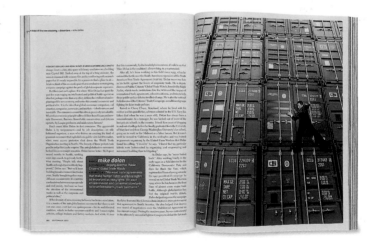

Covers Tell the Story

The magazine stirs up enthusiasm for the theme of its latest issue starting with the cover. The bold, text-driven headlines and cover lines that are now familiar to newsstand readers actually derived from *Fast Company's* first issue, where an all-type cover proclaimed the magazine's manifesto for the new rules of business: "Work is personal. Computing is social. Knowledge is power. Break the rules."

After several issues, designers set about to recapture on the cover the same magic and excitement that articles within the magazine conveyed. "Our conclusion that it wasn't the people we wrote about that were interesting, it was the things they were thinking about and the things they were saying that were unique," Mitchell says. "Suddenly, it was clear what should be on the cover. The whole magazine design philosophy is inspired by the brilliant ideas and quotes that are in the articles."

Beyond the text-heavy covers, the same commitment is made throughout the magazine. Occasionally, quotes instead of a static headline will open a feature article. A catchphrase may inspire an issue's theme and pop up in openers throughout the magazine. For example, one issue argued the difference between companies

"built to last" and those "built to flip." A handwriting-like script typeface was assigned to the concept and followed it through several related articles.

Generally, though they call up type to embody the golden nuggets of stories, *Fast Company's* designers stick to two or three typefaces. They use FF Din for a sans serif and Electra as a serif, occasionally employing HTF Knockout for "Net Company," the "magazine within a magazine."

"The limit of fonts is another thing I chalk up to experience," says Mitchell. "Our early issues were all over the map typographically. As I learned that simplicity was the way to go, one of the ways to achieve that was to strip everything down, including the typefaces. [Simplicity] also really united the overall look of the magazine and created its signature style."

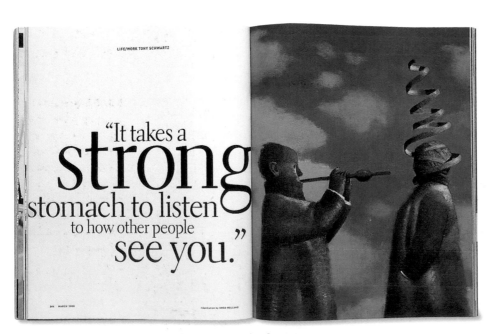

above Designers stick to a few typefaces used in varied ways. A large serif face with little leading introduces this feature, reversing the magazine's commitment, on subsequent pages, to wide spaces between short text blurbs.

left A single quote acts as the headline on a story's opening spread, with only a surreal illustration backing up the strong statement.

Integrating White Space

The theme of simplicity, in fact, overtook the magazine's entire design two years into publication. While still indulging in a hyperactive use of type and art, designers scaled back the chaos by including more white space, consistent design elements, and relatively clean pages. Now, when a layout steps into the experimental realm, it stands out even more among other low-lying designs.

The revival of simplicity emerged from Mitchell's personal revelation. "The concept of white space was a result of a sudden urge in 1997 to simplify everything—my life, my job, and especially my magazine," he says. "The times just seemed to call for it." Mitchell's own design style, though, did not adapt to the decision easily. "It didn't come naturally to me," he says. "But I knew we needed it, so I just built it into the grid. Then I didn't have to be conscious of leaving room for space—it was just there."

Adding a tall margin to the top of the page was the most significant step. Nicknamed the "attic" by *Fast Company's* art staff, this white space persists throughout the feature well. Designers try to leave it open, though occasionally they'll add pull quotes to the space.

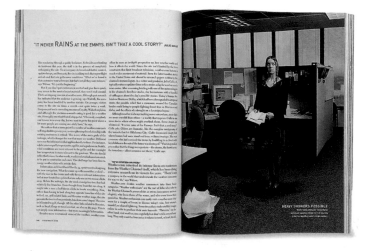

left This quiet department page is a lesson in simplicity. The four-column article with a tiny stick-figure illustration and orange type complementing the pink background tells a compelling story about corporate culture.

Fast Pack 2000

left *Fast Company's* illustrations are its hallmark. For a story about the magazine's roundtable of experts, cartoon likenesses of each participant arriving at the site of the event are used rather than photos.

Because *Fast Company* is about people and their ideas, the magazine relies heavily on photography. Portraits may be candid—a series of snapped facial expressions, a group photo in which most people are looking away from the camera. They can also be staged for humorous or curious effect. Whatever the scenario, images are meant to provide insight into the subject's character, an approach as effective at telling the story as the article itself.

"One of the first things we decided about *Fast Company* photography is that if the best we can do is get a picture of a guy at his desk, we suck," says Mitchell. "That type of image is contrary to the spirit of *Fast Company* and the business environment today. You may be the CEO of a multimillion dollar corporation, but you're also a mother, wife, sister, gardener, painter, juggler, and a thousand other things. If we simply take your picture at your desk, we ignore all that."

That's a radical approach for a business magazine— but then, business culture has seen unbelievable changes in the past decade. *Fast Company* has not only grown to reflect those changes but also has been instrumental in helping shape them. Design helps each issue shout new rules and ideas across the culture like a town crier, documenting them as they emerge in the context of new outlooks and possibilities.

Capturing Personality and Spirit

While artists try to be more restrained, the team is still dedicated to art and color that reflect the accelerated spirits of die-hard readers. Color inside the magazine, for instance, generally is muted, reserved for information boxes and display text, but the cover may scream fluorescent orange, rich sunny yellow, or more subtle blue and beige. The magazine doesn't use a palette, though designers tend to stick to brighter colors as the situation calls for them.

Artwork is another way *Fast Company* steps outside the boundaries of simplicity. As in other business magazines, illustrations take on great importance. Rather than always being the abstract depictions of a complicated concept common in other titles, however, illustrations in *Fast Company* are often more literal, sometimes even replacing photographs with caricatures of profiled people.

below Portraits of businesspeople, as in this shot of roundtable participants, are unfashioned and unexpected, meant to capture subjects' complexity. Depicting professionals as regular people is *Fast Company's* commentary on the changing landscape of business.

above The hauntingly beautiful monotony of row upon row of light bulbs opens a series of profiles on innovators. The word idea in the headline is placed directly over the one lighted bulb.

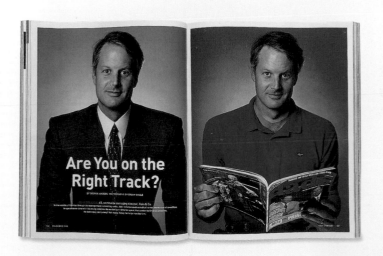

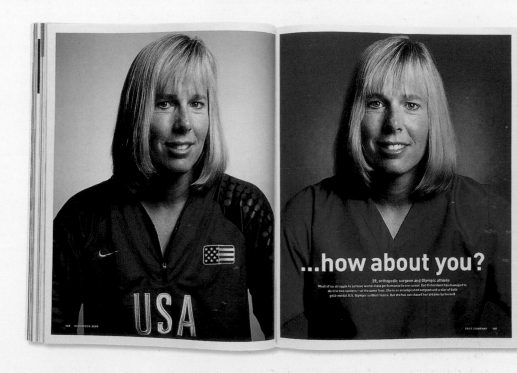

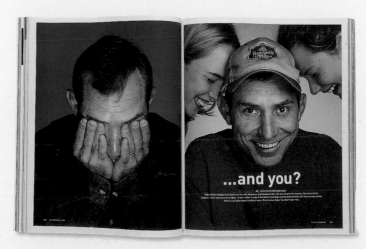

above, center, and below
Once again using portraits to explore a subject's many sides, designers delegate space for three opening spreads—with a progressive headline—before getting to the meat of the story.

Business Strategies for the Digital Age

The business landscape in the new economy has a much different shape than it had 10 or 15 years ago. Rules are crumpled and discarded every day; success is a democratic process based just as much on good ideas and elbow grease as it is on family money and Wharton MBAs.

The challenge of communicating with the new executive is one that *Context* has accepted with confidence. With its bold colors, ornate illustrations, and hands-on design, the magazine lays out a visual playground without downplaying the serious nature of the subject matter.

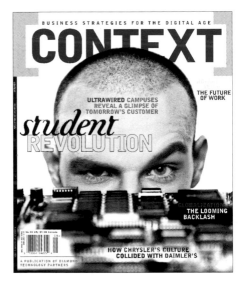

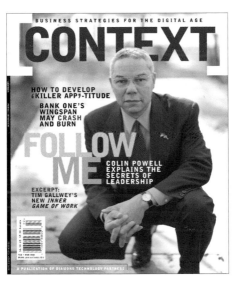

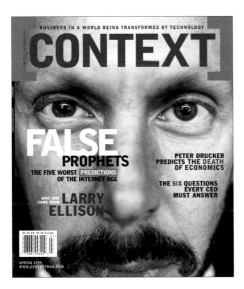

above *Context* uses images that communicate from below the surface. For a cover story about students' technology use, a buzz-haired 20-something peers over a circuit board. The blurred computer chips and funky green cover lines add modern flavor.

above Colin Powell's sober, direct gaze introduces the theme of leadership for the February/March 2000 cover story.

above Even a portrait of Cisco CEO Larry Ellison is cropped for enigmatic effect—a more up-close-and-personal approach than the hundreds of other pictures of Ellison in the press.

WHY IT WORKS:

Context's artwork, graphic design, and articles are all intimately tied together. The stylish, stimulating colors of the modern business world are represented in illustrations and the type that complements them, and each layout's type treatment and graphics are customized to reflect the theme and tone of the accompanying article.

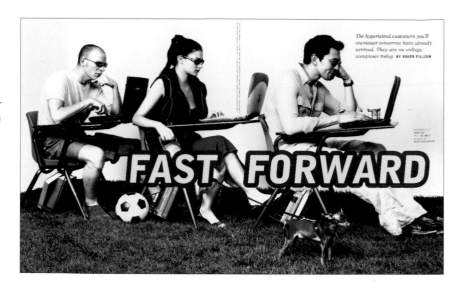

Dual Role, Dual Design Needs

Context began as a custom publication, a marketing piece for consulting firm DiamondCluster International. It took the form of a traditional magazine and accepted high-profile advertising. Yet its controlled circulation sent the magazine directly to the desks of corporate CEOs and other senior executives, offering them business analysis but also acting as a subtle pitch for Diamond's services.

Context is now available on the newsstand, though its circulation is still qualified, says Mark Maltais, the magazine's design director. Articles include profiles of inspirational figures (Bill Gates and Colin Powell have graced the cover) and influential companies as well as analysis of technology and trends—targeted to executives but written to appeal to a range of readers.

The dichotomy of the readership makes interesting demands on the magazine's design. It must be sophisticated but not intimidating, and it has to draw in both busy company leaders and people who don't necessarily know their way around a business magazine.

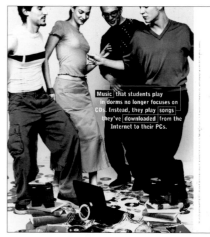

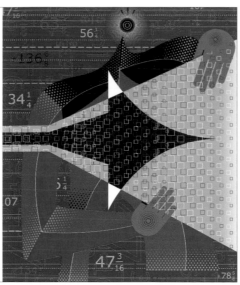

left Illustrations frequently employ the rich colors of *Context's* palette, reminiscent of modern business interiors and logos. This abstract depiction of companies that share bandwidth exploits the magazine's trademark red, green, and blacks.

Conceptual Illustrations

Fearless use of color and engaging graphics help *Context* achieve this goal, and illustrations are a major component. *Context's* artwork is a festival of color and patterns, sweeping up the idea of each article with ferocious energy. Fun, complex, and always intriguing illustrations often carry the rest of a story's design.

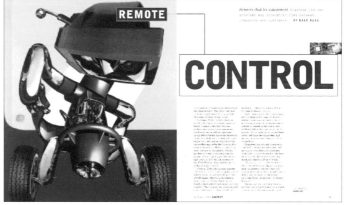

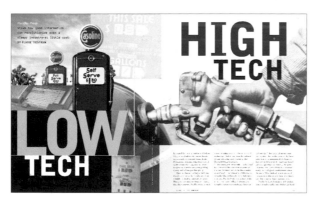

"The challenge is to keep the overall look and feel from getting too serious, and that often leads me away from photography," says Maltais. "We're communicating hefty business concepts, and they really require an illustrator to boil down the point into pictorial scenarios that shed light on the piece."

Illustrations take several forms. Literal or abstract drawings or graphic renderings accompany some stories. Cartoonish, sad faces march across the opening spread for a story on the elimination of middlemen; a bride struggles to hold up a stack of papers to illustrate a story on wedding services; a headless body embraces a funnel of interconnected boxes for an article about companies that share bandwidth. The illustrations

above The concepts *Context* tackles are hard to photograph, so the magazine frequently uses illustration. A robot revs forward in this article about remote sensors; background and text elements pick up the color and movement of the artwork.

above Designers latched onto a symbolic image—a lone gasoline pump in the parking lot of a successful national company—and carried it forward to build a theme about companies that achieve their goals without technology.

THE RUMORS OF MY DEATH...

...have been greatly exaggerated.
Middlemen say they won't go quietly.

left Even a drawing of the Grim Reaper adopts a humorous tone with the exaggerated dismay of cartoonish faces.

below *Context* strives for a different take when it photographs people who often appear in business magazines. Schwab co-CEO David Pottruck's bowed head and folded hands present a humble pose in this photograph.

often reflect the colors of the magazine's palette, the contrasting reds and blacks and softer greens and golds that characterize most pages.

Context also favors photo illustration or montages of type, photos, and illustrations. Illustrations may directly relate to a topic or be a bit more conceptual, but they add a sense of depth to pages regardless.

One interesting aspect to note: Illustrations often call up retro images. Old-fashioned images of gas pumps illustrate an article about a successful but low-tech company. Sepia-toned photos of antique clocks and cash registers accompany a story on knowing the customer. Black-and-white photos of 1950s autos float against pixilated digital backgrounds to demonstrate how innovative technology can become classic. These nods to the past offer a tongue-in-cheek departure from the world of high-tech.

Pure photography is not altogether ignored, however. Profiles of executives or leaders doing interesting work often call for photos, says Maltais. Portraits that are sincere but informal often serve well as *Context*'s covers.

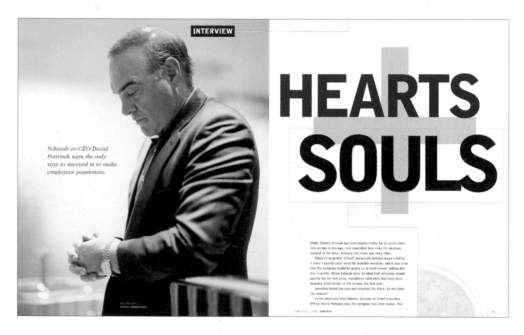

INTERVIEW

Schwab co-CEO David Pottruck says the only way to succeed is to make employees passionate.

HEARTS
SOULS

right Old cars, even when they're diving off cliffs, still convey a feeling of lighthearted whimsy. In this montage, they're mingled with psychedelic prints for a story on the best and worst technological applications.

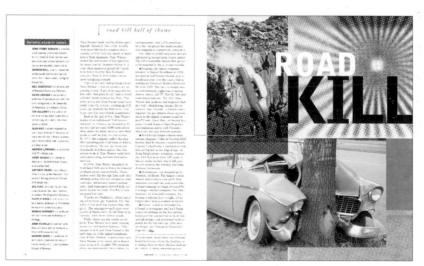

ROAD KILL

Peter Drucker says to forget the dictum, "know your customer." The key, he says, is to understand those who aren't your customers.

Peter's Principles

When Peter Drucker arrives for an interview, he is a delightful mix of Old World politeness and cut-to-the-chase bluntness. The 88-year-old Mr. Drucker, who is a giant among history's thinkers on business and who doesn't need to worry about impressing anyone, is wearing a tie even though he knows that these he is meeting are all dressed casually. He fusses over the tie, worried it might not be on straight because he tied it in the car.

He then declares, in his rich Viennese accent, that the kinds of questions he has been told he might be asked are "an abomination." He sets himself the task of offering refinements—and, not surprisingly, has excellent ideas about how to find more precise questions.

Mr. Drucker also offers a glimpse of his dry humor. When someone uses the term "cash cow" in passing, he says, "You know I invented that term—for which I will roast in hell forever."

When he begins the session—which is moderated by Context editor-in-chief Paul Carroll but which also involves two dozen senior executives from an array of industries—he makes a friendly suggestion. He says that if his answers wander, he should be treated as a mule. "The first thing you do with a mule," he says, "is hit it over the head with a two-by-four if you want its attention."

His suggestion is, of course, unnecessary, and Mr. Drucker proceeds to offer a broad series of observations about why innovators so often fail, about how the business world is devolving into a series of permanent, part-time relationships, and about how a business can differentiate itself in a fast-changing world. Along the way, he gets in a few digs at some prominent executives—and at himself.

of the configuration that is the value system of the customer. Without that understanding, you'll know a good deal about your product, a good deal about your service, and not a blessed thing about your customers.

CONTEXT: Once you start to know something about your customers, how do you differentiate yourself from your competitors?

DRUCKER: The customer never buys what you think you sell. And you don't know it. That's why it's so difficult to differentiate yourself. Because you have to differentiate yourself in the customer's terms, and not in your terms.

There are very few companies in the world that can turn out superior products ahead of what the competition offers. And you can't get business any more by being cheaper. Not for very long. Quality, service, yes, you can still differentiate them. But fundamentally you have to differentiate yourself by structuring yourself within the customer's

CONNECTING WITH THE CUSTOMER

CONTEXT: Lots of companies talk about getting closer to the customer. You've made the point, though, that most companies don't know much about their customers. Would you elaborate?

PETER DRUCKER: Very few of us, myself included, know the customer. One reason is that all of us believe, and must believe, that the product and the service we produce is important. But 99.9% of your customers couldn't care less about your product or service. You are just not that important in their universe. And that's almost impossible to accept.

The second reason is that you amass an enormous amount of information about the people who buy from you. Yet, for almost all companies, at least 70% of the people or organizations that should be your customers are not. So, if you want to understand the customer, those people who aren't your customers are the key.

Plus it isn't so easy to define a market any more. Yes, all the questionnaires, all the statistics are helpful. But you can't depend on the statistical aggregates we now call information. I have for years been preaching that nothing beats sending executives going out twice a year for two weeks to take the place of a salesman or saleswoman on the front line. Then executives will get some glimmer

> **FOR ALMOST ALL COMPANIES,** *the customer doesn't buy what you think you sell. And you don't know it.*

38

CONTEXT SPRING 1998

FOR CONTEXT BY MARK MALTAIS

above Old and new unite as black-and-white photos overlap. The green line weaving through many *Context* layouts tilts and unevenly crops photos, then targets the interview subject. The result chops the layout into negative parallelograms.

Headlines According to Mood

Context's design team, consisting of just Maltais and designer Gretchen Kirchner, may think outside the box when it comes to illustration, but they step back inside the four walls with their use of text. Callout quotes and subheads are infiltrated with lines and rectangles that circle key phrases and draw the readers' eyes directly to them. These can set the mood for an entire page, as they often highlight particularly wacky or grim phrases.

Though *Context's* type families don't exceed a few fonts, the way type is used runs the gamut. Maltais chose Caslon as body text for its high-end, classy look and employs the sans serif Bell Gothic as display type. This font, in a range of colors, frequently serves as a show-stealing headlines for features. A curly italic face waltzes into modern-looking pages as callouts and pull quotes.

To add an edge, Maltais also uses faces called OCRA and OCRB. "They have a quirky, electronic, crude look," he says. "[Each typeface] is sort of a hybrid of old and new. It has classic elegance, but it reminds readers how contemporary the subject matter is."

Behind this parade of type, the designers often drop duotone images of digital equipment reminiscent of the stronger illustrations on facing pages. These not only give pages depth but also act as forward-thinking elements that tone down the severity of *Context's* heavy white pages.

This kind of duality makes *Context* successful. Fearless illustrations and crude digital type harmonize with fine quality and classic looks in much the same way that renegade entrepreneurs confer with seasoned executives in the boardroom. The magazine feels young and daring but serious and respectful of tradition—a happy medium, you might say, in the world of business magazines.

car WRECK

American ingenuity collides with German efficiency in the Chrysler/Daimler-Benz merger. BY BILL VLASIC AND BRADLEY A. STERTZ

BOOK EXCERPT

OFF THE CUFF
In this issue, and issues to come, Off the Cuff will offer glimpses of the dialogue occurring on the Digital Frontier. Keep your eyes and ears open—we'd love to add your observations to the evolving conversation.

PHONE PHONIES

Annoying people by making disruptive noises has been [considered distasteful] since the human body first learned to make nasty sounds on purpose.
—Miss Manners, on cell phone etiquette.

HOP, HOP, HOORAY

DOUBLE, DOUBLE, TOIL AND TROUBLE

The world is no longer flat. Earth is no longer the center of the solar system. Moore's Law is no longer true.

I predict the Internet.... will soon go spectacularly supernova and in 1996 catastrophically collapse.
—Robert Metcalfe, founder of 3Com and currently publisher of InfoWorld Magazine, wrote in 1995. Oops. Never mind.

PUSH LOSES POLL

CONTEXT PREMIERE ISSUE

17

right Designers overlay solid red and black boxes against pale green and white ones, incorporating colored text, boxes, and rules for a clean department layout with an interesting flow.

THE OSTRICH

Lexis-Nexis may be squandering a 25-year lead by ignoring the Internet. BY CLAIRE TRISTRAM

CONTEXT SPRING 1999

left Illustrations, type, and graphics cooperate. Here, a story on Lexis-Nexis's lag in Web services portrays the company with its head in the sand. The giant s in the headline resembles the neck of the mechanical ostrich opposite.

Business 2.0

New Business Rules for a New Economy

The information age has altered the way people read. There's so much information that people, by necessity, have to tune out in order not to be overloaded. They also have come to expect content to be fast, lively, and interactive, even in two-dimensional print media.

Nobody relates to this more than the businessperson, especially the founders and executives of fast-track startups who work 17-hour days and have hundreds of magazines and Web sites clamoring for their attention.

To bring this audience the longer-form analyses and profiles they need to run their business, *Business 2.0* keeps its approach simple. The magazine puts articles center stage and offers visual tools to help readers apply what they learn in an enjoyable, hassle-free way.

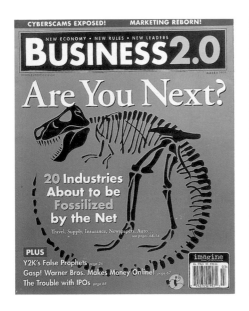 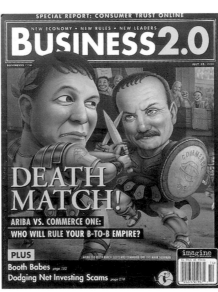

far left Covers must grab the attention of fast-moving readers, so they're clever without being complex. For the March 1999 issue, a dinosaur skeleton is a humorous poke at the Internet's effect on old-school industries.

left Illustrator Thomas Reis came up with this parody of business-to-business competitors when the movie *Gladiator* was released. The illustration is an instantly recognizable concept that inspires a laugh and a second look, another newsstand grab for hurried passersby.

WHY IT WORKS:

Business 2.0 is dedicated to making articles as user-friendly as possible. Infographics, callouts, type treatment, and simple layouts work together to build a pleasant, easy, and familiar read.

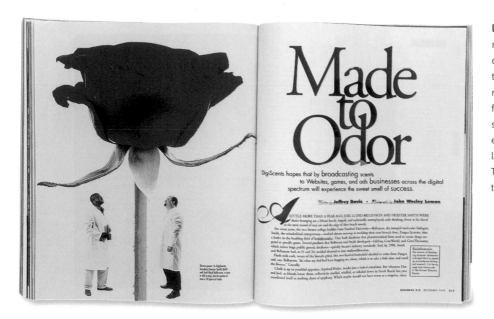

Fun with Business

The business magazine's concept grew out of a social conversation between Chris Anderson, CEO of publishing company Imagine Media, and several friends, including Amazon.com head Jeff Bezos. The title launched as a monthly in late 1997 and hit the newsstands half a year later.

Many new economy business titles also were emerging around that time, so *Business 2.0* had to carve its niche. "We weren't going to be a news magazine," says art director Laura Morris, who helped found the magazine with editor in chief James Daly. "We offered bigger package stories. Instead of making it newsy, we made it a how-to magazine, explaining how to make it in the new economy."

Unlike business magazines of the past, new titles had to be more "mass consumerish," Morris says. Suddenly, everybody wanted a piece of the action. Therefore, though content was aimed at upper management and CEOs, design had to appeal to a broader audience. "I made it a little more fun and creative than other books, something that a non-businessperson would find dynamic visually," Morris says.

The model was so successful that, in June 2000, *Business 2.0* went biweekly. Currently boasting an all-paid circulation of 350,000, the magazine packs its pages with business tutorials and short pieces on new products and market trends as well as long, thoughtful pieces on the smartest paths to steer.

Borrowing from the Web

One reason for *Business 2.0's* success is the simplicity of its presentation. Morris and her team make ease of reading and navigation a top priority. "A businessperson who's very busy doesn't need design that overshadows text," she says. "We needed to design a magazine that wasn't too complex."

Morris points out a prime example of this commitment to navigability: The table of contents resides just inside the magazine's front cover. A gatefold page opens up to a spread ad, but the contents pages are the first readers see—a rarity in magazine publishing, where the contents usually are buried between layers of ads.

To keep readers aware of where they are and what they're looking at while flipping through the magazine, designers color-code sections of the magazine. Red tabs head pages in the front of the book, black ones run across the well of in-depth articles, and blue tabs mark the back of the book.

Morris admits that while she doesn't necessarily feel she's been influenced by Web design in her creation of the magazine—"It's a totally different thing," she says—she borrowed the color-coding navigation idea from online media.

That's not the only Web element *Business 2.0* uses, in fact. Elements that are immediately recognizable in the Web platform, such as the pointy hand cursor and linked underlined words, take their places in *Business 2.0's* design. Every time an article refers to a Web site, a small gray tab preceded by pointing hand icon juts into the text to call out the related URL. When interesting facts or definitions relate to a term addressed in the paragraph, the term is underlined and colored red, and a nearby box contains the data.

Designers also like to stick information in boxes, especially as sidebars or resource lists, to make it more accessible. "We like to provide as many entry points, as many different places to pull the reader in, as possible," Morris says.

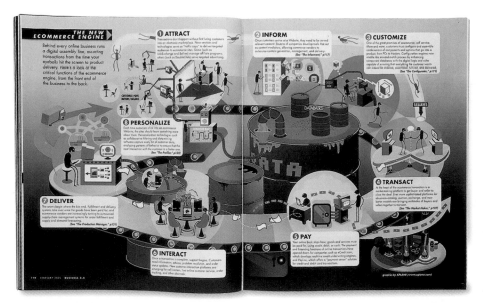

left The magazine first hired Xplane to portray workflows and diagrams, such as this e-commerce engine map. The ant people that characterized Xplane's illustrations eventually became an integral part of *Business 2.0*'s brand.

Simple Touches That Make the Brand

Morris doesn't like to overdesign the magazine; pages are generally white with black type, with colored subheads, pull quotes, single images, and the occasional icon or illustration to break up text. Type rarely strays from the classic, matter-of-fact Garamond and Futura families. Pages occasionally dip into a palette of violet, rust brown, pink, and pale green but often stick close to the primary navigational colors for accents. Gray-beige and mustard gold are often used for backgrounds.

One technique *Business 2.0* has employed to enliven its pages, however, has become an important part of its brand. Early on, the magazine hired a company called XPlane to make a diagram of a business concept to illustrate a story. What emerged were elaborate infographics abuzz with what Morris calls "little ant people"—stick figures with funny facial expressions racing from one section of the diagram to another.

The infographics help *Business 2.0* explain concepts in an easy-to-use format, but the illustrations have also become a large part of the magazine's personality. The stick people now make cameos on the front cover and in other products, including conference literature and the Web site.

right Horizontal striping is a common motif throughout *Business 2.0*. Note the combination of solemn gray with loud primary and secondary colors and steady portraits with tilted graphs and silly illustrations.

far right Sometimes designers pull out all their ammunition at once—at least in the color department. The magazine's entire palette is represented in this listing of the top 25 Web sites.

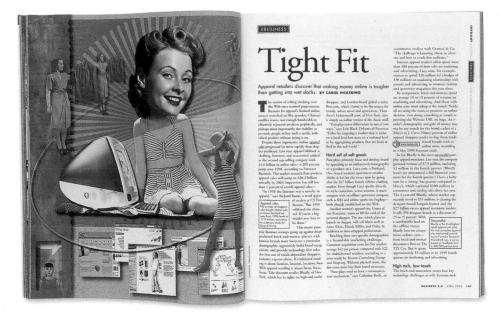

Personality Through Illustration

The XPlane graphics make up only a small part of the illustrations in *Business 2.0*. These people-focused pastels and collages generally add life to layouts without being heavy-handed. They're friendly, vaguely literal depictions of concepts and scenarios.

Covers are a little different in this regard. Though some are all text, they are always bright and demanding. A big part of the readership buys individual issues at airport magazine shops, Morris says, so the front has to scream at hurried consumers racing to catch a flight. So while not complex, covers are, at times, high-concept.

For example, for a cover story called "VC Scorecard," Morris got the idea to put players' faces (in this case, venture capitalists on the move) on baseball cards. On another cover, a dinosaur skeleton served as the perfect icon for a story about industries becoming extinct in the face of e-business.

Designers try to be similarly creative with photography, which is usually reserved for portraits. "These people aren't comfortable in front of the camera," Morris says. "We try to do enjoyable things, get people out of their offices." The point of the pictures is to show how much fun the subjects are having in their jobs, she says. Ironically, photographers often need to separate them from their work in order to depict that.

By establishing a laid-back atmosphere in its design, *Business 2.0* can proceed with establishing an authoritative but casual voice—a tone to which people in today's fast-paced business world are receptive. Design works like a twinkle in the eye, quietly and playfully supporting the magazine's new ideas.

left The magazine is always looking for ways to make portraits more interesting. In this case, designers replicate the typeface of a 1960s fashion magazine for a profile on spunky, independent executive Gina Smith.

right Photographers are always seeking ways to get executives to do something fun and active for the camera while maintaining a sense of what they do. Here, a CEO of an online document delivery company shoots paper airplanes at the camera, while a notebook paper theme boosts the layout.

Tricks of Modern Magazine Designers

The principles of good magazine design are timeless, but techniques evolve with the ages. The following list includes twelve trends in design and layout, each noted in multiple magazines profiled in this book.

Spacious top margins

Designers interpret the concept of white space differently than usual with this subtle technique, used often in magazines that run long, in-depth features. A band of white space at the top of pages—generally two- to three-inch margins, allows breathing room in text-heavy articles and creates continuity throughout the well or the whole magazine. It's a way of opening up a page when there isn't a great deal of room for experimentation with negative space otherwise.

Skim-friendly pages

Whether the magazine's format includes longer, analytical pieces or choppy compilations of boxed text, designers are catering to a generation of readers who don't invest the time to curl up for a lengthy read. Boxed text, frequent colored subheads, callouts, and pull quotes pepper articles so readers' eyes move easily from anchor to anchor—making for a refreshing, entertaining reading experience.

Fun with pull quotes

Pull quotes are standard elements in publication design: They act as artistic ways to break up the monotony of a page and also serve as promos to draw readers into articles with the promise of more juicy information and quotes. A few designers have invented ways of making them more interesting. Among these, pull quotes are enlarged or colored to stand out but remain part of their sentences—a way to highlight good quotes and statements while saving space and avoiding repetition. Other techniques involve turning quotes sideways so they run vertically up a page, or running them edge-to-edge across several columns.

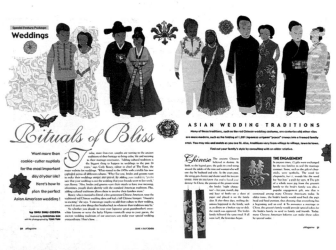

above *Fast Company* uses tall top margins in its well to add breathing room and build continuity from the front to back of the book.

left above *A*'s natural, "skimmable" layouts include anchors such as subheads, colored text, dingbats, and sidebars, which help readers jump from section to section without getting bogged down by text.

left below *Dwell*'s designers offer a departure from the ordinary pull quote by blowing up text within body text to highlight important quotes or sentences. The technique, originally invented to save space, has become a signature part of *Dwell*'s design.

Custom typefaces

Several design departments approached typographers to design unique typefaces for their magazines, either for the magazine's logo or to use throughout the magazine as display type or body text. Magazines tend to follow typeface fads, so many titles may use the same font families for their headlines or cover lines. Custom-designed typefaces not only nail down a desired brand image for a magazine more accurately than existing faces, they also ward off imitation by competitors.

Web-inspired design

Elements familiar to the Web community have crept into magazine design, especially in new economy business magazines and titles that appeal to younger readers. Boxes containing information and section headers that resemble navigation bars or pull-down menus are frequently spotted techniques. In a few magazines, designers make unabashed allusions to the Web—inserting "pop-up" boxes associated with underlined ("linked") text, or using Internet icons such as the hand-pointing cursor.

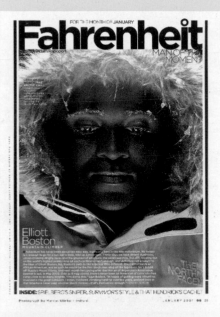

left In a redesign in early 2001, *GQ* introduced a custom-designed type-face, inspired by faces on early twentieth-century subway posters, for its display type to sum up the magazine's straddle between traditional and modern.

Humanism in photography

Almost all designers interviewed for this book referred to the increasing call for more realistic, personal texture to the art they used. Almost all of the profiled magazines make efforts to include people in casual, warm scenes that are true to life, though depending on the subject of the magazine, they interpret the need for humanism in different ways. They may try to show natural living environments by shooting candid scenes of people in a room, sitting with their backs to the lens or interacting with others far from the camera's eye, or use "people scenes" to add chaos and comfort to pristine, minimalist layouts. Business magazines entice featured entrepreneurs to play in front of the camera to expand the notion of the businessperson as family member, friend, and human soul.

below *Real Simple* tries not to *over*simplify its articles; one way it prevents doing so is to add natural, warm chaos by including pictures of people with its images of décor and food.

above To help readers more easily access pertinent information about Web sites and technical terms referred to in articles, *Business 2.0* inserts callout tabs listing URLs (including the Internet pointing hand cursor icon) and "pop-ups" containing definitions and explanations.

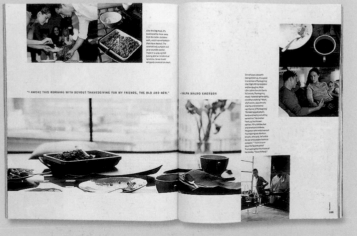

WellBeing

mend a potent herbal mixture called triphala. A combination of amalaki, haritaki, and bibhitaki, triphala strengthens the digestive process, provides nutrients, and pushes out toxins from the body. With a mild laxative effect, it enhances the health of the gastrointestinal tract by rejuvenating the membrane lining of the intestines and by stimulating bile production. Triphala improves liver function, helps purify the blood, and removes accumulated toxins. It is also high in vitamin C and linoleic oil.

Triphala also helps address a wide range of disorders, from irritable bowel syndrome, ulcerative colitis, constipation, and diarrhea, to anemia, eye disease, skin dis-

HEALTH**WATCH**

For the past several years, we've been hearing reports about the benefits of green tea, particularly its role in preventing cancer and other serious conditions. But those who've made drinking it part of their daily routine might wonder: If steeping tea a little releases powerful antioxidants, will steeping it longer produce more of a punch? Probably not, say researchers at the University of Hawaii. In testing the ability of green tea to inhibit colon cancer, the biochemists found that most of the antimutagenic components were released in the first couple minutes of brewing.
Source: Mutation Research

The aromatic bark of the cinnamon tree has more going for it than just great taste. Microbiologists have recently confirmed the spice's age-old reputation as a versatile food preservative—in this case, as a potent match for *E. coli* bacteria. Kansas State University researchers added a teaspoon of cinnamon to apple juice that contained 100 times the level

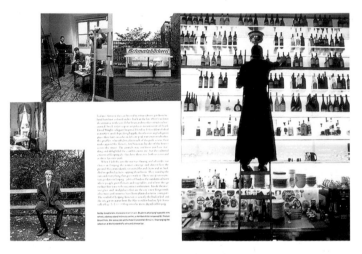

of *E. coli* typically found in contaminated food. In three days, the spice had killed off 99.5 percent of the bacteria. Considering that 10,000 to 20,000 of us get sick each year

from food-borne illness, it's good to know that we can turn to the most common of kitchen staples for protection.
Source: Chemical Market Reporter, HerbClip

Could dry cleaning be killing us? That's a question Representative Carolyn B. Maloney (New York City) would like the Department of Health and Human Services to start investigating. A recent study of 1,350 Boston-area women between the ages of 35 and 75 suggested a link between the use of professional dry cleaning and a greater incidence of breast cancer. "Although the study looked at only a limited segment of the population, it raises troubling questions for women nationwide," Maloney says.
Source: Office of Carolyn B. Maloney, Washington, D.C.

Tummy Tonic
The ayurvedic cure-all triphala
can boost sluggish digestion.

IN AN EFFORT to stay healthy, you probably take strides to keep organs such as the lungs and heart in top form, through practices like pranayama and meditation. But it might pay to set your sights lower.

"Some 80 percent of all degenerative, chronic diseases have their origin in inefficient digestion, assimilation, or metabolism," says Dr. Rama Kant Mishra, an Indian-born ayurvedic physician who is currently director of research and product development at Maharishi Ayur-Ved Products International in Colorado Springs, Colorado. "If we are unable to properly digest and assimilate the food we eat, the body will not receive the nourishment it needs to maintain and regenerate itself. Moreover, digestive dysfunction creates *ama*, a toxic byproduct, which can wreak havoc on normal bodily functioning if allowed to accumulate over time."

To strengthen the digestive fires, ayurvedic physicians traditionally recom-

orders, yeast infections, and problems related to the female cycle. According to Dr. Mishra, most anyone can benefit from taking triphala, although it is contraindicated for pregnant women, people with chronic liver conditions, and for those taking blood-thinning drugs. In rare cases, if a lot of ama has accumulated in the body, nausea or a skin rash may develop when you first begin taking triphala as impurities are pushed out. If that happens, stop taking the herb and consult with an ayurvedic doctor before taking it again.

Take the herb for about six months at a time, and then take a four-week break before continuing. If you take triphala in powder form, ½ teaspoon every evening before bedtime is recommended. If you take it in pill form, follow the recommendations on the bottle. Monitor your daily bowel movements. If they get too loose, it's time to cut back on the dose.
— Eva Herriott

left *Yoga Journal* runs text against the edge of the sidebar and refrains from using border rules—a way to add color and variety without dividing up the pages into disruptive boxes.

Bleeding boxes and sidebars
Another twist on a publication design standard, sidebars and information boxes bleed to the edge of the page to provide variation from the grid. Some designers also eliminate the margins within sidebars, so that text butts against the borders of the box. These techniques are most successful when sidebars use background color but no border rule, so boxes and their copy blend easily into the rest of the page.

Combining black-and-white and color photography
Choosing to shoot a story in black-and-white or color has always been the photographer's contribution to establishing the mood of a finished piece. These days, if the profiled magazines are any indication, photographers and designers may no longer need to make that difficult decision. More and more, designers are mixing black-and-white and color imagery, presenting them effortlessly and unapologetically alongside each other for a more complex representation of an article's message.

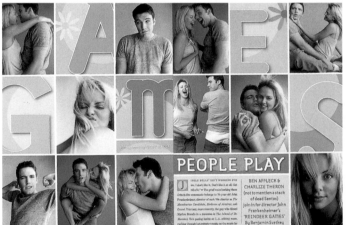

PEOPLE PLAY

Checkerboard layouts
A way to show variety while also tapping into the artistic effect of repetition, the checkerboard organizes a grid of different illustrations or photographs speaking on a similar theme. Such a collage-like formation causes readers to linger for several minutes, studying the contrasting and complementary nature of the featured images. Checkerboards often are seen opening feature stories.

above Designers at *Travel & Leisure* easily combine black-and-white and color photography, a way to offer many perspectives on a single subject.

below This checkerboard layout in *Entertainment Weekly* demonstrates how the technique can be used to create artistic repetition and colorful variety at the same time.

Table of contents

In the magazine publishing tradition, the table of contents usually is buried several spreads deep into the front of the book, wedged inconspicuously between ads for designer clothes and cars (or other high-profile products, depending on the magazine). But more magazines are tinkering with this formula, experimenting with the contents pages for utilitarian or artistic purposes. *Business 2.0* places the contents on the inside front cover so readers can find it easily, for example, while *Blue* has led into the contents with a few photographic spreads in past issues.

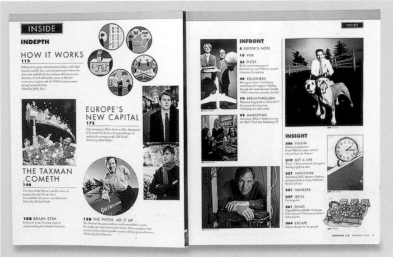

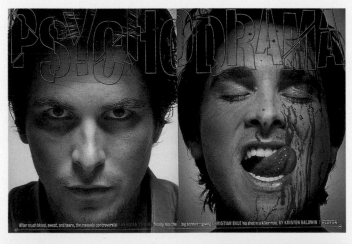

Type as illustration

By no means a new technique, manipulating type for illustrative effect lives on in modern magazine design. This means everything from blowing up significant letters in a headline to building elaborate opening illustrations around display type to open a feature story. It's a way to let page designers flex a little muscle, playing off of commissioned artwork and setting a mood to set the article apart from the rest of the magazine's features.

Depth and texture

The commitment to building three-dimensionality in magazine layouts signals the end of minimalism in design. Magazines use shadowy lighting in photography, overlapping design elements, cut-out negative shapes, and even textural or metallic coatings to create the sense of depth in pages—a way to make magazines jump out at readers in an era of media interactivity.

left **Surface* achieves a three-dimensional illusion with its line shapes and colors in its margins. Driving home the point about the maximalist approach in fashion, designers doodle in the margins with line art, then color in the background to add another dimension.

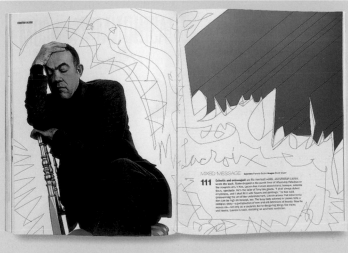

above *Business 2.0* always places its table of contents inside the front cover, part of its commitment to make the magazine easy for readers to access.

left Type often almost literally interprets the subject or mood of an article in *Entertainment Weekly*.

Glossary

ascender: The tall part of a letter that extends above its body.

back of the book: The portion of a magazine between the end of the feature well and the back cover, usually containing editorial departments, classifieds, and fractional ads.

balance: The design principle that one side of a layout must be given equal weight to the other. Balance is achieved through the placement of type and graphic elements.

banner: The place where the magazine's logo (and its motto or subtitle, when applicable) resides on the cover (also called a nameplate).

baseline: The line on which the body of a letter sits.

binding: The way a magazine's pages are fastened together.

black plate: Along with cyan, magenta, and yellow, one of the printing plates used in four-color process printing.

bleed: An image printed beyond the edge of the page.

blow up: To enlarge an image.

blueline: A proof printed from the photographic negative of a page; used for a final check before the page goes to press.

body copy: The text of a magazine article.

book: The publishing industry term for magazine.

bullet: A circle or dingbat in front of each item on a list.

byline: The name of an article's author, usually placed under a headline or at the end of the article.

callout: Explanation of a specific area of an illustration or diagram.

caption: Text that explains an illustration (also called a cutline).

CMYK: The process, or subtractive, colors—cyan, magenta, yellow, and black—used for four-color printing.

color separation: The division of color art into four pieces of positive or negative film—for cyan, magenta, yellow, and black printing plates—in preparation for printing.

consumer magazine: A publication that reaches a broad audience with generalized topics; often available by subscription or on the newsstand.

contrast: The design principle dictating that important elements are given emphasis or dominance on a page, using size, color, texture, or placement, compared to less important ones.

copy: Text.

cover: The front of the magazine visible from the newsstand (outside front cover, or OFC), as well as the inside front cover (IFC), inside back cover (IBC), and outside back cover. Cover placement is the most expensive ad space in the book.

cover lines: Text on the cover that's meant to lure readers to features inside the magazine.

crop: To cut or trim edges or sections of an image.

custom publishing: Publication of magazines that act as marketing or public relations tools for companies.

cutline: Text that explains an illustration (also called a caption).

cyan plate: The metal plate of a page to which blue ink is applied during the four-color printing process.

deck: Text below a headline that briefly summarizes or provides a lead-in to the article.

descender: The part of a letter that drops below the baseline.

dingbat: A decorative graphic or character.

display: Type that is larger than body type, such as headlines or pull quotes.

drop cap: The first letter of an article or section, usually occupying two to four lines of the first paragraph.

duotone: A halftone image printed in two colors, usually black and a lighter color.

flag: Typographical and graphic treatment of the magazine's title on the cover.

folio: The page number in the top or bottom margin, sometimes accompanied by other information (such as the magazine's date).

font: All the sizes and styles of a typeface family.

format: The size, shape, and design characteristics of a magazine.

formula: A magazine's editorial makeup, specifying types of content and regular departments.

four-color: The printing process that uses four primary colors—cyan, magenta, yellow, and black—to reproduce color artwork and layouts.

front of the book: The portion of a magazine between the front cover and the feature well, usually containing high-profile ads, the table of contents and mastheads, news, and editorial departments.

function: The reason behind a magazine—who it serves and what it strives to communicate. Understanding function is instrumental to planning a magazine's design.

gatefold: A long page folded toward the magazine's binding to create four panels.

glossy: A magazine with a shiny surface or coating to its pages. The term is also used to define a magazine that is a standard magazine newsstand size (usually 8 by 11 inches to 10 by 13 inches or 20 by 28 cm to 25 by 33 cm, on average) as opposed to a tabloid.

grayscale: The range of tones between black and white in an image.

greeked text: Nonsensical characters that act as placeholder body text when designers are mocking up a page.

grid: An invisible structure that guides the placement of graphics and text on a page.

gutter: The margin of a page that's nearest to the binding of the book.

halftone screen: A process in which an illustration with continuous tones, such as a photograph, is broken into dots, then reproduced during printing by running the dots together.

IBC: Inside back cover.

IFC: Inside front cover.

leading: The measured white space between lines of type.

line art: Art that's black-and-white instead of continuous tone.

logotype (logo): Typographical and graphic treatment of the magazine's title, usually found on the cover and table of contents page.

magenta plate: The metal plate of a page to which red ink is applied during the four-color printing process.

margin: The measured white space at the top, bottom, left, and right edges of a page.

masthead: A box, usually at least one column wide, listing the magazine's editors, designers, business staff, and information about the publishing company, subscriptions, and contact information.

matte: A dull, unglossy finish on a page.

montage: The assembly of several photos or illustrations into a single piece of art.

nameplate: The place where the magazine's logo resides on the cover (also called a banner).

OBC: Outside back cover

OFC: Outside front cover

pagination: The process of creating complete page layouts and putting them in order by page number using computer desktop publishing software.

palette: A set of colors that can be used in a magazine, defined in advance to ensure a consistent look and brand from issue to issue.

perfect: A type of binding that uses glue to hold pages together.

pull quote: An excerpt from a quote within an article that's been pulled out, enlarged, and used as a design element to break up body text.

saddle stitch: A type of binding in which long sheets are laid on top of each other, stapled in the middle, and folded.

sans serif: A typeface that does not have serifs, or feet.

self-cover: A magazine cover that uses the same paper stock as is used inside the magazine.

separate cover: A magazine cover that uses heavier paper stock than is used inside the magazine.

sequence: The design principle that the designer can choose the order in which readers look at items on a page, using size, color, shape, and placement.

serif: A typeface that has serifs, or feet—short lines at the end of each of the letter's appendices.

signature: A single sheet of paper on which multiple magazine pages (usually 4, 8, 16, or 32 pages) are printed on the back and front. Then the paper is folded to page size, trimmed, and laid together with other signatures to complete the entire issue.

silhouette: To remove the background from a halftone image.

six-color: The printing process that uses six colors—cyan, magenta, yellow, black, and two spot colors.

slab serif: A typeface that uses heavy, even serifs (also called a square serif).

spot color: A solid color, often used for accent, that's printed with one separation plate (instead of multiple plates used in process color).

square serif: A typeface that uses heavy, even serifs (also called a slab serif).

stock: The paper on which a magazine is printed.

subhead: A short headline used to break up sections or paragraphs within body copy.

subtractive color: The color created by combining cyan, magenta, and yellow ink on white paper.

tabloid: A magazine that is the size of a tabloid newspaper, or half the size of a regular newspaper—approximately 11 by 15 inches.

trade magazine: A magazine that serves a specific industry or reader according to profession (also called a business-to-business magazine).

typeface: A style of type.

unity: A consistency in design style throughout the magazine.

well: The section, usually in the middle of the magazine, that contains the longer feature articles. Often there are fewer ads in the well than in the rest of the magazine.

x-height: The body of a lowercase letter.

yellow plate: The metal plate of a page to which yellow ink is applied during the four-color printing process.

Directory

A

aMedia Inc.
677 Fifth Avenue, 3rd floor
New York, NY 10022
212-593-8089
www.aonline.com

Illustrations:
Philip Anderson (p. 41, bottom)
Gregory Benton (p. 42, top)
Edward del Rosario (A-10)
Christina Sun (p. 41, top, p. 42, top, p. 152, center)
David C. Wong/Shooting Star (p. 44, middle)

Photography:
Alex Berliner (p. 42, bottom)
Marina Chavez (p. 43, bottom right photo in top image)
Jordan Doner (p. 45, bottom)
Gerard Gaskin (p. 44, top)
Roberto Ligresti-Davies (p. 43, bottom; p. 110, bottom)
Alia Malley (p. 43, top right photo in top image)
Kelley Meyers (p. 43, top left photo in top image)
Jenny Risher (p. 45, left photo in top image; p. 110, top)
Joanne Savio (p. 43, bottom left photo in top image)
Art Streiber/Montage (p. 40, left)
Mikael Schulz (p. 45, right photo in top image)
Jason Todd (p. 45, middle)
James Worrell (p. 33, top, p. 44, bottom)

AURAS Design
Rob Sugar
8435 Georgia Avenue, 3rd floor
Silver Spring, MD 20910
301-587-4300
www.auras.com

Ayers/Johanek Publication Design
John Johanek
8230 Rolling Hills Drive
Bozeman, MT 59715
406-585-8826
johanek@publicationdesign.com

Blue
611 Broadway, Suite 405
New York, NY 10012
212-777-0024
www.blueadventure.com

Business 2.0
Imagine Media Inc.
150 North Hill Drive
Brisbane, CA 94005
415-468-4684
www.business2.com

Code

8484 Wilshire Boulevard, Suite 900
Beverly Hills, CA 90211
323-651-5400
www.codemagazine.com
Courtesy of *Code* magazine.

Context
875 N. Michigan Avenue, Suite 3000
Chicago, IL 60611
312-255-4715
www.contextmag.com

Photography:
Patrik Andersson (p. 143, middle)

Details
Fairchild Publications Inc.
7 West 34th Street
New York, NY 10001
212-630-4000
www.details.com

Photography:
Jake Chessum (p. 19, bottom)
Jeff Jacobson (p. 21, bottom)
Steven Klein (p. 18, left, p. 19, middle)
Larry Sultan (p. 19, top, p. 20, bottom)
Michael Thompson (p. 21, top and middle)

Dwell
99 Osgood Place
San Francisco, CA 94133
415-743-9990
www.dwellmag.com

Entertainment Weekly
1675 Broadway
New York, NY 10019
212-522-1212
www.ew.com
©(2001) Entertainment Weekly Inc.
All rights reserved. ENTERTAINMENT WEEKLY
is a registered trademark of Entertainment Weekly Inc.
Used by permission.

Fast Company
77 N. Washington Street
Boston, MA 02114
617-973-0300
www.fastcompany.com

GQ

4 Times Square
New York, NY 10036
212-286-2860
www.gq.com

Credits:
Design Director: Arem K. Duplessis
Director of Photography: Jennifer Crandall

page 12, left
Art Director: Paul Martinez
Designer: Arem K. Duplessis and Paul Martinez
Photo Editor: Jennifer Crandall
Photographer: Michael Thompson

page 12, right
Design Director: Arem K. Duplessi
Art Director: Paul Martinez
Designer: Paul Martinez
Photographer: Robert Erdmann

page 13, top
Art Director: George Moschalades
Designer: Arem K. Duplessis
Photo Editor: Karen Frank
Photographer: Michael O'Neill

page 13, middle
Art Director: George Moschalades
Designer: Arem K. Duplessis
Photo Editor: Karen Frank
Photographer: Art Strieber

page 13, bottom
Art Director: Paul Martinez
Designer: Arem K. Duplessis
Photo Editor: Jennifer Crandall

page 14, top
Art Director: Paul Martinez
Designer: Paul Martinez
Photo Editor: Jennifer Crandall, Catherine Talese
Photographer: Tom Tavee

page 14, middle and page 153, top
Art Director: Paul Martinez
Designer: Paul Martinez
Photo Editor: Jennifer Crandall, Kristen Schaefer
Photographer: Markus Klinko and Indrani

page 14, bottom
Art Director: Paul Martinez
Designer: Paul Martinez
Illustrator: Kristian Russell

page 15, top
Art Director: Paul Martinez
Designer: Arem K. Duplessis
Photo Editor: Jennifer Crandall
Photographer: Steven Sebring

page 15, middle
Art Director: Paul Martinez
Designer: Arem K. Duplessis
Photo Editor: Jennifer Crandall
Photographer: Michael Thompson

page 15, bottom and page 153, top
Art Director: Paul Martinez
Designer: Arem K. Duplessis
Photo Editor: Jennifer Crandall, Kristen Schaefer
Photographer: Ben Watts

page 16, top
Art Director: Paul Martinez
Designer: Arem K. Duplessis
Photo Editor: Jennifer Crandall
Photographer: Michael Thompson

page 16, middle
Art Director: George Moschalades
Designer: Arem K. Duplessis
Photo Editor: Jennifer Crandall
Photographer: Norman Jean Roy

page 16, bottom
Art Director: George Moschalades
Designer: Arem K. Duplessis
Photo Editor: Jennifer Crandall
Photographer: Norman Jean Roy

page 17, top
Art Director: Paul Martinez
Designer: Matthew Lenning
Photo Editor: Jennifer Crandall
Photographer: Stewart Shinning

page 17, middle
Art Director: Paul Martinez
Designer: Arem K. Duplessis

page 17, bottom
Art Director: Paul Martinez
Designer: Arem K. Duplessis
Photo Editor: Jennifer Crandall
Photographer: Anita Calero

HOW
F&W Publications
1507 Dana Avenue
Cincinnati, OH 45207
513-531-2690
www.howdesign.com
©1999 HOW magazine

Samir Husni, PhD
Professor of Journalism
231 Farley
University of Mississippi
Oxford, MS 38677
662-915-5502
hsamir@olemiss.edu
www.mrmagazine.com

I.D.
F&W Publications
1507 Dana Avenue
Cincinnati, OH 45207
513-531-2690
www.idonline.com
Courtesy of *I.D.* magazine

Real Simple
Time Inc.
1271 Avenue of the Americas
New York, NY 10020
212-522-1212
www.realsimple.com

Sony Style
Time Inc. Custom Publishing
1271 Avenue of the Americas
Suite 2872D
New York, NY 10020
212-522-1212

**Surface*
7 Isadora Duncan Lane
San Francisco, CA 94102
415-929-5101
www.surfacemag.com

TransWorld Surf
TransWorld Media
353 Airport Road
Oceanside, CA 92054
760-722-7777
www.twsurf.com

Travel & Leisure
American Express Publications
1120 Avenue of the Americas
New York, NY 10036
212-382-5600
www.travelandleisure.com

Walking
45 Bromfield Street, 8th floor
Boston, MA 02108
617-574-0076
www.walkingmag.com

Photography:
C. Taylor Crothers (p. 88 bottom)
Laura Johansen (p. 47 top)
Catherine Ledner (pp. 86 top, 87 top)
David Roth (pp. 84, two photos; 85, two photos; 86 bottom, 87 bottom)
Eric Tucker (p. 89 top)
Richard Schultz (p. 89, bottom)
Angela Wyant (pp. 88 top, 89 left)

Yoga Journal
2054 University Avenue
Berkeley, CA 94704
510-841-9200
www.yogajournal.com

Index

A...33, 40-45, 110
Abbink, Jeanette Hodge59, 60, 61, 62
Adbusters...108
advertising and design108-109, 133
Anderson, Chris ...147
Arnold, Kathryn ..79, 91
audience demographics11
Bello, Roland48, 53, 54, 56, 57
Berry, Pamela97, 100, 101s
Blue.........................92-93, 102-107, 108-109, 113
borders ..79, 83
boxes29, 42, 57, 105, 117, 148
Business 2.0....................................10, 146-151
Carson, David ..73, 92
Claire, Julie ...128
Code11, 34-39, 94-95
color palette.................14, 16, 22, 38, 44, 56, 75,
 81, 89, 107, 118, 125, 129, 149
Condé Nast ...19
Context...48, 140-145
Crandall, Jennifer ...16
cropping ..67, 87, 104
Daly, James ...147
departments.............14, 22, 39, 90-91, 94-95, 148
design process ..46-51
Details ...18-23
DNR..19
drop caps ..42
duotones ...35, 51
Duplessis, Arem ..13, 14
Dwell9, 49, 50-51, 58-63
Elle ...35
Elle Décor..52
Emigre ..10
Esquire ...128
Entertainment Weekly............9, 24-29, 46, 47
F&W Publications115, 121
Fairchild Publications.......................................19
Fast Company......................9, 32, 134-139
Fitness ..85
Folio:...19, 133
Gan, Dina ...41, 110
Gear ...35
Generation X..65
Generation Y..72
genres
 architecture..58-63
 business................134-135, 140-141, 146-147
 custom publishing127, 140-141

cultural................................34-35, 40-41
design58-63, 64, 58-63, 64
entertainment.....................................24-25
exercise/health78-79, 84-85
fashion ..64
home décor53, 58-63
men12-13, 18-19, 34-35
surf ...72-73
trade109, 115, 121
travel96-97, 102-103
GQ..12-17
Graves, Michael ...59
grid14, 30-33, 50, 100, 116
Harper's ...12
Harvard Business Review.....................135, 140
Harwood, Rockwell18, 20
Hawk, Amy116, 118, 119
Hazen, Shawn49, 50-51, 59, 63
Hess, Charles...36
Hessler, Geraldine25, 26, 28, 47
Hostetter, Marc73, 74, 75
HOW31, 33, 114-119
Husni, Samir, Ph.D.9, 70-71
I.D. ...10, 120-125
illustration.........16, 26, 28, 45, 48, 66, 142-143, 150
Imagine Media ..147
Interview ...35
Isley, Alexander..116
Italian GQ..35
Jacobs, Karrie ...39
Johanek, John132-133
John-donnell, Riley48, 65, 66, 67, 68, 110, 112
Kirchner, Gretchen...144
Koppel, Terry127, 128, 130
Life ...12
logo/flag24, 45, 61, 82
Lowrey, Saralynne..39
Maltais, Mark....................48, 141, 143, 144
Mitchell, Patrick135, 136-137, 138
Mooth, Bryn ...116, 118
Morris, Laura ..147-150
Ms....108
Muller, Jennifer...128
National Geographic25
negative space54, 68, 86, 125, 137
newspapers ...10
1920s design ..60
1950s design ...26, 60
1990s design10, 88, 92

Nylon ..35
photography16, 20-21, 28, 36, 37,
 44-45, 56, 62, 63, 68, 74, 80-81, 97, 122-123, 131,
 138, 143
pull quotes......................................42, 63, 89
Raygun ...10, 92
Real Simple11, 48, 52-57
Red Herring..109
redesign91-95, 116, 132-133
Robinson, Eugene ...35
Rolling Stone..130
Schrier, Amy ..103, 112
Sergi, Lisa10, 47, 85, 86, 88
Seventeen ...72
Shape..85
sidebars ..83
Skinner, Christa92, 104
Sony Corporation ..126
Sony Style ..126-131
Stewart, Martha ...52
Sugar, Rob ..132-133
**Surface*10, 64-69, 110, 112
Tan, John ...42, 45
texture ..66
Time Inc.12, 25, 53, 127, 128
Town & Country................................21, 52
Trade Gothic (typeface)...................................60
TransWorld Media ...73
TransWorld Skateboarding73
TransWorld Surf.......................................72-77
Travel & Leisure11, 96-99
typography15, 26, 61, 82, 86, 119, 130, 135, 144
Utne Reader..134
Vibe...35
Vogue..25
Wallpaper ..64
Walking10, 46, 47, 84-89
Wieder, Jonathan78, 80, 91, 111
Wired......................................10, 121, 140
Wohlfarth, Jenny121, 123, 125
Web design10, 22, 35, 41, 45
Writers' Digest..115
XPlane ..149
Yang, Jeff...45
Yoga Journal11, 78-83, 90-91, 111